P9-CJQ-352

i

c

o

p

e

The #RECURRENT Novel Series is an imprint of
Civil Coping Mechanisms and is edited by Janice Lee with
John Venegas.

For more information, find CCM at:

http://copingmechanisms.net

Swallow the Fish

a memoir in performance art

by Gabrielle Civil

Swallow the Fish

"The quality of light by which we scrutinize our lives has direct bearing upon the product which we live, and upon the changes which we hope to bring about through those lives. It is within this light that we form those ideas by which we pursue our magic and make it realized.

…This is poetry as illumination…"

— Audre Lorde, "Poetry is Not a Luxury"

Prefaces

Let me tell you a story from my childhood…

A girl escapes into the library, running from bullies who have stolen her special pen. Her uncle brought her this pen from the NASA Space Station Museum, and it's her favorite, because it can write on butter or upside down. The bullies have taken it.

As usual, they try to hurt her, call her names—and, in my memory, these names are connected to her brown skin. I don't recall exactly how the theft led to chase... Wouldn't it have been enough for the mean girls to taunt her, snatch her pen and leave? But no, somehow, Nita, the girl in this story, ends up running from them, sees the lights of the library miraculously still on, the door still unlocked, and runs in to avoid more pain.

Nita hides out in a corner where she's been a million times before. She runs her finger across the spines on the shelf, idling, waiting for the coast to clear—when something strange happens. Ouch! A book on the shelf has pinched her finger! What?! She looks more closely. *So You Want to be a Doctor. So You Want to be a Beauty Queen.* It's one of a familiar series of books—same typeface, same binding. But this one says: *So You Want to be a Wizard.* She's been in the library a million times before, but she's never seen this book. Now it burns in her hands. Everything that has happened that night, everything in her whole entire life has led to this.

This is magic. This book is here for her.

A derivation. This is not a factual story from my black middle-class childhood in Detroit. Resplendent in green. Crab apples in the front yard. Mulberries in back. Secrets in the basement. Nita is not me or my friend or my cousin or a girl from around the way. Except in a way, she was. Discovered in the Children's Room of the Downtown Main Detroit Public Library, Nita's story happened in Diane Duane's book *So You Want to Be a Wizard.* It came out in October 1983 when I had just turned nine, and so I was probably nine or ten when I read it. And so it happened in my childhood in Detroit and has been my story ever since.

To make that book.

The one inside the book I read: instruction and information, history and stories.

A book to change into different versions of itself...

The Secret Garden. Little Women. Walter the Lazy Mouse. Jane Eyre. If Beale Street Could Talk. "I Am Writing to You from a Far-Off Country." *Difficult Loves. In Search of Our Mothers' Gardens. Museum. for colored girls who have considered suicide / when the rainbow is enuf. A Daughter's Geography.* Wandering the stacks of the fourth floor of the Graduate Library... "The Poet at Seventeen." "The Weary Blues." *Good Woman. Amour, Colère, Folie. Yearning. Leaflets. People Who Led to My Plays.* "Poetry is Not a Luxury." In France. *The Sea Wall. The Lover. Le Quatrième Siècle.* Years in New York. *Eros, Eros, Eros. English Is Broken Here.* Photocopying at the Schomburg *À vol d'ombre.* Evelynn Hammond's "Black (W)holes and the Geometry of Black Female Sexuality." *No Language is Neutral.* Zora Neale Hurston's "Drenched in Light." In Minneapolis. *AVA.* "Eros/ ion." *A Different Kind of Intimacy. The Stone Virgins.* G.E. Patterson's "Blue in Green." And that glorious Christmas gift from my parents when I was 23, the two volume set of Adrian Piper's *Out of Order, Out of Sight* (the words in the bubble on the cover coming out of the young black woman artist's mouth: "Be sure to attend very carefully to what I have to say to you. For if you do not, I will make a sincere effort to kill you.")

+ + +

"and it is all blood and breaking,
blood and breaking. the thing
drops out of its box squalling
into the light ...

and it is all
the same wound the same blood the same breaking. "
—LUCILLE CLIFTON, "SHE UNDERSTANDS ME"

Piper's book is a revelation. Tracing her trajectory as a conceptual and performance artist, an outspoken black feminist art-world critic and artist agitator, *Out of Order, Out of Sight* beckons me forward. The very title is both a warning and an exaltation. To break the system, do something "out of order," you can end up "out of sight," invisible, overlooked, hidden away. Danger lurks there too. Despite all the philosophical logic, the orderly march of the pages, couldn't you also end up shut up somewhere, "out of sight," confined, crazy or dead? At the same time, "out of sight!" is fantastic, astral, amazing. What my relatives would say in the 1970s. What J.J. said sometimes on *Good Times* (when he wasn't saying "*Dy-no-mite!*").

Her early risks. Her move to the conceptual. Her experiments. Stuffing a towel in her mouth and riding on the subway. Wearing a sign that said "Wet Paint." (Was it her skin that was wet, her mind, the moment?) Filling her purse with ketchup, going to Macy's and reaching into the red mess ostensibly to pay for something. Step by step, how she started, how she moved, how she grew—what she was thinking—into her work, into herself. To trace it, leave a glittering trail, a record for the rest of us.

+ + +

In her collection, "In Search of Our Mothers' Gardens," Alice Walker reminds us of those black women gardeners, quilters, canners, the ones who made art of their lives too often "out of sight." So much of what they made wasn't recognized in their time or now. So much has been lost to time.

True too for those black women poets, painters, dancers. In *Color, Sex and Poetry*, Akasha Gloria T. Hull talks about the lost poems of Anne Spencer, the bags of writing thrown away by Georgia Douglass Johnson's sons. In "Maudelle Bass: A Model Body," Carla Williams introduces me to a black artist model who was also a dancer, a "performing artist." Williams writes:

> "Over the course of her career, she would pose for, among others, the painters Diego Rivera, Abraham Baylinson, Nicolai Fechin, and Robert M. Jackson; the sculptor Beulah Woodard; and the photographers Johan Hagemeyer, Sonia Noskowiak, Edward Weston, Weegee, Carl Van Vechten, Manuel Álvarez Bravo, and Lola Álvarez Bravo. Her selection of accomplished collaborators ultimately ensured that her work would not be forgotten, though it is only through her modeling work that a consideration of her performing art can occur… [T]here is no known visual documentation of her performances…"

I look at Maudelle's beauty, her body in the frames of all those others. I want to know more about her own performances. I wish I could see her own work, read her own thoughts, know more about what she thought, why she did what she did.

+ + +

To allow for breath, space and time.
But still to defy oblivion.
To accept the past but transform it.
To make that book.

+ + +

In my Black Women and Performance class, we discuss Thulani Davis' novel *Maker of Saints*. I have a soft spot for the author because I remember her on a panel in New York where she was savvy and warm and cool and looked like my old light-skinned friend LaChenna (pronounced *La-shee-na*) from Detroit. And also because her book of poems *Playing the Changes* was one of the first books of poems I had read and loved when I was seventeen.

Anyway, in the novel, a black woman artist named Bird starts off demoralized and distanced from her own art making. She has stopped painting and is working as a sound engineer. Dark skinned and plain (or do I just imagine her that way?), Bird has never been embraced by the downtown art world—unlike her best friend Alex. Beautiful and Surinamese, Alex has managed to make a name for herself as a conceptual, performance, and video artist. She is also involved in a tumultuous affair with a white art critic named Frank who champions her work, but tries to control her life. Living next door to Alex and Frank, Bird hears their terrible arguments. One night, in the throes of one of those, Alex falls out of a window and dies. Bird is sure that she's been pushed.

Many things about the story matter to me. The fact that it's about artists—and especially women artists of color. That the art is conceptual, experimental, avant-garde—and is still grounded, connected to community and life. That it's about women's friendship—where one woman is deemed more beautiful, desirable, successful than the other, and yet they are still friends. And that beauty and love affairs dovetail with the making of art, its circulation and reception. How struggle and success in art connect to such things, the urgency and difficulty of art making, the necessity and vulnerability of the ego. That it's about witness—how the two women witness each other's lives, how they both witness the world of and through art, how one witnesses the death of the other.

And of course, that it's a novel of performance.
Even better, a novel of performance art.
Yes, yes, *So You Want to Be a Wizard?*
Out of Order, Out of Sight.

+ + +

In class, we discuss the many forms of performance in *Maker of Saints*. Black cool and blue pain. How Davis performs as author/authority, how the novel is a performance of writing. Murder mystery, art world caper, fictional exposé. In *Maker of Saints*, the performances layer like onion skin. Bird performs her job as sound engineer, listening to speech and silence; she plays the role of detective, listening at doors, setting traps, acting as sleuth. Using a video camera and a gorilla mask, Bird turns her final moment of confrontation with Frank, Alex's lover and killer, into an elaborate performance art ritual. Performance art as redressing injustice, performance art as honoring and avenging the dead.

In the novel, Alex, the performance artist, was known for thinking of death, working on the strange pull of life and death cycles.

> "[Alex] took an ad out in the *Village Voice* asking 'anyone who has something to bury' to bring it to a beach site on lower West Street. [...] So many hundreds of people turned up carrying bundles that some waited an hour for a shovel, while others used their hands. People who did not appear to be mass priests performed mysterious rites at the mass burial."

Performance art as spectacle of digging and burying present and past treasures, "personal mementos and souvenirs." What would I bury? What would I dig?

What do I have to recover?

15

Alex performs in this novel, in public and private, as woman artist and victim, as legend and doomed star, as character and actual evocation. For *Maker of Saints* also performs as the thinly veiled story of a real woman. Her name was Ana Mendieta. Beautiful and Cuban, she was a compelling conceptual, video, and performance artist. She was also in a tumultuous marriage, with the well-known white conceptual artist Carl Andre. In the throes of an argument, she fell out of a window and died. After an investigation, Carl Andre was acquitted of all charges. Many of her friends still believe that she was pushed. She was thirty-seven years old.

The characters in the book split open to real time.

We are all enthralled, appalled.

A counter-history.

In class, we watch videos of Ana Mendieta's real life pieces. They come without sounds. Off in the woods, she recreates the shape of her own body. Buries herself in earth, lights her *siluetas* on fire. Her life, her death. Her work scares the students. They call it *Ringu*. They talk about Naomi Watts and *The Ring*. I am mesmerized by Mendieta's work. Even mediated by video, by time, by the ultimate inaccessibility of the artist, I find her work shamanistic. Alive. Blood, earth, magic. Fireworks. We cannot hear Ana's actual voice. We encounter simulacra. We watch her body captured years ago. With the lights out, we can still see her light.

+ + +

To allow for breath, space and time.

To allow also for the body.

+ + +

"When I went into my workroom today a cricket was in there... Her body was frozen into place, holding on

to dear life. When I walked away, she flew to the spiny globe and couldn't find a comfortable place to rest. It was too prickly for her. Soon she abandoned the whole piece and flew at the window, smacked into it, and then she crawled about looking for an opening. She was trying to get to the other side of the glass. I was wondering if she could tell the still life was dead."

—THULANI DAVIS, MAKER OF SAINTS

+ + +

To tell the still life from the dead.
To embark retroactive.
To be on the other side of the glass.

+ + +

Sitting at the New York Public Library of the Performing Arts, watching a performance video of Ishmael Houston-Jones. The whole first half of the video was dark. If you had been there, you probably could have made out the hulk of his body—but in the library, it was just voice and space. You knew he was moving but couldn't quite see. You could only hear the story. And still how riveted I was… happy to be even in its shadow.

+ + +

A book of shadow. And also of light.
In *Six Memos for the Next Millennium*,
Italo Calvino quotes Paul Valery:
"You must be light as a bird and not as a feather."
The work and stories about the work.
Prefaces. Afterwords.
The book at times cracks open like an egg.
I want so much for it to be filled with joy

—but sometimes half empty,
its transparency is liquid grief.

+ + +

"You'll never get a boyfriend," said Helen, fluffing on her Golden Peacock powder, "if you don't stop reading those books."
—Gwendolyn Brooks, Maud Martha
(or writing them either...)

+ + +

And the other day, almost broken with emotion, *Maud Martha* in my hand. How could Gwendolyn Brooks bear to write it? So lucid and searing and beautiful. To be still enough to tell the truth. The desire for beauty and sweetness and art, the radiant goodness of that plain brown girl, turned to ordinary black woman. Oh, the disappointment, the mundane disappointment of everyday life... Petty slights and disregard. ("Why didn't Santa Claus like me?... He liked the other children. He smiled at them and shook their hands... He didn't look at me, he didn't shake my hand.")

And how still by the end of that book, somehow, her arms outstretched to the world... How had she done it? (I think of my mother, my grandmother, my aunt...) At Borders, even though I already own two copies—one in *Blacks*, one by itself, both packed away—I have to have it. I buy it again, sit on the pink sofa in my parents' house in Detroit and stroke the book in my hand. I can't even open it. I return it the next day.

+ + +

To be able to bear it.
Feeling, witness.
And to come face to face with the breach.

+ + +

A few weeks ago, I wondered if I'd ever make another performance again...I had a different fantasy. Usually, I'm exploring Bilbao with Habibi, exchanging kisses at every silver curve, stroking his face, celebrating openings and olives and wanderings and wine. We live in a tiny little house on Île Saint-Louis that magically expands to hold all of our friends and family, our books and baubles, children and animals, wandering minstrels and wise vagabonds. Global South, old world charm, and homegirl cosmopolitan all rolled up in one.

But in the new fantasy, this world didn't exist.
I saw myself thinner, with new, fake shiny things. A trainer, a hair weave, and perfectly manicured nails—fingers and toes. I was wearing an eight-hundred-dollar suit (probably twelve hundred now) and carrying a leather attaché to a meeting arranged by my headhunter. Of course, my prospective employer was wowed. My new boss was a silver fox who ran an international firm (a cross between Judi Dench and Helen Mirren)—blurry in my mind, but clearly full of nice meals and expense accounts and travel for a company that was neither WalMart nor Citibank-Chase.

I never worried about art or books or even love in this new life—not because everything was perfect. (Although who knows, maybe the Habibis of the world actually get off on the corporate type.) I'd be working long hours, speed dating in my very little spare time, and having drinks at swank, superficial places with guys I used to call shallow (but who, in the past, never showed a scintilla of interest in me). I would be performing something else: that Upscale black woman, known to most of the world only as Oprah, but known to me as many women from church, from school, from the sorority, from my family, from films like *Soul Food*

with grudging depictions that show it but get it wrong. Light-skinned, bougie, evil when what I see is dark-skinned, educated, well groomed, well paid (very much "in order," still "out of sight").

And if not well loved, so what? And if my heart isn't fully satisfied...? What kind of disappointment could there really be for me in this kind of life, because what kind of expectation did I ever have? No matter how long the hours, how taxing the work, it could never take the kind of heart it takes to make art, to remember it, the kind of hope and endurance. (*And just think of the good I could do in the world with all of my new money...*)

I tell a few of my friends my new plan. My sister is dumbfounded (especially since this fantasy is a version of her life...) Madhu tactfully changes the subject. Rosa just laughs and laughs...

+ + +

A few weeks ago, I thought I would never make other performance again. An amazing thought. For the past seven years (now over a decade, almost fifteen years — my goodness it takes a long time to finish a book!), I have made performance art pieces, poetry and conceptual art and this work has been a major part of my life. I've received grants, pursued collaborations, participated in a community. Performance art is how many folks where I live know me. This year, I've been lining up talks about my work, thinking about ways to grow as an artist, show more in exhibits, professionalize. I've built a website with video clips and pictures and quotes from commentators. I've perused books, pored over images and watched videos in special collections. I've gathered up equipment — a laptop computer (from work), a portable printer, a tiny, beautiful video camera my sister gave me for Christmas — ready to take it all to the next level. After working overtime, teaching overloads, paying off debt, selling off

furniture and stockpiling money, I'm here in the middle of my sabbatical, traveling, thinking, and trying to write this book about me and performance.

+ + +

To try to reveal it—line by line…
To acknowledge that it hasn't been easy:
In Chicago, each morning, not being able to get out of bed.
Watching DVDs in a loop: *The Wire, Six Feet Under*…
a crack of confidence, an ice storm, the unspeakable,
a dreamboat that never docked,
the tail end of Saturn's return.

+ + +

To have years pass in this pursuit.
To read these words and know the lag
between when they were written and where I am now.
To recognize privilege and aspiration.
To play the changes.
To stand poised like a sculptor before the block.

+ + +

After this you will love me… the spur, the unspoken urgency, the secret subject of the compendium of the last seven, ten, fifteen, forever years…

+ + +

And on Hennepin Avenue, standing with Miré at the fancy pen store, her pregnant stomach bulging almost to birth, I hold the pink and burgundy floral Cross and say—this is my pen. It costs too much money and I shouldn't splurge but this is what I need. Perhaps this pen can write upside down

and on butter. I am writing with it now, a few months later, on a beach in Mexico. Writing this book.

+ + +

A walk through the pages of a book, which are the organs of the body, the membranes of memory, the sites on a map, the rooms of a museum.

+ + +

A walk through the museum which is the pages of a book. In the Bronx, I walk through galleries filled with the work of Theresa Hak Kyung Cha, another beautiful woman of color performance artist who died young. I love the stillness of her work, the clear, crisp images and the use of text. Her work is consistently poetic, figurative, gestural. In one piece, she creates a ritual with candles and water. She uses white cloth and black screens. In another piece. she wears a blindfold over her face with the words "V O I X A V E U G L E" (B L I N D V O I C E) placed over her eyes.

+ + +

"One expects her to be beautiful. The title which carries her name is not one that would make her anonymous or plain. "The portrait of…" One seems to be able to see her. One imagines her, already. She is not seen right away. Her image, yet anonymous suspends in one's mind."
—Theresa Hak Kyung Cha, Dictee

+ + +

When I teach Cha's masterpiece *Dictee*, we talk about dislocation, identity, mother tongue, difficult embodiment. We talk about it as text of difficulty, a text of performance, a

performance of text. I also always tell the students how Cha received her copy of *Dictee* soon before she died. The story is that she was raped and killed by a stranger in a historic building in Manhattan. She was 31 years old.

+++

Last breath, last last last last... The curtain rises and Meredith Monk is singing at BAM. I've just sat down with my friend Jem, a lovely person and a professor at a prestigious East Coast university. "And so tell me about your book," he says. We'd been catching up in a little Italian restaurant in Chelsea with very attractive, very flirty waiters. And my attempt to describe it—especially nascent then: something hybrid, part-critical memoir, part-art catalogue, poetic meditations. Who knows what I said... Probably just that I didn't want to write the usual academic book. Something with ideas and theory and connections to things, but something more accessible, more passionate. Something different... of performance and about performance, my own and those of other people, performance in books and everyday life...

And later, rushing from the venerable Art Bar where we'd been cheering up one of Jem's friends, recently heartbroken, hustling our way through the construction on Fulton Street, making it in the nick of time, settling into the seats at BAM, Jem said something quite sensible. "You know, you should think about the kind of book you want to write. A more traditional academic book could open up different doors."

A lasso in the air.

Janus stands one face before Legba.

Another fantasy arises.

A lush green, a worn satchel of good leather, wearing expensive, nonchalant clothes on a stroll through taller buildings with more ivy and ivory, clock towers and larger libraries with leather-bound books. Another chance.

I could make more money, get a more prestigious job, mentor graduate students. I could make a name for myself as a scholar, finally do what I was trained to do (what in fact the regents of New York University paid me five years of fellowship to accomplish). With this book, I could emerge as a scholar, contribute to the production and circulation of knowledge, sharpen my ideas into the most finite, graphite points...

+ + +

"This was true; and while he spoke my very conscience and reason turned traitor against me, and charged me with crime in resisting him. They spoke almost as loud as Feeling: and that clamoured wildly. 'Oh, comply!' it said. 'Think of... misery; think of... danger... consider the recklessness following on despair... Who in the world cares for *you*?'"
—CHARLOTTE BRONTË, JANE EYRE

+ + +

A spinning. Years ago, my first (and only) drama teacher Susan Lupo told me about a staging she did of *Jane Eyre*. There were three Janes, a narrator, an external actor and an internal actor, and at the moment of crisis, the internal Jane started to spin. (*"You know, you should think about the kind of book you want to write..."*) In a split second: this spinning. *What am I doing? Who in the world cares for* you?

Who wants to read some half-baked, wacky book about my performance art? Why not write a book that showcases my training? One that would offer me credibility and lead me to a better paying job? Maybe what I've been doing all these years has been fine. But is this how it will stay? Me living in the Upper Midwest teaching at a small women's college? Or will I leave my job as professor, try to be an artist, fall flat

on my face and end up adjuncting six classes a year without health insurance? Or working a crappy job with two weeks of vacation? What am I resisting? Why not just do: "Dissertation II: The Sequel—This Time I Mean It." I don't even know exactly what this book is supposed to be—

Last song / Last song / La la la la la la last song."
The lights dim and the show begins. Meredith Monk sits at a piano in spotlight, her black hair no longer in dread-like braids, instead in a long straight ponytail.

La la la la la last.
And it dissolves. The question, innocent and well meaning. The other door.

To look at Meredith Monk on the stage with her band of merry rascals, with her projections and her songs. They sing in strange voices, move their bodies like airplanes. A short Asian man kicks his legs like a cowboy, dances bow-legged on the stage. A white woman winds her arms like a kerchief around her neck. The whole group harmonizes. Every gesture offered as if it were the last. To think of a chance of having a life like that, of being with others, making work and sharing it with the world—knowing that some people would like it and some would hate it and many would never even see it. My anxiety dissolves. The trail for myself.

To make the book as that last breath…

+ + +

"The strain of being born
over and over has torn your smile into pieces
often I have seen it broken
and then re-membered
and wondered how a beauty
so anarch, so ungelded
will be cared for in this world.
I want to hand you this

leaflet streaming with rain or tears
but the words coming clear"
—ADRIENNE RICH, "LEAFLETS"

+ + +

The book that Nita read and the book that I was reading were the same. A metatexual mine. The story I'm telling is a story about reading about reading... A story about magic which was for her and for me books and pens and stars and adventures and a cute boy who arrives and talking cars and pain and power and beauty and everything that I would later call poetry and art and performance and ideas... A story about making it... this book and this life...

And some days, I think I can have it, that I have it already. That the poems and performances I make are transformation. Not perfect, but evident—a crack in concrete sidewalks to mine the ore underneath, which is tongues in mouths and hands on the smalls of backs and laughter and philosophy and hoppin john and hip hop and the critique of hip hop and chance meetings that lead to long mystical afternoons and that Edmund Wilson quote on the bulletin board of the place where I once worked: "In my childhood, I always knew there was something better than this. Be it books or Paris or New York or love."

And that this is almost it.

+ + +

Art of all kinds is not just the practice of making, it's the practice of being in the world a certain way. It's a certain susceptibility, and it's also sacrifice—the offering up of everything with only a few strings attached. The reader, the witness, the lover all have to pay attention. Have to bear it with you and give it time. But even after that, they may not take you, may not love you or even like you. It's only the

giving of the making that's evidence of being alive. Whether or not you take it can't be my responsibility, whether or not you like it can't be my affair. It's mine only to give—always fully… without hipness or irony or fear of being corny or cheesy or naïve or indulgent…and when it's all over, to recognize what's lasting, to cherish what's left...

+ + +

Approximations. Traceries.
I write the names in my notebook with my pink floral Cross
pen—art training letter (love) / infestation of gnats / circulation /
the secret garden (closet) / whisper (the index of suns) / economy /
anacaona / after "hieroglyphics" / berlitz / how's work? / displays
(after Venus) / heart on a sleeve / …
I gather them around me like a cloak or a spell. Who knows what
will arrive…To call the book: How to Be a Performance Artist…
My Beautiful Friends, Their Lives and Loves… The Disingenuity
of My Disregard… Here's My Psyche in the Sink! Watch it
Swim!… My Last Will and Testament… My Earnest Egotism…
A Yarn to Wind Down the Marking Period…Swallow the Fish…
My Heart, Star-Shattered for You

+ + +

Listen, I am writing this right now so if there comes a time when I give it all up, when I call the headhunter, when it goes out the window or is snuffed out too young, or thrown away or left only to someone else's frame, when I turn like Rimbaud into an arms dealer in North Africa or I take flight, metamorphose into a cricket or fall through glass into something or someone else, I can say there was a time when I had heart, or that this was the heart of my endeavor, that I did what I could, that some of it was good and all of it was the best I could muster. That I tried to make my last breath,

make my breath last. That I wanted to realize imagination and synthesize my most important things: poetry, art, images, environments, making, teaching, engaging and connecting with others… but also the truth, about magic, the need to be seen, the attempt to be more fully in my body, to be noticed, to be desired, to be loved. And the making, the thinking that was part and parcel. And that there can be some record of all of that…

And I think of Nita and Meredith, Adrian and Maudelle, Anne and Georgia, Ana and Theresa, all the black mothers in all their gardens, all the brown girls searching for their pens—

and this book is for them and for me and for you.

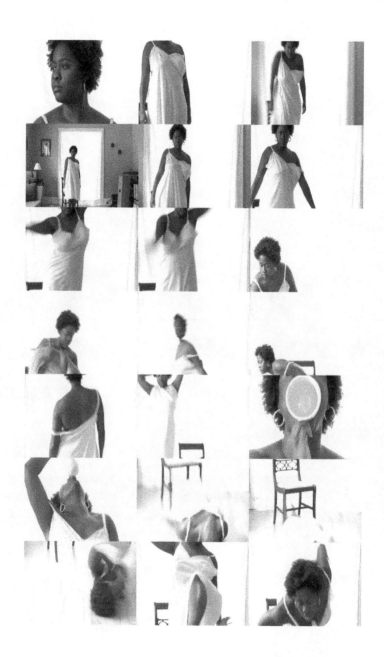

(from "Art Day," with Ellen Marie Hinchcliffe)

31

Début

"It takes courage / to enjoy it"
—Björk, "Big Time Sensuality"

"So I'm doing a thing at Patrick's," Miré was saying.

"I know there are hooks and water, but I'm trying to figure out the part with the fish."

"Fish?" Flávia asked, "Your piece is about fish?"

"No, it's about other things. But I was thinking about having a goldfish swimming in a bowl while I did the first part, then maybe do a thing with a rope and hooks or a knife. And then do something that transforms the fish, changes it."

"Oooh. A goldfish," I said. Lines from Rita Dove's "Dusting" popped into my head: "the clear bowl with one bright / fish, rippling / wound!" or "wound" to rhyme with around.

"I like it. Could you pour the fish from the bowl into a pitcher or something?"

"Or you could start with the pitcher," Flávia suggested.

"Then you could drink from the water."

"I think I need to do more than just sip the water.

It needs to be a more powerful gesture."

"Swallow the fish," Colin said.

"That's what you know you want to do. It's small and biodegradable."

"Eat a goldfish?" Evie interjected, eyebrows raised.

"You don't need to eat it," Colin continued.

"Or chew it or anything. Just swallow it."

"Colin," Flávia fussed. "Miré can't hurt animals for her art. That's not right."

Flávia's crickets had chirped blithely unharmed and she'd released them all at the end of her show.

"She doesn't need to hurt it. Just swallow it.

And if it's necessary for the piece, then she needs to do it."

"Is it necessary?" I asked, repulsed yet titillated by the idea.

Swallow the fish? The whole thing had a new jack, lyrical black radical appeal, but was also old school performance art. Dramatic and crazy and slightly dangerous. Art at the level of life and death. Embodying the natural kingdom. Something indulgent and a little mean but tapping into another kind of power. Breaking taboos. Dancing the fine line between crazy and brilliant. Feeling something alien and alive move from transparency into your body, fish, rippling wound or wound.

But who would really do this?

"Hmm," Miré responded.

SWALLOW THE FISH

I had never thought of myself as a fearful person, but performance art made me confront my fears. And also my desires. At the start, not the question, what would a performance artist do, because the answer was everything, anything. At the start, this question: who got to do those things? Who got to be a performance artist? Which people in which bodies?

I remember seeing Karen Finley in New York City. She hadn't swallowed any live animals (although it wouldn't necessarily be beyond her), but she had stripped down to just panties and put her feet in a basin of water which (as anyone who has ever stepped naked in water knows) gives you the overwhelming desire to pee. Karen Finley calmly told us that was what had happened to her, grabbed a bucket, and peed right there into it on stage. It was shocking, but also liberating. It was the brazen nastiness of white girls that had always been intimated to me in my youth. (*White girls, you know how they are... They'll do anything. Pee in the woods, walk around butt naked in the showers. They're loose, they're easy, they're crazy.*) As a black girl, as a strong black woman, I was supposed to be appalled and superior to that kind of behavior. But at times, I was covetous. How come *they* got to do that? Where did they get that allowance? I had never seen a black woman do such things and wondered if it were even possible.

Years ago, I had an artist show-and-tell at my house. I'd started moving from poetry into performance and had just gotten a big grant to turn my experience translating a long Haitian poem into a new performance art piece. When Colin suggested swallowing the fish, something rippled in me. I wanted Miré to swallow the fish. I wanted her, a black woman, to stare down craziness, to allow herself to be crazy, to do something crazy on stage. Hell, I wanted to swallow

the fish myself. To be as loose and crazy and unstoppable as those white lady performance artists like Karen Finley and Holly Hughes and Marina Abramović. I wondered if I could do it.

"If it's necessary for the piece, then she needs to do it," Colin had said. The realization of need. Going deeper, taking it all a step further. I thought of the time I showed my landlords, my two great, gay godfathers whom I adore, some segments from *Divine Horsemen*, Maya Deren's documentary on Haitian *vaudoun*. One moment in the dance, the *houngan*, the priest, slits the throat of a chicken. You see its blood pour down to the earth below. That death is a necessary ritual that connects the worshippers to the spirit world beyond. My landlords were outraged at the violence, but I felt honored, stirred. We were witness to the transfer of one life to another, one energy to another—not for entertainment or shock value but for transformation.

Swallowing the fish would have to be like that.

Making performance art as well.

To swallow the fish, you had to have something more than a reason. In a way, you had to reject reason itself. You had to have spirit (and perhaps spirits and the spirits too). Especially as a nice black girl, as a strong black woman. You couldn't just get away with whatever. Hell no. You could be crucified for that, or worse, gain a bad reputation. Animal murderer. Race traitor. Nasty girl. Acting crazy. Acting up. Performing. Anything could happen to you. Anything could happen. It couldn't be pretense or something to do for kicks. It had to be real. There had to be some black art, some power, some need and conviction that warranted that kind of transformation. A particular kind of magic...

In the end, Miré chose not to swallow the fish or even to use a goldfish in a bowl at all. She passed a bucket with a freshly caught trout through the audience, a hook still dangling from its lip. She told a story in the accent of a

fisherman displaced from his home, tying hooks into knots in a net. Then she masqueraded as a corporate raider with a clipboard, planning a new corporate development on the site. She only did the piece twice, one weekend at Patrick's Cabaret in Minneapolis, and hasn't revived it since.

In the meantime, that goldfish (*rippling wound or wound*), the challenge to swallow it, became mine. It belongs to anyone moving toward the form of performance art, struggling to figure out what it means, what is required to do it, what kind of body and spirit you would need.

A DÉBUT

I sat in a short white dress and a blue wig,
in a child's schoolroom desk, the text in my hand,
Lia sitting across from me.

I sat alone in a short white dress and a blue wig,
in a child's schoolroom desk, the text in my hand.

I sat alone in whatever clothes and whatever hair
in a child's schoolroom desk, the text in my hand.

And what does it mean that I'm not so sure exactly
how it happened? To pinpoint my first performance
is already a slippery task...

BODY DANDER, DUST

Ssshhh! Who's talking is the quiet me. Slacking off in this library on a big research jam. My first stab at freedom, my final, what they call my thesis. I was so nervous and excited that for a while, I kept on changing my mind, what I wanted to do. I've gone through "Hair Styles," "Rednecks," "Melanin," and "Women's Poetry of Blood." As you can see, at least, I'm getting more scientific. It seems flaky, I know; I want it all. And maybe I can get it in my mind. My friends keep teasing me: get it together, girl. But it just gets bigger and bigger until it's the least of things. So that when I talked to my advisor—a lovely Black woman waiting to exhale—her eyebrows practically jumped off the roof. What exactly are you trying to do? Whom exactly are you trying to reach? And I repeated, not quiet, this is for the outside world. And anyway, Miss Lady, this is out of your hands. No matter what, I'm doing this study of dust! * * *

And they call me crazy! This woman flipped out. You would have thought I had said I was sucking people's blood, digging in people's souls. Jesus! I just want to write sixty pages on dust, a nice onionskin paper, bound in red. Even my friends started to trip out. My Marxist friend asked: Is this political? A proletariat study of factory life? My feminist friend answered him: I know what this is. Third world women, migrant workers and maids. They left me alone soon enough. They're used to my brainchilds. Emphasize the brain. I'm not much of a body. I have good scores and friends, a nice personality, and what they call a vivid imagination. I'm kind of a wallflower Nineties style. All head and full, dark round throb. It seems that I am rarely touched. No one comes in here; no one puts out.

* * * It's O.K., I don't mind dancing alone. In fact, I'm the first one out on the floor. I like to be out there when it's still full of air. I love the strobes when they're flickering and spinning. I love it when my body can still catch light. Anybody is possible. Every thing. I remember one time, I was out there on the floor. This was far-away-a-while-ago and after the dance floor filled out to full, this foreign man came up

This moment. What I know for sure: I am in New Mexico and it's summer and a weekend, so I am not working and have the *casita* where I am staying all to myself.

A few other choices for furniture exist, but I am sitting in a child's schoolroom desk, the kind where you slide your body into the apparatus and put your papers on the wooden slab before you and your books, if you have any, down below. I have no books. I have the text in my hand and I love it.

It is a play, or a long poem, called "Body Dander, Dust," and it was written a few months before in one of those beautiful blurs I've experienced only once or twice in my life. One minute I was looking out the bedroom window of my West Village apartment, and the next, language generating itself faster than breath, almost faster than recording. And all my yearning and bookishness and language love came out in a torrent.

How right then, that my performance of this work would feel the same way. In my memory, I am wearing my blue wig, something I used to do while walking in the Village (although my Detroit friend Lisa Mayberry who could sing in a public restaurant at the drop of a hat was completely mortified by me in it). And I am wearing a white dress, the one that most belongs to a reading I did my last year of college with my friend Eric Leigh called "Between the Pillars of Fire and Cloud."

It was our second major reading together, and we bought beautiful linen paper and red and blue pastels to ornament each flyer. And we hung long, theatrical swatches of fabric in a well-appointed room in the Michigan Union. And we invited guest artists, poets and musicians who appeared at the end. And we rehearsed. And it was a real *thing*, a poetry reading, an event, a performance. And yet, it's not the start that comes to mind.

to me. In the spin of the light, this foreign man was beautiful. Let me tell you: I was close. I was so close I could feel and smell and touch and be touched. What? The bulge of anybody, everything. Him smelling like cigarettes and liquor and cloves and him feeling like leather seats in a brand new car, him feeling me, up and down with a great big smile. And he pulled me so close I thought I might fall in—but one of my friends pulled me away. I have beautiful friends, both female and male. They're so good to me, I almost fall in love. It's more of a fantasy, a kind of a crush, something to stand me in my mind. I always think of the women's hair. How their crowns fall to manes twirled in fingers, become faint strains left behind. For the men, I always picture the teeth. Bright and white and straight and clean.

* * * Well O.K., not always. Some need a few braces. But no matter what, there's always the idea of a mouth. Something holding something strong. After a wreck, you can identify a man by his teeth. You can always dream. My mother would say: What's strong in the hoof. And by hoof she means all the bony, interesting parts, all the parts at the bottom of things, all the parts that can stand alone. For her, the teeth were the least of it. But for me, I'm about the least of things. What's strong in the hoof...will stand and move in air. Teeth and hair. The attraction of dust. * * *

So then, Miss Lady asks in a huff, what is your purpose? Your methodology? My mouth, I answer. My eye in light. And especially, my fingertips. Oh my! I was speaking the unspoken tongue, squealing on pleasure, hers and mine. No not factories, the proletariat en marche. Not a third world, migrants or maids per se. This is about circling, landing on skin. This is about longing, strains left behind. Hair and teeth. We breathe. Ssshhh. Listen. I'm working this out. Like that night, I was quiet, alone in bed. And I was listening to something that crept over my skin. It was so beautiful. It was like a down. It was like a fog, but it wasn't wet. At first. A dry grace. Until a sweat came on my skin and I wanted that sweat to be a hand. I wanted to be held and held so hard.

Instead, this concentration. Not a reading. Not a rehearsal for a play. Something for real. The text in my hand, the language in my body, fully present in that child's schoolroom desk, in New Mexico, in the moment.

That day in New Mexico is without verification.
There is no video. There are no photos.
And I doubt there were witnesses.

I remember inviting a woman whom I had met that summer, Lia, née Linda, over to the house to hang out. She was also a poet and later in the summer, we would create and perform a "Lip Reading" with her then-boyfriend Mark accompanying us on percussion. We'd kissed our flyers with different colored lipsticks. And as I recall, we had a pretty good turn-out. They actually broadcast this reading on New Mexico public television although I never saw it.

Still, I'm not sure that Lia came over. It seems logical that she or someone would have been there—or why else would I have pulled out that desk in the middle of the room and started to render "Body Dander, Dust?" Why else would I have inaugurated such a surge of feeling? Yet, even if she were there—and I don't think so—she somehow fell away. And after that summer, I never saw her again.

It's not audience that makes a performance. It's not necessarily intention, at least not immediately. You can fall into it. It can happen in a blur, or as a deliberation: one minute sitting in a chair, the next an interior opening, a sparked intuition. Without forewarning, without audience, publicity, declared set, technical trappings, lights, makeup, costume—although a blue wig can be a magic touch—performance begins for me as an occasion of consciousness, a framing, a practice of emergence.

Huddled under covers, it was like a dance. Alone under beauty, dark on the floor. Waiting for a spinning light. I could feel skin under my fingertips. I could feel it wanting to rub away like stone. I could rub to feel it peeling away in strips. Like shavings or something coming up off a burn. Or a hangnail, a skin angel blowing free in the wind.
* * *

I read that once. I get it all from books. I felt it, so beautiful. I was completely sick. I'm not usually a body, only a mind. Only on the dance floor, alone, in bed sometimes. Sometimes a voice. I felt such ache. I felt such joy, such joylessness, my body aching like a violin string, my skin an organ playing me. My body throbbing like the string of a bow and inside I wanted an arrow, a great bulls-eye. I wanted to touch teeth, hold on to hair. And I wanted it real, right there in my hands. Something holding something strong. I was so alone. I felt sick to my skin. So I turned on a flashlight, aimed it in air. And what was there whirling in that circle of light?

Dust. A light dander touching everything. A dry grace. And I knew that dust had to have flecks of my skin, me, small pieces of my touch. And if I had had sex instead of feeling this ache, it would have been more than my skin, mine and somebody else's. Filling the air, the floor, my bed, my lungs. And I knew that's what I wanted to do. I would do it for credit, research that dust. That's the only thing I know how to do. That's the only way I know how to do it. Hair and teeth. Moving together in air. What's strong in the hoof… all the sex we breathe. The sex we let go of, through our fingertips, like strands of hair, strains left behind. Foreign bodies dancing so close. * * *

All the bits of body landing everywhere. A way to touch, being touched all the time. Circling in light. In dust. All the people I ever saw. In dust. All the people I read about in books. Poets and politicians. Marxists and feminists. Hair stylists and dentists, scientists of skin. All in dust. Or that saint who swore she had some

In my truest memory of that performance, I am alone. I am performing for myself, by myself, to myself and to the whole world. Performance as the start of knowing and being myself in a new way.

For myself, unprecedented.

This was my début.

of Jesus' hair. (She must have been some lonely black woman.) The bits of body we need for survival. In dust. Or all the ones I saw on the street.

* * * There was this beautiful couple I wanted to be. Not just her, although she had the prettiest sandals. Small gold strings running up her legs. But both of them together. Standing, moving in air. What's strong in the hoof… is strong in dust. I almost fell in love, a fantasy, a kind of a crush. They were golden, a grand mélange of things. And they were slight, you know how people like slips of things. And their hair was curly and their bodies were smiles. They saved their teeth for telling each other after. And at one point, she touched the side of his cheek. And now I can say, some piece of that skin was winnowed away, floated to me, touch to touch.* * *

And think of everybody who ever touched. And think of how they all somehow touched me. My friends with their smiles, good hair, good teeth. That foreign man, his dance of smoke on my skin. My mother with a do-rag in her hand, polishing and polishing with Lemon-scented Pledge. It not only stands, it moves in air. She'll never be able to wipe it away. What's strong in the hoof… Even Miss Lady can't be blamed. A woman like that, you never can tell; you never know what you would find inside. Dander and dust. Breath in skin. She's lonely. Yes, yes. This scintillating life of the mind. I want some body. I'll study dander, dust. A thesis of skin, floating flecks of sex. The least I'll have, the certainty of touch. Not a history book or a chemistry, a geography of air. Miss Lady, I'm trying to make a map.

In celebration of my twenty-fifth birthday, I posted 25 targets all around Athens, Ohio, the small college town where I was living on fellowship, not far from West Virginia. That September, gratitude *bubbled* through my veins. After four years as a graduate student in New York City, this place was a salvation. O to be in one piece—still broke but with a little money coming in. I would be making the most money I had ever made in my life—a whopping $25,000—and could make some progress on the credit card debt rapidly compounding interest.

Two years after my summer in New Mexico, I had my first car and even my own house—a ramshackle mother-in-law next to a larger house with two apartments—between the highway and an often unmown lawn. It became a field. One of my neighbors was a football player. The other, a painter who got to listen to Guns-n-Roses while she scripted word after word on large canvases. Anything was possible. There are places outside of New York City. I could imagine and write and finish school, which was lasting forever. But also which had been allowing me the kind of youth where I could read tons of books and think about them and see art and watch puppet shows at Clemente Soto Vélez and help organize happenings and walk the streets of the city—going to the last independent bookstores in Manhattan before almost all of them closed down.

Even then, I would have told you I was learning to be alone. That it was important for me to learn to be alone as a person, as a woman—which, in retrospect, was a strange thing to say. I was never one of those girls who came out of the womb with a boyfriend. I was social, but independent, a bookworm, a poet, I would have said, an eater of life. Then why was I so afraid? Afraid and still waiting, waiting. Waiting for something to happen. (*New York, Paris, love...*) In

the meantime, I was lining up my targets one by one. I was articulating desire.

The heart of *25 Targets* is dissemination—sowing and spreading seeds of language in the world. It pursued personally the explorations of language in public space that I'd done in New York with the Madhu and Rosa in the No. 1 Gold Collective. The experience of doing this work, circulating language in a new way, had started to change my sense of myself as a poet and as an artist. I starting trying more deliberately to fuse language and image, the literal and the figurative, public space and private experience. I became interested in manifesting poems more materially, circulating them in the world and consequently, confronting myself.

And my body, young, plump, female, brown, in my shack in Athens, Ohio, laying out the bright orange hunting targets bought at Big Lots, mixing the forest green paint. How it felt to mark each word and select it, stencil and paint it. How it felt to move through the space of that town in a new way, scouting places for delivery...

On the day before my birthday, the sun was hot and the world was bright with possibility. I taped targets up under footbridges, on telephone poles. I remember putting one target up, maybe *"stillness"* or *"leaves"*, on the bulletin board of a Taco Bell and it was immediately pulled down. I saw it go into the trash and watched it without regret. I had put my desire into the world. And I had to deal with the way the world treated it. (Perhaps there's a lesson here about attaching your deepest desires to Taco Bell...)

No one knew what I was doing. Few probably saw. Or if they did, their account of what they were seeing would likely have differed from mine. I knew and felt and moved my words through space and necessarily my body as well.

gold...post...flow...stillness...foxy...verse...moves...
jungle...burnish...astonished...greek...skills... leaves...
bubbles...words... amour...body...open...tongue...
freestyle... concentration ... tender... red hair. . .feathers....
flower...

[signature scribble] — approx. 45 hrs. ___

Project Labor: mulling words, tracing, cutting stencils, inking, taking mistakes, making copies, taking pictures, dreaming; approx. 45 hrs. ___

Project Materials / 3 packages of 20 Crosshair Hunting Targets from K-Mart @ $2.99 each / 1 package of gothic roman stencils $3.99 / 1 bottle of olive green acrylic ink $4.50 / X-acto knife $4.50 2 sponges $1.99 from K-Mart / gold marker from Kinko's $4.50—all + tax

+ Björk: "I'm going hunting... I'm a hunter..."

25 Targets
a pronunciation of desire

gabrielle civil
september-october 1999
athens, ohio

In anticipation of my 25th birthday and in celebration of my arrival in Athens, Ohio, I took twenty-five cross-hair targets and stenciled an aim on each one. These were:

amour astonished body bubbles burnish concentration feathers flow flower foxy freestyle gold greek jungle leaves moves open post red hair skills stillness tender tongue verse words

After photographing and photocopying my targets, I posted them in various places around town with no explanation.

I unleashed my desires.

A week later, I disseminated this booklet.

Inspirations

10/12/99 — my twenty-fifth birthday

Carrie Mae Weems & Adrian Piper

Odysseas Elytis' "Ageodrome":
"When I opened my guidebook I understood. No maps or anything. Just words. But words leading precisely to what I searched for..."

Jasper Johns

Tess Gallagher's "Devotion: That it Flow; That There Be Concentration":

Linda Montano's *Art in Everyday Life*

Lyn Hejinian's *My Life* (a true birthday book)
"for those who love to be astonished"

I had long been investigating the question of poetry in the world; *25 Targets* activated my body in space.

Here, my body became actual, physical, if largely invisible. This spoke to my sense of myself in the world but was also pushing me into new territory. I was no longer just performing myself (in a child's schoolroom desk or even for a crowd of poetry lovers on a stage.) Without deliberate audience, I was moving deliberately, practicing, moving through space.

It was the start of my re-embodiment.

To think of a performance where the body is not seen.

To trace only its evidence or what remains. I look at a photo of Ana Mendieta's *siluetas*. I see the burned imprint of where she was, an outlined reminder and the realization: she is already somewhere else.

Many people didn't see the targets. Some glanced at them once and never looked again. For some, they made more work. Too bad. A necessary lesson: I get to take up space. Most people never got to see them. Even me. After painstakingly making them, I didn't get to see the targets for as long as I will remember them. Years have passed since I held the 25 targets in my hands, mixed the paints, and stenciled the letters. And it was only one week at the most— that this work was made—that my targets were crafted and placed out in the world. Some only lasted for 10 minutes, the longest maybe for a month or so…

I asked some nice guys in a bike shop if I could put one up there and it stayed up for weeks and weeks until I think I told them they could take it down. Why did I tell them that? Today I would let it go, walk by each day until I left town, watching it fade, helping me remember, letting it turn into something else…

Vikas picked up the samosas. Laura from Hawaii wrote the name on the top of the cake with frosting from a little tube. "C-h-i-m-e-r-i-c-a-l." I mispronounced it at first until Doug Kearney roundly corrected me. Instead of emphasizing shimmer, you have to signal a hard k. He was right: the event was alchemical.

In August 2001, in New York City, we were on the brink of another era and we didn't even know it. I had already moved to Minnesota but was back in New York to make art and be with my friends. Ira's eyes opened wide when Madhu cut a pomegranate in half with a long sharp knife. This was how it started.

NO. 1 GOLD PRESENTS

In Brooklyn where we lived, you would see signs for

	NO. 1 CHINESE FOOD
	NO. 1 FRIED CHICKEN
	NO. 1 HAIR BRAIDING
And so we became	**NO. 1 GOLD ARTISTS**

No. 1 Gold was—and is—the conceptual art wing of Witness Tree Literary Arts, Inc., a non-profit literary community arts education organization that my friend Rosa and I founded in 1996 as NYU grad students in Comp Lit. A year later, Madhu came on to become the third creative/administrative director. Together we designed and facilitated workshops

and literary events across the city. We wrote grants, made community contacts, raised funds, and pitched creative ideas. Our mission, "to celebrate the liberatory force of literature in diverse communities," allowed us to rethink traditional events and spaces.

Through Witness Tree, I'd designed and facilitated a Celebration of Poetry and Engagement at Revolution Books in Manhattan; dressed up as a Poetry Fortune Teller (blue wig!) in bookstores and bars; and, along with Madhu and Rosa, designed and facilitated automatic poetry events in public spaces. (At one of them, I ended up embracing a very attractive North African *mec* from Paris in Washington Square Park.) All of this was perfect training for performance art (and some of it already qualified).

As we were designing and facilitating community workshops for Witness Tree, Madhu, Rosa and I were growing more and more interested in conceptual art. We would talk about Group Material and Félix Gonzáles-Torres and Fred Wilson, pore over catalogues, and see shows. We were thinking a lot about our experiences in galleries, museums, dance clubs, and lecture halls. We were three young, talented, earnest women of color in New York City, ready to be artists in the world.

To facilitate this, we created No. 1 Gold Survival Kits, transparent pouches full of markers, stickers, stencils, glitter, scissors, glue and other necessary tools for impromptu acts of beauty and infiltration. More than just public art, we considered the city to be a site for public writing. We aimed to add our signatures in glitter and gold.

+ + +

The most legendary No. 1 Gold endeavor was *The Gold Leaf Project*. We had just completed a major series of Witness Tree workshops and had some extra funds to spare. Madhu had

the idea to wrap a large number of poems and disseminate them in public places. Maybe a thousand, she said. Rosa promptly upped it ten times. ("If we're going to do this, let's do it big," she said.) And like that, we set off to wrap and circulate more than ten thousand poems across all five boroughs of New York City.

We selected a range of ten poems (including works by Edna St. Vincent Millay, Langston Hughes and Nâzim Hikmet) and then exercised prodigious math skills to buy the appropriate length of shiny gold foil from Kate's Paperie in SoHo. I still recall the amused face of Jaime, a guy who worked there, as we looked at two different kinds of foil, the measurements of one in yards and the other in meters, and started to crunch the numbers. (Hint: 1 yard = 0.9144 meter.)

I can't give away all of the secrets of the No. 1 Gold Collective, how the poems got photocopied, how they all were pressed and creased and wrapped in foil—but imagine a folding and unfolding night, a gilded, proliferating carpet, fast hands, Chicano videos, and a bunch of newscasters cutting up in the wee hours when they knew only the bleary would see them.

We did *Gold Leaf* on Madhu's twenty-third birthday. She was dressed very beautifully in a long Indian skirt. Rosa and I were also dressed to impress although I can't recall what we wore. As with so many of our early projects, we took no pictures and depend now only on our individual and collective memories. In the morning, we split up with very full bags of gold leaves and decided to meet back at E.J.'s for chow and popcorn to compare notes at the end of the day.

It was bright and cool and I walked all through different parts of the city, trying to reach unlikely spots for poems. There was more solitude in the dissemination than I expected—and a lot of beautiful views. *The Gold Leaf Project* allowed me to see the city in new ways. I rode the Staten Island Ferry, leaving a little stack of gold leaves near the concession stand

where my godmother had worked years ago. I stopped by libraries, bookstores, newsstands, hardware stores. I walked with purpose, tucking gold leaves next to piles of things, newspapers or flowers or fruit displays at bodegas, talking to the guys at the front each time.

I learned early that it was better not to try and give anyone anything by hand. The trick with *Gold Leaf* was to set something down next to a person and walk away. Curiosity always pushed that woman on the subway, that man on the bus to pick it up and see what it was. I put them on car windows, slipped some in open bags. The space of the city magnified a trillion times in relation to one palm-sized wrapped poem. The city was so vast. We would have needed ten million to make a dent. I thought again about Félix Gonzáles-Torres' wonderful spill pieces where he had factories produce tons of candies and children could come and pick up handfuls and fill their pockets and sleeves. That desire for excess and spillage, that craving shows up in some of my later performances.

So scale was a key thing I was starting to learn with *Gold Leaf*, multiplicity and smallness. Also the way that one's artistic purpose can inflate until it seems like the only thing happening in the world. I remember walking into a business where a middle-aged Italian man was talking to his secretary. I walked in the door and said: "This is *The Gold Leaf Project* and I'm offering you this gold leaf." And he was like: "Hold on a minute. Can't you see I'm busy here." And I remember my realization that I was inside of an art bubble, that I had been breathing the ether of this for hours on end and these gold treasures were not the center of his world. And I was surprised—not at him, but at myself—how I had breached his world completely thoughtlessly and for that maybe he shouldn't have been impressed by what I was offering him. (I had a similar experience years later when I was reading poems on a public bus in Minneapolis when one guy, clearly

upset, said: "DO YOU HAVE TO DO THAT?" These art interventions always sound so good beforehand...)

But *The Gold Leaf Project* did delight some people. Up in a braiding shop in Harlem, many braiders liked them a lot (although I wish we'd had one in Wolof or French.) One client actually came up to me and asked for a poem. I could imagine it going up on her refrigerator. Some of the poems went out with pre-stamped postcards to return to Witness Tree. The responses that came back were all positive. One woman even said that finding one of these poems made up a little for having been mugged the week before. In that way, we became a part of the regenerative magic of the city.

While *Gold Leaf* was ultimately about dissemination, it raised interesting questions for me about the presence of the body in public space. It helped me realize, in fact, that dissemination is never disembodied. Even if a body is invisible in relation to the discovery of an object, the object itself can be understood as a trace of that body, and it can matter tremendously whose body is leaving the trace and how that body moves in the world. This would come alive for me later in *25 Targets* and would remain a central question for me in my performance art practice.

Chimerical was the first live performance event of the No. 1 Gold Artist Collective. We had all done poetry readings before, but we wanted to do something else. Something with more verve, more humor, and more color. I had already started thinking about performance art practice and *Chimerical* became a conscious experimentation with poetry, delivery, action and gesture.

I recited a poem while painting my nails. Rosa sang a poem in a clear, rich voice. Madhu read an art training letter while Rosa pulled down handmade art-giveaways from the wall and handed them out to the crowd. I teetered through the audience in glittery high heels. We ate and drank and offered a dance floor for a motley assortment of poets, grad students and strangers. The event was a success.

We called *Chimerical* a re-dressed reading, a conceptual art party, for me another foray towards making performance art.

(above from *Chimerical*: Rosa, me, and Madhu)

POSTSCRIPT (OUTSIDE HISTORY)

A few days after *Chimerical*, I was back in Minnesota when the sound of my godmother's voice on my answering machine startled me out of bed. "I'm looking at what's happening in New York right now. Your mom says you should have already left, but I'm calling to make sure." I had no idea what she was talking about. I ran to the TV and saw those shocking, outrageous, now indelible images. A plane flying directly into the Twin Towers. September 11, 2001.

I immediately picked up the phone and encountered busy signals. Over the course of the next few days, my New York friends and family made contact. They were fine, thank God, shaken up like everyone else, but fine. I wanted to go make sure. I wanted to witness what was happening in this place that had been my home for years. Like so many people outside of the metropole, I was horrified by what was happening and couldn't quite believe my eyes. I had just been there. And in a few days, I was scheduled to go back.

Four years after my New Mexico début, the New Perspectives Theater Festival accepted "Body Dander, Dust" for production. In my memory, the date for the production was September 17 and I had already bought my ticket.

I could go. I could assess the devastation for myself; I could see the very first production of one of my pieces. These were two separate desires, but deeply united—for wasn't New York the place where I'd really become an artist? Was this place still intact? How was it holding on? Deeply aghast, I was also alienated. By coming to Minnesota, I felt like I'd abdicated my belonging to this place, that a monumental event had occurred and I was off-stage, that this thing would divide me from my friends, from my own past. I wanted to hold on to New York—to what it was, what it had been to me, what it had made me want to be, what I wanted to become...

My parents put their feet down.

"You know you're not going there," my father said over the phone. "The world is so crazy right now, who knows what will happen." My mother said. "Please please please don't go." The repetition of that word. And also the hook into that deep part of myself, that desire to please.

And so I didn't go—a decision I regret to the extent that I would have loved to have been fearless and undaunted. It was a scary time. None of us knew if another attack was coming. They had incinerated the World Trade Center. They had tried to blow up the White House. A list had been reported with other targets, more in New York, but also weirdly even my hometown Detroit, even Minnesota's Mall of America.

My parents didn't want me to go. But at almost twenty-seven years old, I was grown enough to have gone anyway.

I didn't go. They were right.

I didn't belong there, a voyeur to another city's tragedy, even if it used to be mine.

I stayed put, stayed outside of history. I mourned those who died; my heart went out to their loved ones, to all the New Yorkers attacked, traumatized, displaced; the unidentifiable, the unrecoverable, the undocumented workers; the firemen, the bankers, the pre-school children; the ones who suffered hate crimes for being brown and/or Muslim after the attacks. I missed my friends very much, talked to them as often as possible in those days. Rosa promised me that if they still had the Festival, she would go see the show.

And so that's what happened. In the face of everything, it was amazing that the New Perspectives Theater managed to have the Voices of the Edge Festival at all. They postponed it for a week or so. But the show did go on. A testament to their valiant spirits and their belief in the power of art.

Rosa went for me and gave me the report: a young black woman wearing an African headwrap, read from a book.

The actor's name was Melody Brooks, and at on some level she was embodying me.

In terms of performance art, my memory of my own rendering of this work, completely anonymous and personal, contrasts with this production, public, yoked to a national tragedy. Likely the only witness of the first, I was never witness to the second. I embodied myself in the first work, was disembodied/re-embodied in the second. The New Perspectives production is a lost ghost to me, the unknown twin of my original performance.

At the end of the show, Rosa conveyed to the director and the actress my thanks and my regrets.

...and Adrian Piper's funk lessons and Jayne Cortez' jazz and Coco and Guillermo's fake Indians in a cage. And Cecilia Vicuña standing, smiling before us, a long, thick, red mass of cotton running down from her waist through her legs, trailing to the ground, her quipu *against strip mining silver in her native Chile. Her singing, her poem, her performance with a thin rope and a black feather. And Bently Spang's strange slicing of meat, his Indian of the Future coming to life as the video projected a hilarious tour of that Indian's present-day trailer, how his hips moved a little and electronic music pulsed and strobe lights whirled as he sliced meat and then later how the audience came to the stage and wrote their wishes for the future on his body. Political scrawls beckoning new attempts, new languages of art and action...*

hieroglyphics

"...an historically transmitted pattern of meanings embodied in symbols, a system of inherited conceptions expressed in symbolic forms by means of which men [and women] communicate, perpetuate, and develop their knowledge about and their attitudes toward life..."
—Clifford Geertz, The Interpretation of Cultures

What is the training of an artist?

Disposition gives desire. Talent would make it easier.

Hard work is unavoidable for even those with the first two. Training is something else: a more methodical way of approaching, considering and developing a body of knowledge.

At the start of all this, I wondered a lot about how to gain training in performance art, how to strengthen my skill base and build a solid foundation. Would I need to go back to school and get an MFA? Was Adrian Piper taking apprentices? Or could there be other models of training, ways to move beyond a self-proclaimed artist identity into deeper understanding and stronger work?

Art training letters became a way to do this. Madhu and I decided to exchange letters as a kind of mail art, and also a way to declare, document and extend a sense of ourselves as artists. This would be our training.

These letters emphasize the raw experience of life as the material for art making. Whether handwritten, typewritten, word-processed, or collaged, art training letters are exercises of the body (materialized in language, sent across space). There was never a set number of letters we would write or a set rate of frequency for their dispatch. One of these became the text of "art training letter (love)."

"Little over a month after 9/11, Gabrielle Civil walked up the 3 stairs to the raised stage at the Babylon, Art and Cultural Center and performed - "Art Training Letter Love" for a standing room only audience. The night had seen political poetry, film and theater all denouncing the U.S. government's appalling response to the attacks on 9/11. Civil offered something else. Intimately she and her tape recorder carried on a conversation about a recent sexual fling she had in New York [note: *actually in Minnesota*]. She adorned herself with honey and glitter and continued to recount the details of her sexual encounter on the tape and through her correcting her own memories of the night. The straight-forward descriptions of sex and the sharing of her inner dialogue were vulnerable and erotic. When the story revealed its connection to the events of 9/11, there was a small charge of energy that you could feel through the room. Gabrielle Civil brought the experiences of the body and the inner thoughts to a night mostly out of the body and in the head. There was a collective leaning in from the audience as she moved about the stage, to hear everything she said, to hear the breath we all needed to exhale in those tight days.

—ELLEN MARIE HINCHCLIFFE

ART TRAINING LETTER (LOVE)

… art training letter (love)…9.21.01 My dear mk…
green how i love you green—if I say that this is an art
training letter—does it mean even more that art is life.
Or if I tell you that it felt like a Marguerite Duras novel—
that I felt like I was in a Marguerite Duras—would that help
you better understand, better able for me to understand.
If I tell you that he calls me honey—that he said I want to
get inside you are you sure you're bleeding or even
before that when I stopped struggling / to parallel park
on the left side and just did it and walked 3 short
blocks in the surprisingly bashful sun looking beautiful,
would you say like Kristin that I'm distancing myself,
that I'm treating him like an experiment, that I've been
physically intimate but am guarding myself, focusing on
exteriors—or like Alpha would you say—
stop thinking so much—let yourself desire.
But what if I wanted it, I want him but
somehow it's desireless or I split myself in two and
touch him and order him to show me his chest and
then show him mine and he looks at my bra (with
a little wonder "that's pretty") and I laugh but at the
same time am outside of it. I pull down his pants and have
his really lovely cock in my hands, under my lips,
but I'm still outside of it—and I'm quiet—and I stroke
his body and look up at him and I say (with some wonder)
"you're really beautiful" and he doesn't say anything.
And he wants to get inside me and I don't let him. And now
we're speaking of things we haven't before + now—
in this moment on this green—I want to—I'm not sure—
weep—there's a sob in my throat but then I just pull off
the rest of my dress and look for a minute at the map
of the world on his wall with thumbtacks in places
I think he's been: Morocco, France, Chile, Turkey I think
in the side of my eye, but all of that's just a glance

and I turn back at him to him and he pulls me down
between his legs and he looks at me and he kisses me
and his tongue is in my mouth and I can't believe
I'm there and I want to feel more than I'm feeling
and I'm not sure what I really feel because my wits
are about me but I'm kissing him up his chest
to his chin and he's strangely silent saying again—
I want to be inside you honey. (Am I telling you too much
Is this too much information) and his testicles
(which are perhaps my favorite part of him)
are so purplish red blue—and he pulls me close
to him and is very quiet and I think touches
my hair—while what I really want is more kisses—
and what I will demand for my birthday is 27 kisses
and he comes on my belly, a little on my breasts, my cheek—
and jumps up, long and lanky to grab a towel and
lays it on my breasts and grabs a comforter—no
a sleeping bag—and pulls my head on his chest
and I think okay here goes
here's the part where he's the man and he gets to sleep
and I'm the woman and I get my cuddle but I'm
supposed to want to talk so I say to myself—stay
quiet—just be here with this man holding you and
don't shake—just be here—and he says—what are you
thinking now. And me—who has always been suspicious
of people who are silent and when you ask them what
they are thinking say nothing—stumble and I say I-I
don't know. nothing. I guess I'm just glad to be here
with you and he doesn't say anything for a minute
and I touch the vein in his neck and I say,
"What about you—what are you thinking…"
And he says: "The bombing. I'm thinking
of the bombing. And all the Arabs that live here,
not like me, but the ones with families, kids
who are Americanized. And how they're scared now.

And he told me how yesterday,
one of his co-workers had said, "Hassan,
do you have a bomb in your bag?" And I felt
so outside and so fucked up and so sad and
so amazed that he was telling me this
in his big bed, in his small bedroom, in his
incredibly rumpled, messy, smoky, bachelor pad.
And all his travel posters of Morocco + his poster
of Matisse in Morocco + his cookbooks and his huge
plastic jar of change. I write this and I wonder am I
aestheticizing him? I write this and I want to kiss
him into oblivion almost—until he's not a man
but something I can trust. He told me he took
his sister to Hooters because she wanted something
truly American. I think randomly of Yoja w/Bilal
in Niagara Falls. I think of how when Hassan licked
my nipples, held my breasts in his hands—
I didn't feel anything. How quiet he was. How tired.
How sweet when I first arrived. mk, I showed
him 4 or 5 pictures from Yo's wedding and
he said "what a beautiful family you have."
How he laid his legs around mine. How he did sleep
for hours after we'd—but what did we do? He wanted
to be inside me but he wasn't. What is sex?
Forgive my Catholic school/ Monica Lewinsky
issues but when I think about what we did,
about his taking my hand and laying it close to
his heart, almost spooning, I wonder—
is this the euphemistic sleeping together?
Is this all he wants—for me to come to his house
and hug and kiss and touch him between sleep?
I really don't know what I want except to strut
in the sun, I guess. And to be kissed everywhere.
I left him sleeping. There was mud splattered
on my car when I returned. [heart pronounced love] gfc

ARTIST NOTES (from my notebooks)

Thumbnail Sketch:
I play an audio tape of me reading this art training letter, while I perform a ritual, and speak after / back to the tape.

influences
Marguerite Duras (somehow implicitly, *The Lover, The Atlantic Man, The War*); Karen Finley's "Shut Up & Love Me" (honey); Ishmael Houston-Jones' "Dead" (audio tape, physicality against disembodied voice—so lovely); *Chimerical*, the No. 1 Gold poetry performance/conceptual art event at the Asian American Writer's Workshop 8/01; Madhu reading her art training letter at *Chimerical*; thinking about ritual and aesthetics

the ritual
setting up—making up—messing up—
cleaning up (failing)—getting up

This ritual is embodied and performed while the art training letter plays on a cassette tape in an old-fashioned shoebox tape recorder.

Specific actions of this ritual include:
making the bed of the two folding chairs with the red sequined cloth, spreading honey on my arms and legs, dipping the make-up brush into the glitter, blowing the brush, applying the glitter with the brush, fighting the honey, cracking the ash, blowing the ash into dust, applying the ash as a touch up or cover up, manipulating the cloth, making it into a coverlet, a veil, a comforter, a stole, a hobo bundle to come and to go.

The specific sequence of these gestures is to be determined during the course of the performance. It must be practiced, but

not rehearsed. Sometimes words or phrases can be interrupted, challenged or repeated. It can also be done in virtual silence—with a mind/body split.

The recorded text is a precise transcription of the letter sent to Madhu H. Kaza on September 21, 2001.

Performance Materials	Cost
Two folding chairs	*already had*
red sequined cloth (twin bed size)	$10
two tubes of Melo honey	$4
two containers of multi-colored glitter	$5
one container of red glitter	$2
one poofy Estée Lauder make up brush	*already had*
one pair of clear prophylactic gloves	$0.49
one pair of surgical blue prophylactic gloves	$0.49
a painter's mask	$0.49
Chanel lipstick in Metal Garnet	*already had*
a red painter's rag	$0.15
a red candle w/ matches	*already had*
an old-fashioned shoe box tape recorder	*already had*
a copy of Marguerite Duras' The War	*already had*
No. 1 Gold style cut cards	$10
an audio cassette tape	*already had*
disposable camera	$8 (charged from Target)

Rosa's advice: It's okay to be not moving as long as it's for a purpose light the candle first?

Art Training Letter (**LOVE**)—drop the bag

MARGUERITE DURAS NOVEL - pull some cards out from its spine, curl up with it, read it

HONEY - open the honey and put a finger full in my mouth while reading

68

AND JUST DID IT - drop the book and start to spread out the materials, spread the cloth on the floor, push all the materials aside—lift it up swirl with it and then lay it over the chairs

FOCUSING ON EXTERIORS - put on the first pair of gloves

start setting up the various elements…start rubbing the honey on with gloves, with fingers? with brush?

HE LOOKS AT MY BRA - start working with the glitter, use the brush

YOU'RE REALLY BEAUTIFUL - blow the brush

put some honey over my eyelids and try to use my fingers to put glitter over my eyes

WEEP - reach for the ash, throw a clod down at my feet…

maybe begin here saying: I don't feel anything…I want him but I'm desireless/ I don't feel anything

TOO MUCH INFORMATION - shake your head no do something good with the cloth… play with the glitter, the honey… maybe start to draw designs with the ash??

KISSES - a honey kiss, a glitter kiss, an ash kiss

A COMFORTER…SLEEPING BAG - the cloth pulls up to show the absence of the chair

DON'T SHAKE - move sideways over the chair?…but then stand up, pull the cloth off the chair like a magic trick, walk around it, have my back to the audience…when the words,

the bombing, I'm thinking of the bombing come

AND I FELT SO OUTSIDE - get the mask, put it on—the bed is on the floor

I WANT TO KISS HIM - put the lipstick on the mask

SOMETHING I CAN TRUST - rip off the mask, rip it into pieces…rip off the gloves

BEAUTIFUL FAMILY - make the cloth a veil… walk in that for a while make the cloth a stole, a bed sheet around me

WHAT IS SEX? start gathering all the things?
cleaning everything up

TAKING MY HAND hand gesture, kisses and sun figure
stand up

STRUT IN THE SUN have everything in the bundle
make a quick strut
turn around to the candle?

LOVE GFC blow a kiss,
raise a peace sign
turn the tape off

THE END

"We begin with our own interpretations of what our informants are up to, or think they are up to, and then systematize those."
—CLIFFORD GEERTZ, "THICK DESCRIPTION"

And how to talk about such a thing—the way that I liked the idea of doing it, the process of bringing it to life, more than maybe doing it, certainly more than I knew how. So much of the work was about closing the deal... I remember unfolding the folding chairs in my apartment— going to the ratty Jo-Ann Fabrics in the strip mall near my house and having the portly lady at the front cut the cloth. And the feel of the honey coming in bears and how it stuck. A note about honey: they found amphorae of it in a shipwrecked vessel deep under the sea—and the researchers tasted it and found it was still sweet. Later I would read Meredith Stricker's Alphabet Theater and think about the honey there—the machinery of the buzz, the manufacture of sweetness and thickness... there was some of that in this, submerged, recovered, and always, always desire. It can never be said enough. Some aesthetics are about fusion—some are about thought—some are about that meticulous faceting of experience, a kind of filigree, some are about blowing things up, magnification, disintegration, but for me—at least then—it was always about want... or at least that's what I think... what I wanted to say then... what I am wanting to say now...

thick description "art training letter (love)"
a black woman enters abuzz
the community politic
older than she looks, but green green green
is she trembling outside too?
unfolding chairs and hanging over them
a red sequined cloth
a setting down
the materials ash
honey, red candles in cold glass
to burning to wax
smudged cards from the *war*
marguerite duras, where are you now?
an old-fashioned tape recorder that will star
in so many spectacles
of body disembodied

voice unvoiced body
painter's mask a smeared chanel red
for sex for heart for war
a glamour red cliché
makes mess
smears paste ash honey
slowly bending
knees a quivering
tinned talk
sideways echo
not knowing
in time
what to figure in
spaces it in skin
intimates it in
animal in air
aftermaths it out

ON AFTERMATH

"I don't know what *that* had to do with 9/11," the emcee said as I was gathering my things up off the stage.

> *"–the record slips*
> *Bam!*
> *Nigger sees stars"*

How to talk about how it feels, this moment at the end of my first performance of "art training letter (love)." A problem of charged comparisons. The immediate rejection of my work and the first lines of Thylias Moss' poem on being called "Nigger for the First Time." My sexual experience with a Moroccan man and the World Trade Center attacks on 9/11. Wanting to be a performance artist and how it feels to be one.

> We see – Comparatively –
> The Thing so towering high
> We could not grasp its segment
> Unaided – Yesterday –

"art training letter (love)" was first performed November 4, 2001 at the Babylon—a Revolutionary Cultural Arts Center in Minneapolis that had started off as a café. Like so many things, it's now gone—burned down in a suspicious fire. But when it was around, it was audacious.

Both the two good-sized rooms of the Babylon had incredible front windows.The first room had a few tables and chairs for the coffee drinking (although to be honest, I don't remember many people drinking coffee or eating there during the day. I'd tried more than once to support the place during daylight hours only to find it closed.) The second room had a stage; folding chairs could come out for an audience. And they did. At the Babylon, revolutionary Afghan women, punk

rockers, activists, spoken word artists, page poets, filmmakers and burgeoning performance artists all threw down in the Mini-apple.

It made sense, then, that the Many Voices event "An Evening of Resistance, Ritual & Resilience after 9/11" would happen here. Many Voices was formed by folks, deeply saddened by the tragedy of Sept. 11 but equally uncomfortable with the militant dialogue burbling around the attacks. Anger, revenge, and violence were literally in the air. The response was to create a place for people from all walks of life to come together, talk and share in that troubling time.

Deeply in the mix, my friends Evie and James told me about Many Voices and invited me to get involved. I had just written "infestation of gnats," after the first US bombing of Afghanistan, but it became increasingly clear to me that my art training letter was a more honest response. It was what I had actually written right after the attacks.

I remember sitting in my friend Sarah Berger's car reading the whole thing aloud on our way to the mall to find me a white suit for a sorority function. I remember how she didn't say anything as I read it, but kept her hands on the wheel—only saying "that's intense" after it was over. I remember thinking that it would be a real test of bravery to do the piece. I remember thinking I had no idea how to do it—what I would do—what it would be like to do that piece. And of course, the whole time I was thinking about it, preparing for it, there was of course him, the memory of this man, the certainty that one can never know what / how another person feels / is . . .

I was meticulous about writing it all down. When I would pour out the honey, when I would smear it into ash. I wrote beforehand not what I did but what I thought I would do. I thought this writing would protect me like a shield. The

idea that I could plan it all out beforehand didn't prepare me for what it would be like to actually perform the work, make art on stage. How I felt standing before the audience, trying to render the past and be present in the moment. I was starting to learn about set gesture versus improvisation, or better said, being in your body in time and space before others.

I can't be certain, but I believe that what I did on stage was clumsier, stranger, more clichéd, more earnest, more thrilling, and more alive than anything in my prior plans. For better or for worse, it was absolutely singular in its presence in that evening. It was experimentation and abstraction in the midst of a community forum. It also literally represented the opacity and weirdness of 9/11 at least to me. Whatever writing I did prepared me little for all this, and prepared me not at all for what happened after...

> This morning's finer Verdict—
> Makes scarcely worth the toil—
> A furrow—our Cordillera—
> Our Apennine—A Knoll—

"I don't know what *that* had to do with 9/11," Evie said. Evie, my friend who I had known for many years, who had studied with me in France during our Junior year in college. Who had put heart stickers on her cheeks at Elizabeth C.'s twenty-first birthday party in Aix-en-Provence. Who had offered me *kir royales*—champagne and cassis. Who had been my dear friend in Minneapolis since I arrived and still continues to be. Could she be the emcee rejecting my performance art?

Even then, I didn't hear her voice as personal attack. It was the voice of community art and opinion. It was also a voice of outrage, a voice wanting to hear loud and clear about the attacks and the bombings and the impending war

and that asshole George W. Bush. This voice let me know that what I was doing was self-indulgent, off-topic, weird, not good enough. This voice told me I had gone too far, hadn't gone too far and far worse, I had gotten personal, artistic, sexual when people had died and more would be dying. Who was I to think I could do performance art? And at an event like this? It was the voice of my deepest fears.

> Perhaps 'tis kindly – done us –
> The Anguish – and the loss –
> The wrenching – for His Firmament
> The Thing belonged to us –

"art training letter (love)" was the first of a whole bunch of Negro firsts for me in performance art. It was my first official solo performance art work, performed before an audience. It was the first time I allowed myself to be sexually explicit in public. And it was the first time I experienced aftermath.

"Aftermath," my friend Wura remarks, "what a strong word to use for what happens after a performance."

> Aftermath, which is to say:
> devastation, failure, shame
> the sense that no one liked it,
> understood it, wanted it
> the sense of being spurned
> the sense of being out there, alone
> or completely alone inside an
> experience, a body
> Jupiter's bloody eye
> Saturn in its icy rings
> a circle within a circle

Years later, at the Conejo Blanco, my favorite bookstore in Mexico City, I discover *Dos circulos centrados* by Alejandro Magallanes in the children's section. The book is very simple,

just the same image repeated over and over again on the left side of each page with one line of accompanying text on the right. The image is a circle in one color inside of another circle in another color. *Un túnel iluminado.* The light at the end of the tunnel. *Un huevo estrellado.* An egg sunny side up. A smashed fish. A scared eye. Saturn in its rings. A succession of images, repeated with different commentary—like a 24-hour news loop. A circle within a circle. A tower and its twin.

> Does art twin politics?
> Can the personal tower
> next to the public as political?
> Or does it nestle within it, a circle within a circle?
> (The title of Karen Finley's book:
> "a different kind of intimacy"?)

Some narratives take the shape of towers and circles. Or rather both towers and circles shape narratives as well. Studying trauma at NYU, I remember my professor Ulrich Baer saying that he thought Schindler's List was not really about the Holocaust. He said it pulled at his heart strings and made him cry, but was really an exhibition of other things — Hollywood power for one, but less cynically the desire for comforting narratives. Not that the story itself was so cheery, but that it could actually be told as a story, that there were heroes and villains, that it happened in linear time. He said that the real movie about the Holocaust was Jurassic Park. A bunch of people stuck on an island with scary monsters that would come and destroy you. Another charged comparison.

> To spare these Striding Spirits
> Some Morning of Chagrin –
> The waking in a Gnat's – embrace –
> Our Giants – further on –
> - EMILY DICKINSON

After I finished performing "art training letter (love)," I heard the emcee's words. I gathered up my honey and my red sequined cloth, left the stage and sat down in the audience in a daze. Next to me sat Jennifer K., a former student, about seven months pregnant. She leaned in and said, "Well, I liked it." This made me feel even more pathetic. At intermission, a few people looked at me askance, others looked away, a few shook my dirty and glittery hand. A History of Art Professor at the U said she thought I could use a few pointers. Thanks very much. I wasn't sure how I felt. To be honest, I wasn't sure exactly what had happened. There was the reception of the piece, what other people were saying (and not saying), but this other feeling I couldn't shake: an internal intensity, a daze, an opening, a rawness from pouring out, a moving towards, a sense of not yet arriving, but also not being where I was before.

Some people congratulated me right then. A few people told me later that the piece haunted them for a long time. And it's funny realizing in the Twin Cities that there are people who know me deeply from this performance—or who met me in that room. It was at the Babylon doing "art training letter (love)" that I met Ellen Marie Hinchcliffe who ended up being a frequent artistic collaborator and one of my very best friends. A poet I barely knew before that night told me later that she'd been there (I didn't see her) and that another artist leaned over to her in astonishment and asked, "Who is that?" And she responded, "That's Gabrielle Civil." Indeed. In aftermath.

For the second half of the evening, I had planned to stay and support the other Many Voices artists. But after the performance, after the emcee's remarks, I felt like I was seeing the world through a scrim. I needed to get out of there. As Ellen was setting up to screen her videos of Iraqi women, I said, "I'm sorry. I'm crazy. I can't stay." She was kind and said she understood. I ended up eating enchiladas with some folks at a Mexican place on Lake Street (Mexico, a

place of prodigious performance adventures later, sneaking in even back then). It took a while before things felt more normal. And I'm still trying to untangle everything that had happened, the piece, the rejection, the political moment and my strengths and weaknesses as a performance artist. The work still has a long pull.

"art training letter (love)" was meant to illustrate the relationship between intimacy and catastrophe. How fitting that its immediate response would feel like more of the same, a circle within a circle. Apt too that my own first taste of performance art aftermath would happen when the whole nation was in aftermath, when I was attempting to talk about my own experience of aftermath to the same event.

Still aftermath was not just a part of "art training letter (love)," it is a perennial state in my performance practice. At the end of performing, you never know what people will say, where you will be or how you will feel.

will you be shaking? able to talk? will you feel euphoria, emptiness? will you be quizzical yourself about what just happened? vulnerable about how well you performed? will you be hungry? chatty? wanting to go out and drink with your friends? wanting to crawl into a corner? wanting to lie down in the back of a flatbed truck and look at the stars? will you be on the moon? will you need first aid? will you have to pay the sound man, give out chocolates and a bottle of tequila? will you be embarrassed? victorious? misunderstood? will your friends hate you or feel sorry for you? will you suddenly have fans? will you be lied to or shunned? will someone finally see you, love you, whisk you away? will you still be you? or will you still be something else?

In aftermath, the performance work is not actually over. In line with the torqued physics of performance time, the art ends for different people at different moments. For some, the first two seconds are enough and it's already done. For

others, it lingers for years. For the artist, the experience of the work in the body often lasts longer than the actual actions of the work. This feeling can overflow into audience reception, it can collide or contrast with immediate outside response or delay an artist's capacity to deal with this response or with anything else. The performance may be over for everyone else but in aftermath, the catastrophe, the intimacy, the possibility remains in the artist's body; it is still cresting and subsiding.

ON VULVA RIOT

> "The connections between and among women are the most feared, the most problematic, and the most potentially transforming force on the planet."
> -ADRIENNE RICH

About six months later, Twin Cities arts visionary Eleanor Savage invited me to perform at Vulva Riot. I was thrilled. Vulva Riot was a Twin Cities institution, a place where women of diverse races, classes, sexual orientations and artistic talents could strut their stuff.

"What do you mean it's women only?" Aravind asked.

I had called him excited about the chance to show "art training letter (love)" again.

"Vulva Riot is a place for women to come together and share their work."

"I think that's wrong," he said. "I think any segregation in the name of art is wrong."

I was dumbfounded. How could women coming together in their own space be wrong? And how could I be friends with anyone who could think that? Hadn't he come to St. Kate's, a women's college to perform? Did he think that was wrong as well? I didn't even want to go there. "It's a man's man's man's man's man's world," I joked. "Would you begrudge women this opportunity to share their work and celebrate and come together?"

"It's the opposite of art," he replied. "Once in Puerto Rico, there was one event that was male only, it was connected to the Church. And I refused to go in out of solidarity."

"It's not the same thing," I said. "Or rather, the need for women to come together, especially diverse women of all kinds, all backgrounds, is a necessary response to male exclusion."

"All of that is politics. And we're talking about art."

"What's the difference? We're talking about life and experience."

We both hung up in a huff.

Flávia was annoyed. She was also set to perform that evening. "Who is he to tell us as women what we can and can't do?"

Teaching at a women's college, I would sometimes forget that a desire for women's empowerment doesn't come like fluoride in the water. Even with the so-called "crisis of the boy," the higher number of women in higher education and law school, the visibility of women in government and business, women are oppressed, face sexism, misogyny, discrimination. We are disproportionately responsible for the domestic sphere, are deemed part of a lesser caste, face abuse, rape, and double standards. Even in the over-industrialized, technologized world, even in the world of art. Good grief, had he never heard of the Guerrilla Girls?

And the feeling of having to go over it all again, debates that happened decades ago, to be the stern voice of the feminist with an upswept bun and long nineteenth-century skirt, to be the stickler, the killjoy. And yet also to insist: the consolidation of power that happens in all-male spaces is different from the solidarity that can arise from claiming and naming women's spaces. The first maintains and further codifies a status quo, the second essentially disrupts it.

Wait, is that really true? As the years have passed, as debates have raged over transgender presence at women's colleges and festivals, as greater visibility has emerged about non-binary genders, simple exclusivity has been revealed as quite complex. Women have a right to select and invite our communities, but our righteousness is a tricky thing.

Still, should Vulva Riot have let men in?

Hell no. The Twin Cities offers plenty of opportunities for men to present their work, (Walker Art Center, hello!) and women's space, while fraught, remains vital. The world

is not fair and it's not equal. Enforced literal equality often works against fairness and justice. Not everyone gets to have access to everything at every time. Only the entitled think this is how the world works, or even how it should work.

What Aravind didn't want to admit was that the world was still sexist, that women in the Twin Cities still needed to support each other, and, more importantly, that we still had the power to set a boundary and create a space without men. Aravind didn't picket and didn't comment on it again. We still remained in friendly flirtation.

Unfortunately, Vulva Riot no longer exists and it's a shame. Even now, as my father grumbles that "women are running everything," we still need places like it. As women and artists, we still need to be able to come together to question ourselves and each other, to push and to nurture, to practice solidarity and showcase our work.

That night at Vulva Riot, the house was packed. The event was predominantly white, but there were some people of color. Self-identified women on a spectrum of sexuality and gender identification mingled together in the audience and in the set. A writer with swank glasses emceed and read her work stretched out on a divan. A group of women yodeled.

I redid "art training letter (love)" and it was better than before. After I did my piece, my friend Flávia and I giggled together in the bathroom. She told me she loved it, but that I needed to watch out at the end. I needed to not be afraid to make a mess and then take the time I needed to close. I've never forgotten this advice.

For me, one of the most gripping things about "Infestation of Gnats" is the wonderful build-up of crystallized moments that unmask the multiple viewpoints at the center of the work, and at the heart of contemporary life. At the end we are left asking ourselves -what do we feel about things, what is really important and who we are listening to. The work resonates rather than provide simple messages.

—STEVE BUSA, RED EYE THEATER

directive: I stand a brown seed, now wound in diaphanous paper, honey and ash smeared in a halo of earthen light... glow of ecru, hints of sunray, kernel, pomegranate seed...throughout this, it is the permeation and permutation of light that creates the effect of beauty and also of war. throughout, I am raveling, unraveling... the light grows

voiceover:
Emily Dickinson's "I Heard a Fly Buzz When I Died"

i came here to be buried
in mud
or burned
hot rocks
unfurling
beauty treatment
rest
i can't find—
i can't wait—
rest
mud
mud
mud
smeary memory
mud
mud
mud
i can't find—
i can't wait—
for life

mud
i came here for
beauty rest
nature is never
beauty
rest
i should have gone
to the big apple
the steel apple
ash
fifth avenue
chelsea
downtown
mud
hot rocks
mud
smoldering under the ash
nature is never
i need to
wash this away

voiceover:
Lucille Clifton's "last night we killed all the roaches"
and Rumi's "gnats in the wind" / light permeates, dims.
the effect of Balthazar's feast: the writing on the wall.

THICK DESCRIPTION
"INFESTATION OF GNATS"

this is the ritual.
kneel before the paper dappled with black.
kneel even in your purple and blue high heels.
spangled. open toes peeking.
your long ochre painted skirt.
your strange black bustier.
your metallic scarf.
it will change on your head.
jemima, babushka, guerrilla.
for now, kneel and tear.
long strips in your hands.
pull the paper long and hear the ripping
live mingling with recorded ambient poem.
there's my directive
and emily dickinson as well
i heard a fly buzz beauty and also of war.
crush the paper, reverse time. the bloom
becomes bud again. now hard packed seed.
kick off your shoes.
climb your fear to the rafters.
bundle it there. it hangs. no longer paper.
something transformed.

sometimes
i feel like
I am walking
through a swarm
an intelligence
my own
seeping through
a war
 my skin
he doesn't like it when i say
discombobulated
imbricated
inextricable
he doesn't like it
he doesn't say
he doesn't like it
he doesn't say
he likes it either
a war
 a swarm

you descend the ladder,
turn to make the path.
hard charcoal laid in tracks.
crawling on your knees.
making trance aloud now the poem.
i came here to be buried
the you now an i. a clearing making
my way making a maze of seeds to the yellow
spiral painted stone. once there more voices
lucille's roaches and rumi's mystical gnats
and i am gathering the paper, balling it up,
crushing it using the whole of my arms.
i am bundling it into my rust
pomegranate scarf to make it like
a honeycomb dripping from a tree
like what katherine dunham put under
her scarf in haiti the offering for the spirits
and i do something terrifying for me
i kick off my heels and turn to climb
a carpenter's ladder up to the rafters
to hang this prize out of the way
everything prepared and i
return and put on my shoes and
yes, every gesture then and now

ten of them on a pencil eraser
fifty on the fit of my nail
cluttering the corners of my door frame
a million pressed, dying,
blurred against my skin
an intelligence, a madness
not killing, buzzing furious
like that poem by alice notley
that time i read
to my best friend
and she wished i was her boyfriend
and i brought a crepe from the afghan
(was he really an afghan, have i rearranged his skin)
and i flirted with him like a man
and it was sugar and lemon
and he was so shocked
and he almost fell into a man hole
and steam
and fly smelled the lemon
and buzzed in her mouth
and came apart and burst
and fragmented into the confetti of swarm
and a war, a swarm
and slathers itself on the front of my house
and it smushes and it stills and threatens and it calls
and i tie a rag around my head
and i spray the green off onto another clean rag
and i clean them off my art/ not art postcards
and the circular for vacuums and planter's nuts
and the electric bill
and on the mail box
and in the mail box
and off the porch
and especially off the screen with its mesh gritted teeth
and my heart is meshed beating furiously

and i'm thinking how many crushed
under the head of my nail
and the angels dancing on a pin
and *electroluminescence*
and *cathexis*
and *palimpsest*
and *intelligence*
and *glow*
and *you*

everything had to be thought
learned and done
everything was a challenge
how to step into those heels
without my hands
how not to tremble if i needed
to turn one over
bend down and actually slide into it but yes
i did stand tall and speak the sometimes
and snapped my hands in an understory
to the words themselves sometimes i feel like
always my favorite part of the poem
a war a swarm
and then momentum climbing back up
the ladder bringing down the bundle shake
what's in there out and put it in down
with the charcoal in the bucket
on the spiral painted stone.
And keep speaking these words layered

incantation sugar confetti planter's bill
and light the paper on fire and hope
you can strike the match and the paper
will catch and the one night the paper
didn't catch and you didn't know then yet
what to do and so there was just a sputter
a plume of smoke but that was just once
the other nights it blazed and you stood
and pulled the scarf up to your face
and over your mouth and tied it in the back
pulling the ends long to stretch out your arms
and letting the ends go with your arms still
outstretched and the lights dimmed until
it was just you and the blaze and mankwe's
voice voice-overed *first there's dying,*
then union like the gnats /
inside the wind

"eat soup / build a fort / set it on fire"
-Jean-Michel Basquiat

ON INTERPRETATION

The fire has blazed. A hung breath of silence has been punctuated by applause. Lights up. A quick bow. And now I am sweeping. Aravind has doused the flames and moved the acrid bucket from the stage. So much to do. Ronnell will be on next and he has to dance in bare feet. So I need to sweep up the sesame seeds, gnat impersonations, scattered all over the stage. It's over tonight. It's time to clean up, clear it all away—
excuse me, what was that?
A man in a leather jacket has rushed up to the stage.
He's white, young, but probably older than I was then.
He has dark hair but I don't remember the rest.
I'm in a hurry.
what was that about?
it was my work, I say.
In my memory, it sounds like I'm speaking another language.
I'm in a rush. A broom in my hand, I have to clear this away.
The next performer is coming on and—
no really, I want to know. I saw a lot of things there—but I want to know from you—what just happened here?
I stop. I look up. His words are not aggressive.
They're urgent. Something has moved him.
He didn't say: what was *that* all about? He said: *what happened here? You've said something in another language that I don't understand.* He said: *I've looked at all of this*—the paper, the windows frames, the ladder, your words, your body, the charcoal, the seeds, the fire—*and I can feel you're speaking but I can't understand what you're saying.*

well, what did you think it was about?
I said: *what did you get out of it?*

> *what did it make you feel?*
> I dropped this line: *what matters about the work*
> *is what you see, what you get out of it.*

and the stage was coming apart behind me and the backdrop was changing and he looked at me for a minute and threw up his hands or maybe he just slipped away and I finished sweeping the stage and Ronnell went on and I went home and finally took a breath and I felt like somehow I'd lied or closed a door in a man's face.

> and that night,
> when I closed my eyes, another voice said
> *you were wrong. . .*

No.
Didn't that man know as much about what happened in that performance as I did? He wasn't just looking at pictures or watching a video—he'd been there. He'd seen my body in motion, in space and time. He'd heard a tangle of languages, watched a ritual unfold. It's not the performance artist who builds meaning: it's the artist and the audience together. It had to have meant something to him. It meant enough for him to ask me. Couldn't he just ask himself? I wanted to know myself: what did that mean? What did that mean to you? Did you see yourself there? Did you see your own ritual from the land of dark-haired men, with piercing eyes, oh yes, I remember now his black eyes, and make a connection. You tell me what it meant.

my little voice rolled her eyes.
and if he'd said that the piece was about rainbows and kittens.

> I would have said that he was blind.
> I would have said that he was lazy.
> I would have asked for him to show
> me evidence in the text.

but he didn't have the text.
Yes, he did. I was right in front of him!
 but what about the rest of it?

 what about walking out your door in late winter and seeing that strange buzzing of gnats and having to walk through it even when walking away from the reports of the bombing, the kneejerk reaction in Afghanistan, the strange heavy days after the World Trade Center attacks? what about the way it poured out of you, the language, how you sat down and how the murderous rage you felt at those dumb insects swarming you, not allowing you to pass untouched going in and out of your door, how that transformed itself into liquid language and came out in a rush and how it all got mixed up, your outrage at the bombing and your outrage at those gnats that made you want to kill them, kill something, anything, how it transformed your own doorstep into a war zone—

 but this is too much. (and now it sounds like I'm speaking in a French accent.) *zis eez too moch. zis eez too moch informaychon.* (Are we in a café now or a seminar in Université de Paris VIII? Am I wearing a beret with my nightgown?) *zee artiste* should not (have to) explain. all that was merely occasion. spark. *zis* not the performance. (besides, all that is pretty personal. besides all that was right there. couldn't he see it? couldn't he hear it in the words? probably so, he just wanted confirmation, he just wanted me to tell him he was right, but how could I when it started there but became different, so much more...)

but, you could have told him the other part.
(and now she sounds like a little girl whining or taking her big sister to task.)

how after the art training letter, you felt like you wanted to have help. you wanted to understand more about staging something. you wanted to push poetry, deliver it some way else and so when you got the grant for hieroglyphics, you looked for someone to work on it with you. you didn't want the sole responsibility of it on your head. you wanted to

learn more about your body, how it could move poetry in space. and so you contacted miré regulus, that red-bone girl with the big hair, asked for her help. and she thought it over and she asked you: we can do this two ways—we can take the text as sacred or as we work we can make changes to it. which do you want?

And I wanted to keep the text. I wanted it to be a layer—something given, something not to work on. The other things at play—how to animate it, not just recite it. And how not to turn it into a play. There was never a question of showing a door, having me walk through it and fighting gnats with a rag while an image of news coverage of the bombing of Afghanistan played in the background. Although that could have been a choice. And the man might not have had to ask me what the hell was going on. The war would have been clear. And maybe someone else could have done that and it might have been good. (Although that sounds way too literal to me. It would take a performer of far greater skill than I to make that work—which is to say an actor.) Instead, the understory. Instead the development together of a structure, as much the structure of working in the body as working on the piece.

Should I have told him about the Rodney Yee videos? the breathing exercises? Because the piece was as much about all that as it was about anything else. The fear I had to face down climbing that completely vertical ladder? Should I tell him how this was my first time working in a theater, dealing with technical details like sound boards and lights. about all the layers, the way those other poems were other gnats? buzzing, lighting on my skin? Should I tell him about how each element was deliberate—*oh he already knows that*—how the charcoal, which started as a placeholder for something else, became a touchstone for me—*he just doesn't know what it means.* How scared and thrilled I was to be doing it. How so much of the theatrical structure came from Miré, maybe he should ask her.

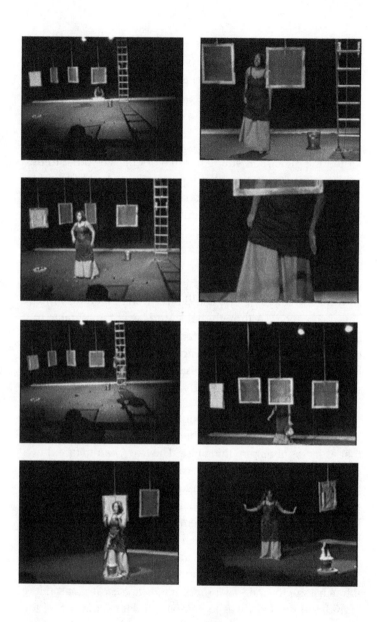

She was the director after all—and there was that moment I'll never forget, when she was telling me her ideas about the end of the piece and said, "But wait—we could do such and such." And she said, "Stop. Let me get through the whole end." And I felt checked, felt the weight of her power in what we were doing, and I allowed her to finish and knew that I had given her the responsibility—yes, just tell me. You tell me what you see, you tell me what we should do, you tell me what it should mean.

Gabrielle Francine, are you that big of a coward?
Ou goldbricker ca-a!

Uh-oh, this voice sounds like it's Kreyòl now.
(Has my Haitian grandmother, who never got a chance
to see me live in performance, somehow come into the fray?)
 a replay: *what was that about?*
 it was my work, I say.
no really, I want to know. I saw a lot of things there—
but I want to know from you—what just happened here?

Maybe the hardest thing about what happened is that the man asked me for interpretation right at the end of the show.

 you don't like Q+As? Post-performance discussions.
 enquiring minds want to know:
 was this autobiographical?
 drawing on syncretic black religious rituals?
 how exactly does this relate to the war?
 well, I didn't see a bombing in that at all?
 and all those voices, why were they all at the same
 time? and...?

Right after the show is the absolute worst time to talk to a performance artist about anything.
 but this is the best time, really the only time
 to have an exchange with the audience.

Better to sweep up for the next feet, clear it away, not clear it up...
oh, but it isn't cleared away. and you don't want it to be.
you want it to linger like that flame after the lights went down.
you are aiming for the slow burn of the mysterious.
your "infestation of gnats" was a poem.
no wonder you're having problems.

Often in my poetry classes, students get defensive and upset about poetic meaning. They engage in interpretation under duress. They split into camps. Either they believe a poem has one, concrete specific meaning (and that the poet is an asshole for not just coming right out and saying it. And maybe you're an asshole too for not just cracking the code for them). Or they believe that a poem—a work of art—can mean anything to anyone. If you get the bombing of Afghanistan and I get kittens and rainbows, well we're both right. There is no right or wrong. Interpretation becomes a mirror that just always reflects back.

What is the critical apparatus to engage a performance art work, a work that started as poetry on a page and moved into a theater, a piece that happened only three times many years ago and has never happened since?*
What did it mean then?
What can it mean now and how?
How has the meaning changed over time?

Many things happened for me with "infestation of gnats," but when I remember it, these questions and my encounter with the man in the leather jacket comes first to mind.

What bothers me about what I said, or didn't say, it is that it puts me into the camp of unthinking bombs or kittens and rainbows. What bothers me is that I blew him off: I was too much in a hurry.

Today, in that same moment, maybe I'd hand him a business card, my web address, a copy of this book. Maybe, I'd ask if

he wanted to have a longer conversation, coffee or a glass of wine. Maybe I'd say: *The bombing. I'm thinking of the bombing,* although those words aren't mine. Maybe I'd give him a special document (à la Adrian Piper's calling cards) kept in my bag especially for occasions such as this. Maybe I'd take his hands in mine. What I know I'd try to do is stop rushing or running away.

Praises to the figurative, to the head scratching, tangle of images that still insist on their deliberateness and their deliberation. Praises to the man in the leather jacket who wanted to know more. He was right to try and find out what I was doing. I was right to resist easy explanation but wrong not to take him into account, not to offer him something for and in a process of interpretation. The slow burn of the mysterious isn't everyone's bag. Interpretation becomes a fumbling in the dark at the moment when the lights come up.

Will you tell me? Will you let me in?

Today I try to breathe and take the time.

* HOW TO RESPOND TO A WORK OF
PERFORMANCE ART YOU'VE JUST SEEN BY
PROFESSOR GABRIELLE CIVIL, PH.D. & BLACK
FEMINIST PERFORMANCE ARTIST (*ahem,*
she pulls the pipe out of her mouth and places it the pocket of her
tweed jacket.)

It's right to ask questions.
Still, start from the gut. Feel out resonances.
Assess oppositions, narratives and matrices,
what's said and not said.
What can't be understood and why.
Take your time. Breathe it out.
Take account of the body and time, the body in time
and always whose body, which body is doing what when.
This includes yours.
Like poetry, a performance art work operates in figures.
Like poetry, it can and does mean many things
to the performance artist and the audience,
some of those things may be shared
and some only singularly experienced.
There may not be one answer.
Like a poem, though, performance art does
and should mean something,
even while it resists narrative or linear time.
Even if the gestures seem outlandish or repetitive
or incredibly simple, if the performance artist is serious,
present and grounded, and sometimes even when she's not,
there is something there. You must have faith in this.
Intention, purpose, grace, bodily control,
spontaneity, vulnerability.
What happens is how.
Take stock of what is happening and what is not.
Like any formal contract, there are some things
it cannot mean.

Employ processes of elimination and accumulation.
Keep pushing. Keep feeling.
You don't have to like it.
You can like it and not know why.
It may not be good. It may not reach its aims.
It be far less than the sum of its parts or far more.
The contingent meaning of performance art
offers and demands openness and multiple perspectives.
Like a poem, it can also always be read
as a commentary on its own making.
Enjoy.
Enjoy?
Enjoy!

ON POLITICS

bite the hand that feeds you...

In the middle of the grocery store, my cell phone rings. On the line is a white woman organizer I don't know. A Sister of St. Joseph and crusader for justice has given this woman my name. "Hello, is this Gabrielle Civil?" "Yes, this is she," I say standing in the produce section. The watermelons aren't quite in season, but maybe a star fruit or a pineapple. No: eat local. She is putting together an event against the Iraq War and wants to work on adding another event. "Maybe a poetry contest, hip hop or spoken word, you know because that's what the young black kids love and that's who is dying over there in the war." What? Am I remembering this right? I'm in the cracker aisle now. Ritz and Saltines shoulder to shoulder, while I am looking for sweetness. Lemon or peanut butter sandwich cremes. She is putting together a community event on politics. A speak out against police brutality. A Martin Luther King celebration. A weekend workshop on environmental racism. An opportunity for progressive artists to make work together.

It's blurring together. Cans of soup. Things I remember, things I've seen, heard about, applied for and didn't get, supported, skipped, did with pride. The aim is clear: talk about issues, reach the youth, bring in some supporting art. Youth here is synonymous with race. She wants kids of color to feel *included*. Perhaps the same way she wants artists to feel included, allowed into a discourse much more urgent than their own (unless delivered in a recognizable cadence). In the frozen food aisle, rows of popsicles are stacked in abundance—solid, colored, popular and cool. She wants work that will be relatable.

"It would be so great to have you be a part of things. I know you're busy with teaching and everything else, but

please consider being a part of this."

"Okay, let me think about it, look at my schedule, and I'll let you know."

And I do think about it. I am completely overextended with teaching, advising, work committees, writing, and thinking about new performance work, but I start to get excited. Catalyzed by the first US bombings of Afghanistan, Miré and I had worked out a performance of "infestation of gnats" that was lyrical and mysterious. I called the Sister to thank her for passing on my name. I called Miré to set up a new rehearsal schedule to remount the show. I sent a copy of the 12-minute performance tape to the organizer only to have her call me a few days later. "I'm sorry. I had no idea your performance was like that... Our conference is political and your piece just doesn't fit. We're going to stick with spoken word."

How often in those early days my work, political to me, never seemed to be political enough, at least in circumstances where the political meant literal community protest. One problem seemed to be expectation—what is expected to be shown and shared at community political events. And who is expected to make what kind of art. As a woman of color, I am expected to produce socially and politically significant work—work that will speak out, represent and make my people feel proud. Instead my work, my response to politics, is more figurative and abstract.

How to recognize politics in work that speaks in and around instead of out? How to enjoy work that reflects back the mess of our world or depicts a process of making order out of the mess, or making mess as a kind of resistant order? These are big claims for "Infestation of Gnats." If the organizer had said, the work is too young, too early, too tentative, it hasn't yet realized its aims, it's not right for us, it's not clear, or even it's not good, that would have been one thing. But what she had said was, it isn't "political enough,"

and that for me was a problem.

In the grocery store, I'd been wary. I didn't know the person on the other end of the line. Why did this organizer contact me? I am black. I like youth. I am black. I love poetry. I am black. I make art and am against the war. She is calling because she heard tell of me through someone else and because she thinks that I can fit into her roster. She isn't calling me because she's heard my work is good; she doesn't know anything about it. She thinks she is reaching out. Yet, when she touches on the reality of who I am, she pulls back. She is the one who comes to me, but then I and my work get rejected. Spoken word and hip hop are great, but they aren't the only black or political aesthetics. They aren't what I do. She wants blacks, youth, art, me, to be a part of it, but only if we fit the bill. She doesn't know who we are or what we can be. She doesn't yet know who I am.

I am a political artist no matter what they say. My work responds to world events, power imbalances and, most especially, it claims and actualizes the presence of a black woman's body in the world. This body is the subject and object of law, discrimination, domination, power, control, organizing, strategizing, coalition building and trying to radicalize or at least radically claim joy. My performance art, whether it be weird, cerebral, strange, hyper-aesthetic, out there, grandiose, straining, intimate, messy, experimenting, whatever, does belong at the political art event along with spoken word, hip hop, singing, drumming, storytelling, oratory and prayer, just as I belong in my community. As a black feminist performance artist, I claim this space as well as a gallery, a theater, a grocery store, the world and the street.

The community rally, the protest, the meeting—even some kinds of academic conferences—are all meant to build solidarity, network and break through into new ways of thinking. Organizers often include art, but only art in forms

that feel familiar. At the intersection of community, politics and art, we need a wider variety of forms. There are political puppet shows, butoh dances, talk pieces, sculptures, videos, villanelles and, yes, performance art pieces; we need more organizers to allow this work to be a part of the program. When my own work has appeared in such forums ("art training letter (love)") at the Many Voices Evening of Resistance, Ritual & Resilience after 9/11 and Vulva Riot, "Berlitz" at Yari Yari Pamberi: Black Women Dissecting Globalization, etc.), responses have varied, from censure to standing ovation. This variety of response is good and a part of any artistic reception. Moreover, the manifestation of a different form of creative thinking is important at a site where people are coming together, responding to problems and brainstorming new solutions. Political solidarity like aesthetic appreciation, takes trust and time, perhaps a leap of faith. Call me to fill your roster, but then don't run away when I show up. My job as a performance artist will be to make it good enough for people to feel its sway, even or especially if it's strange.

For the record, at the check-out, my basket held bagels, bananas, a pinwheel, and some Laughing Cow cheese.

A DOUBLE VOICED POEM

they say we are dying. condoleezza rice. will die soon.
they say we are flourishing. news week.
the gap between black men and black women
is the widest it's ever been. news week again.
7% successful. 76% alone. is this world wide?
buchi emecheta. in my country i'm an elder.
manthia diawara. i have them throw in the tie for free.
i am african when i say hello i say jambo. i say jambo.
a song i learned as a girl. hair. white boys are delicious.
powdered sweet to eat. black girls are delicious, chocolate-covered treat.
dissolution. sugar and salt in the sea.
essence. do black men still want us?
my mother. if you have to ask you already know.
star jones. on the website. you can see the ring up close.
ana mendieta. *siluetas* burned away. nawaal el saadawi.
a circling song. adrian piper. funky chicken. left and right.
a trail of chicken bones. the little mermaid. under the sea.
legs that burn like knives. janine antoni. lick and blow.
evelynn hammonds. triangulated black (w)holes.
the w in parentheses. the sea a salt lick.
jayne cortez. mouth feathers sequins and horns.
if this were papyrus what lacunae what fragments.
abbey lincoln. picking up tiny shards of glass.
nothin but a man. don't let it touch you inside. why lie.
wanda coleman. ectoplasm boogaloo. all the scientists find.
blues. a kente cap for sale. giovanni singleton. call numbers
in concrete poems. a slave ship. a sugar cube. bell hooks and
yoko ono. rising. *balloons balloons. come and buy my pretty balloons.*
yellow green. tangerine. come and buy my pretty balloons.
a song i learned as a girl. my mother at the piano. a glass case of
treasures collected slowly over time. rosamond s. king.
six women in hot tub. what do they say?
inside them all is blood and salt. high stepping body. dissolve.

to be read aloud simultaneously

soon die will rice. condoleezza, dying are we. say they.
week news. flourishing are we say they
women black and men black. between gap the
again week news. been ever its widest. the is
wide world this is. alone 76% successful 7% ?
elder an i'm country my in. emecheta buchi.
free for tie the in throw them have i.. diawara manthia
i am african when i say hello i say jambo. i say jambo.
hair girl. a as learned i song a black girls are delicious,
chocolate-covered treat. white boys are delicious. powdered sweet to eat
sea the in salt and sugar. dissolution.
us want still men black do. essence.
mother my. if you have to ask you already know.
close up ring. the see can you website. the on jones star.
saadawi el nawaal. away burned *siluetas.* mendieta ana.
right and left chicken. funky piper. adrian song circling a
sea. the under mermaid. little the bones. chicken of trail a
blow and lick. antoni janine knives like burn that legs.
(w)holes black triangulated. hammonds evelynn.
lick salt a sea. the parentheses in w the.
horns and sequins feathers mouth. cortez jayne
fragments what lacunae what papyrus were this if.
glass of shards tiny up picking. lincoln abbey
lie why. inside you touch it let don't man a but nothin
find scientists the all boogaloo ectoplasm. coleman wanda
numbers call singleton giovanni. sale for cap. kente a blues
and hooks bell cube sugar a ship slave a poems concrete in
rising ono yoko *balloons balloons. come and buy my pretty balloons.*
yellow green. tangerine. come and buy my pretty balloons
of case glass a piano. the at mother my girl. a as learned i song a
king s. rosamond. time over slowly collected treasures.
say they do what? tub hot a in women six.
dissolve. body stepping high. salt and blood is all them inside.

Fat Black Performance Art

"A scholar's concretizing her social location may help the mutual connection between an audience and herself, but erotic scholarship entails speaking from, for, and about the body. The assertion of an "I" requires more than anecdote and autobiography. I base theory on my body and my experiences and on other women's bodies and experiences."

- JOANNA FRUEH, EROTIC FACULTIES

Slide 1 (1960)
[A fat black woman] swan dives from the window of a building, falling towards her friends who hold out a tarpaulin to catch [her]. A photo captures this moment and a second one captures the empty street. The two photos are fused together to create an iconic image in black and white. Almost forty years later, RoseLee Goldberg, the preeminent scholar of performance art, writes: "The final photograph of [the fat black woman's] self-endangering and bold feat would profoundly influence generations of artists."

Slide 2 (1965)

[A fat black woman] sprawls out in a red unitard, her long black hair [straightened or with a synthetic fall] falling past her chin. She lies on amorphous white forms with red polka-dots, like Dr. Seuss balloons. Some are serpentine and others more like miniature marshmallow pillows. All poxed with red. Goldberg suggests: [The fat black woman's] obsessional art "emerged as much from her episodes of acute depression as from observations of the repetitiveness of daily life."

Slide 3 (1975)

[A fat black woman] stands naked. Her posture is a semi-squat. Presumably, it is red paint painted in a circle on her face and splattered around her crotch. But who can be sure? She pulls a long scroll from her vagina, reading from it a searing litany of male criticism of her art work.

Slide 4 (1981)

[A fat black woman] makes a recording of [herself] saying the names of all the people [she] can remember who have died in [her] lifetime. During [her] birthday party, [the fat black woman] plays the tape and, at the sound of each name, [the fat black woman] falls ritually to the ground, tries to rise up, but, hearing another name, falls again.

Slide 5 (1990)

[A fat black woman]'s performance was catalyzed by the 1987 Tawana Brawley case, in which a sixteen-year-old, black girl accused white men of raping, terrorizing and spreading their feces on her. [The fat black woman] describes in her journal: "I knew I could never go emotionally where Brawley had been, and I could not actually put real feces on myself . . . So I decided to use chocolate. It looked like shit."

Slide 6 (1973)

[A fat black woman] decides to dress up as a once-famous black ballerina who studied with Diaghielev. [The fat black woman] writes innovative plays and inaugurates a series of performance actions in this persona. Esteemed performance critic Henry Sayre writes: "This 'Black face in a snowbank" as Diaghilev describes her in the plays, invader of the "white machine" of the classical ballet, is a complex amalgam of [the fat black woman] and the residues of modernism, cast into radical otherness."

Slide 7 (1993)

[A fat black woman] dresses in a full body black unitard and "paints" an entire gallery floor with her long hair. She does so by dipping her tresses in what Goldberg describes as "a large plastic bucket of Loving Care's 'Natural Black' dye." According to Goldberg, "It was an ironic provocation of male-dominated legacies (in this case that of Pollock and Klein." [The fat black woman] explains: "I feel attached to my [fat black woman] heritage and I want to destroy it."

Slide 8 (2001)

[A fat black woman] goes to Bilbao Spain and makes a clandestine short film, mocking an audio tour's rapturous admiration of a corporatized art institution. At one point, [the fat black woman] gyrates her [fat black woman] pelvis and strokes her [fat black woman] hands across the burnished walls. At one point, [the fat black woman] lifts up her short skirt to show her perfect [fat black woman] ass.

Slide 9 (1971)

[A fat black woman], enthralled by Immanuel Kant's critique of pure reason, took to recording herself photographically to verify her existence. [The fat black woman writes]: "To anchor myself in the physical world, I ritualized my frequent contacts with myself in the mirror . . .I rigged up a camera and a tape recorder next to the mirror so that every time the fear of losing myself overtook me and drove me to the "reality check" of the mirror, I was able to both record my physical appearance objectively and also to record myself on tape repeating the passage in the Critique that was driving me to self-transcendence."

Slide 10 (1992-1993)

[A fat black woman] shares a cell with [another fat black woman] pretending to be an undiscovered tribe of Amerindians. [The two fat black women], who had intended the performance somewhat sarcastically, are appalled by how easily they are apprehended as the real thing: how they are fondled, dehumanized and ridiculed. [The first black woman] is especially upset by the level of objectification [the first black woman] receives, but [the second fat black woman], by virtue of being [a fat black woman] is used to it.

Slide 11 (circa 1970s)
[A fat black woman] has a formative affair with her art professor who helps her discover herself as a [fat black woman]. In later work, [the fat black woman] burns a trace of her own scintillating silhouette in the ground.

Slide 12 (1964)
[A fat black woman] sits in a traditional position on her knees.
[The fat black woman] instructs the audience to take a pair
of scissors and cut her garment anywhere and to any extent
they desire.

Slide 13 (1994-2002)

[A fat black woman] makes a series of five films using a metaphor of male genitalia as its central trope. Among other personas in the series [the fat black woman] impersonates a giant, a de-sexed satyr, a gallant knight and a serial killer.

Slide 14 (1997)

[A fat black woman] sits in a dim room filled with bloody cow bones. She cleans the bones ritually with a scrub brush dipped in water.

Slide 15 (1991)
[A fat black woman] decides to don a suit and crawl the entire length of the island of Manhattan with a small potted flower in her [fat black woman]'s hands.

WHITE ON WHITE

It arrived pure, pearlescent and folded in fours, opening up to a white expanse. How long did it take for me to realize that the white poster in the white envelope wasn't blank? I can't remember... The letters spelled out in the palest pastels, pink, yellow and blue: Aaron Young, Midway Contemporary Art Center. This was an invitation.

+ + +

I went alone. Arrived only a few minutes before the performance was slated to begin. As usual, I was the only black woman in the place. One black man, this time with dreads, was talking to two white women (another common feature at a Twin Cities phenomenon). Perhaps some people were subtly passing from one racial category to another— or placing their ethnic heritage outside of routine racial taxonomies (another Twin Cities phenomena). Still, counting run-of-the-mill phenotypically recognizable black women, there was nobody but me.

I did see one playwright / director that I knew. "Hey," I called, "How are you." He nodded. Coolly. The whole vibe was cool. Well maybe it wasn't cool to anyone else. There certainly were a lot of people there. The usual art hipsters with the Midwestern Williamsburg look, belt buckles, funky shoes, colorful haircuts. Some older professorial types, some burly Minnesotan art workers (the kind that sculpt or work with wood), and strangely a fair number of kids running and playing. It should have felt like community. It should have been warm and fun. It wasn't. At least not to me.

Maybe it was the space, impressive and cool, the way the old Walker Art Center was. Freshly painted white walls, high ceilings. Definitely impressive. The perfect white cube. How nice. How modernist. A phalanx of warehouse windows

took up almost one half of one whole wall. These were quite wonderful, letting in the rich blue-black of the night. Nothing hung on any of the walls. In the center of the room, a large sunglass stand had held scores of aviator sunglasses: red, yellow, blue, now worn jauntily by the crowd. Very Cory Hart in the 1980s. Everyone was wearing sunglasses at night. It should have been fun. It wasn't. Excitement was in the air. All the sunglasses were gone by the time I walked in, so I just walked through the space, looking for friendly faces and of course for wine. It should have been fun. You get the picture. I found a small room where a small projection was going. A couple people were watching. A house in snow. Close by, information about the artist. BFA RISD. MFA Yale. Figures.

+ + +

I do not walk with alienation everywhere I go in the world. I have been to small taverns in rural Ohio, big city bars, San Francisco bath houses, and in all these have felt welcome and happy. But walking through that sunglassed throng, I felt like a Martian. I didn't hate the feeling—indeed, being a black woman in the academy, it wasn't new to me—but it was interesting. I kept wondering: where is the performance? When will the performance start? Is this the performance—me walking through this space without sunglasses with all these Nordic quasi-hipster white people in multi-colored, motorcycle cop sunglasses?

+ + +

A buzz in the air. Did someone speak to announce what would happen? Or did it just start? You could hear it a split second before you saw it. The whirr of blades in the air. A huge gleaming helicopter came flying into sight, shining its lights through the phalanx of windows, projecting shadows

in the air. Did people cheer? Did they clap? The energy in the room totally changed as technology, space, and art collided. I wasn't wearing sunglasses, so what I saw was cool white light hitting cool white walls. A sheer light of pure money. How much had that thing cost? And the meaning, the feeling, the association of this. The shadow raised by white on white. What the hell was going on?

I found some discarded red sunglasses and put them on. The room blurred. Now red on red. The color over my eyes from the sunglass lenses nuanced, deepened the light. People were creating dark red shadow animals with the children. In my vision, red hand birds and red finger bunny rabbits marching across the walls. How quickly people turn away from cataclysm. Not lose interest exactly, but just move on. The helicopter kept grinding. And after just a little while, people stopped looking at it so much. You didn't need to look at a helicopter anyway. Its light and sound filled the room. You couldn't get away from the whir and the swirl of light. But you could talk to your friends about it and whatever else. Experience the light from different colored lenses. Get another glass of wine.

+ + +

I was dumbfounded. Beauty was here, but also a kind of terror. Was I the only one thinking of prison breaks? South Central LA. Dark bodies running trying to hide from authority? Maybe this was the whole meaning of the piece. The helicopter as an image of state authority while, fashioned like authority, we look through rose-colored glasses. Or become naïve masses. Maybe it was all a wry commentary on the repressive state apparatus. Or the panopticon. Or was it more about phenomenology? Process, vision, feeling, transformation? A war waged between light and dark interpretation. The performance of light transformed into pure gorgeous color

onto white walls; the performance of rich disembodied art beamed into a vacuous room of white people...

+ + +

"What do you think?" a handsome woman approached me. She was the first person in the whole place to speak to me voluntarily.

"I'm not sure," I answered. "I have some questions. Don't I know you? You did the Naked Stages program, right. You're Bridget."

"Yes. And oh, you did it the year before."

We smiled. It was nice to have a friend.

"I can't help thinking about race in this," I told her. "What is the artist doing? What does he think he's doing? And how would it be completely different if he were black? If the gallery were in Detroit or DC? Or if every person in this room were black."

She nodded. "Think about how much money this must have cost. It boggles my mind."

"It is beautiful though, isn't it?"

"Oh the quality of light is gorgeous," she paused. "But what are we to do with it?"

+ + +

A tall, blonde, willowy, somewhat fragile young woman joined us.

"Just look at this," she said.

"This is really pissing me off."

We made introductions. Her name was Karin and she was Bridget's friend. They were both artists. They were both feminists. And like me, they were both unsure of what to make of this performance we were—witnessing? creating? participating in?

"I keep thinking how male it is," Karin continued. "It feels so masculine, so aggressive. And just look at these guys..." What she didn't say: it's like we're not even here. How often I had felt that way in art spaces. Had I become used to it? Expectant? Was she less used to being pushed out the picure? I had automatically racialized it, but for her it was about gender: being a woman. Did she feel the audience attention was misguided? Did she want to feel more of it herself? Some people looked through windows; some looked at the walls. Many, if not most, were just chatting, laughing, drinking wine. The helicopter blades kept whipping through the air. The pure white light flooding into the room, everyone seeing a different color. Karin kept looking around. She was clearly bothered. Maybe it was the disembodiment of it all. Or the fact that this was a performance without one central performer, where the orchestrator of the performance may not have even been in the room while the major agent of performance, a helicopter, was hovering simultaneously mechanical and ethereal outside the windows.

+ + +

"I just feel like taking off all my clothes right now," Karin said. She looked around and in her look was irritation, provocation and a little pain. Maybe she too felt alienated or overlooked. Maybe she felt like something was wrong for a helicopter, a mini war machine, an arm of the repressive state apparatus, to arrive without any commentary beyond *pass the wine*. Maybe she just felt left out. I don't know. Bridget and I raised our eyebrows slightly. And a little mischievious imp sprang up inside me. Swallow the fish. I wanted to see what would happen, where this all would go.

"If that's what you feel like you should do," I said. "I think you should do it."

"Really?"

"If this is a performance, part of the work is us. What we do. How we interact and respond. If all this moves you to do something, I think you should do it. We've got your back, right Bridget?"

Bridget nodded.

Fine, Karin's body language seemed to say. She walked over a few feet away to an empty patch on the floor. She sat down and began to untie one of her tall black boots, setting it down next to her with a thud. Without pausing, she untied another one. Then Karin pulled off her slinky black knee highs, the kind that normally peek a little over the top of boots. A feminist strip tease. She pulled her tank top over her head with one swoop. Was she wearing a bra? I don't remember. All I remember were her small, pert breasts. This set off some alarms. Quiet as it's kept, breasts get picked up on the radar. The whirr of the blades, the flash of the light still fills the room. She pulls off her jean mini-skirt, slides off her panties, reveals her flat white belly and the small blond triangle thatch of her crotch. *Voilà*: a naked white woman, the muse, the object, the cornerstone of centuries of Western Art lying in the middle of the gallery floor. The work was complete. Karin put her hands behind her head, crossed her ankles and lay there, radiating anger and defiance. No one said a word. A few people stared. Some college boys smacked their lips. Most people looked for a few minutes, then turned back to their prior conversations.

"Is she okay?" I asked Bridget.

"She's fine. She's tough. Besides we're keeping an eye on her."

The helicopter kept whirring on and on. It had been out there for at least half an hour.

People were starting to leave. Even with Karin still on the floor.

I tried on different pairs of glasses.

What did the light look like with blue colored glasses?

With yellow? How did this change Karin's white body in the white light, proximate to the white walls?

+ + +

It's hard to say how long it took. One thing about the performance, it obeyed the laws of performance time. It felt like years between when Karin laid down on the floor and when one of the gallery owners walked over to her, but it was probably only a couple minutes. He moved purposefully, a little anxiously, but without attracting too much attention. He walked over, knelt down and whispered something in her ear. She turned her head a little to listen to him and didn't seem to respond. But she only waited a beat or two before getting up and pulling back on her clothes, still defiant but with an undercurrent of sheepishness.

She walked back over to us.

"Are you okay?"

"Yeah. He said the artist was afraid I was taking away from his piece. That I was stealing his thunder. Can you believe that?"

Interesting, I thought. What does it mean that he creates this performance, this space for people to do whatever and then can't handle what they do?

"If he can't handle the heat, he should get out of the kitchen," I said. By then, I understood one thing fundamentally about performance: if you open up the space for people to do whatever they want, they will. (My own performance *Anacaona* had taught me that. At one point, the audience was throwing things on the floor, playing bongos, not paying attention to me at all. One woman, the great dancer Merián Soto persisted in throwing corn kernels in my face even after I raised up a machete. But that's another story.)

Whether in the room or not, the artist must be prepared

for whatever might happen...Hadn't this artist opened the door? The white walls, the array of sunglasses, the super expensive helicopter outside? Weren't we supposed to walk through it?

What Karin did was catalyzed by the work, so in fact, it was the work, right? What was the artist trying to lock down? Or was it the gallerist who didn't want a scene? Was this about the piece or the curation of the piece? At the same time, what was really at stake for Karin? Or for me? I had wanted Karin to do it, had added fuel to the fire. Why?

Helicopter search lights swirled.

+ + +

"I'm gonna go find my friends, I'll be back," she said. To my surprise, she seemed shaken. I wondered if it was the taking off the clothes or the fact that not that many people had cared or had been impressed. Or maybe they were seething and ignoring her? She went out for reinforcements. She certainly didn't know me from Adam's housecat. Was I really to be trusted as support in this crucial moment? Were we in feminist solidarity or had I, a black woman stranger, helped her make a fool out of herself? Worse, had I objectified her, helped her objectify herself, or even worse, curated her, rated or discounted her somehow? I didn't offer to strip with her. She didn't ask me to. I wonder what I would have done if she had. She walked through the room with her head held high. The place had thinned out some. The spectators Karin passed were still shielded by sunglasses. Who knows what they were seeing. Although the helicopter still beat against the windows, it was clear we were close to the end.

"Just think if that had been me," I said to Bridget. "The whole thing would have been different."

+ + +

134

What if I had been the one who had taken off my clothes? Like Karin, would they have said I upstaged the performance? Or rather that I degraded it? My big black breasts, my round belly, my love handles, my stretch marks, my fleshy black ass in the middle of that floor. How horrified the crowd would be to look at me. How horrified my mother would be if she heard that I had done something like that. Two different kinds of horror, both from the same root: radical discomfort with the public presentation of the black woman's body. My mother's horror would have come more from a sense of propriety, a defense again centuries of public perception of black women as loose and uncouth, a desire for good reputation. The horror of people there perhaps from their predisposition to that same public perception, undercut by more liberal politics; they are artists after all. How dismayed they would be to face a black woman acting this way, performing this negative stereotype. Could their repressed secret beliefs about black women actually be true?

+ + +

If I had taken my clothes off at the performance, I imagine far more visible dismay on the faces of the people in that room. Or perhaps amusement. As the only black woman there, disrobing would be like the miraculous appearance of a zebra—or worse, an elephant in the room—an exotic, wondrous, completely incongruous apparition. At the same time, this act, my unclothed body, would have reinforced the social order even more. Black women, aren't they like that anyway? Trying to beat that back from their lips.

This is all hypothetical. It didn't happen and I'm not sure it even could have. If I had been wearing boots and leaned over and started to untie one, I could just see that same gallery owner rushing towards me. "Excuse me, what are you doing? This isn't the place for that. We don't do that here."

The assumption being that I wouldn't know or understand art-world etiquette. That an art opening wasn't like some rap video with gyrating hos. It was far more refined and important. And isn't it always like those big black women to call attention to themselves?

And yet what of the fact that I experienced myself there as completely ignored? This invisibility is actually the product of a hypervisibility, a surveillance, an immediate apprehension of difference. When a black person isn't addressed in a white room—whether it's her physical presence or her art—the blindness is usually a kind of sight, a pretense; the silence is a way of letting her know she doesn't belong. Both are false ignorance, ingrained by years of specific social, cultural and academic education. It's a haplessness laid on a rock-solid foundation of equal parts self-delusion and self-satisfaction. Even if they really hadn't seen me or known me or felt moved to welcome me, at the moment I unlaced one tall boot (or in my case kicked off a cocktail pump), I could not have been ignored. I was already both too foreign and too taken for granted—in a way that Karin's white body could perhaps never be.

The recognition of my body (as unlikely, out of place) would have been an irrefutable necessity, binding the people in that room together more than the helicopter or the sunglasses or anything else. As black feminists such as bell hooks and Paula Giddings have argued, my black female body is at the center of the whole racial taxonomy of the Western World. It is the monstrous abomination in the white imagination that caused black men to be so lascivious, so disgusted and displeased with their God-given mates that they had to go and rape helpless white women, causing white men to lean down from their high place on the Great Chain of Being and scoop them up by the neck in lynch-knots. And if the white men were secretly turned on by these bodies, they dare not admit it too openly. Still who could

blame them? Unnatural attractions those black women. Primal. Like jungle creatures.

+ + +

> black, naked women with necks
> wound round and round with wire
> like the necks of light bulbs.
> Their breasts were horrifying...

In Elizabeth Bishop's famous poem "In the Waiting Room," a little white girl waits for her aunt to finish her dental appointment. Flipping through a *National Geographic* magazine, the white girl is horrified by black women's bodies, how they conjure strange feelings about her own femaleness. When the speaker says to herself: "three days / and you'll be seven years old," it rhymes with Karin saying: "I need to take off my clothes"...

> ...saying it to stop
> the sensation of falling off
> the round, turning world.
> into cold, blue-black space...

+ + +

The cold blue-black space of the night churned and split by helicopter blades. The cold blue-black space of racial fear. And again to wonder: instead of Karin, what if it had been me? How many times have white Minnesotans seen a naked black woman's body? They would have seen half-naked ones all the time in rap videos on MTV (and even more on BET if any of them could find it on their dial.) Other than that, it would have to be porn or old issues of *National Geographic* (which amount to about the same thing). Maybe

a few straight men or lesbians there had had black female lovers. Maybe. Or maybe a doctor, a nurse or other health care worker. The one brother in the room had surely spied his mother or sister's body as a boy before going to school and learning that black women were fine, but not *refined*, the standard of beauty. Or maybe he'd had his one bossy black girlfriend who was angry, mistrustful, fussy and loud, and from whom he turned in exasperation and secret relief, deciding instead to be championed by the two very nice looking white girls giggling and drinking wine next to him. Overall, a real black woman's body, although highly mythologized, is deeply unknown—often even to herself. Dignified, conscious public presentation of a body like mine has been rare (or at least minimally publicized).

+ + +

My friend Mankwe Ndosi, a brilliant musician, vocalizer and artist, broke the mold in her performance art work "Sema Yote's Body Music." Commissioned by the Naked Stages program, the same year as my work "*whisper (the index of suns),*" her piece incorporated drums, original poetry, homemade instruments and natural found objects like shells and stones. From start to finish, she performed the piece naked.

Or should I say nude? I remember hearing in an art class once that the difference between nude and naked is sexualization. That an art *nude* for example was *aesthetic*, which is to say *desexualized*. Whereas *naked* connotes raw, sexual and often for women vulnerable. Is it just me or is this bullshit? It makes me think of what Giddings calls in her essay "The Last Taboo," the "unlikely" difference black and white women in the Western white imagination. The difference between the white women in nineteenth century European paintings—nudes—and the "Venus Hottentot" or *National Geographic* centerfolds—naked. The difference

between the little girl in Elizabeth Bishop's poem "and those awful hanging breasts." The difference between Karin lying and the floor and me.

To me looking at Mankwe's unclothed body was literally like seeing my mother, my sister or myself. She was aesthetic; I registered her as beautiful. Naturally, as a woman, she was sexual; for me, though, she was not simultaneously hypersexualized and disregarded. For the other spectators, I'm not as sure how she functioned. Both times I saw her show, the audience seemed quite taken aback, reserved and uncomfortable. My friend Sarah suggests this may have been more regional than racial. That Minnesotans, unlike different but equally provincial New Yorkers, would be uncomfortable with anyone's unclothed body. I disagree. Minnesotans in performance art audiences, Minnesotans at the Midway Contemporary Art Gallery aren't uptight about nudity. Or at least, they didn't seem particularly uptight about my friend Flávia, stripping down to her underwear in her performance art piece "Not About Me," or even Karin taking off all her clothes on the floor. While the gallery owner did walk over to stop her, no one else in the crowd seemed particularly disturbed. (Maybe that was a part of Karin's frustration, her body couldn't register in the same way.) Some audience members at Mankwe's performance seemed literally appalled by her. Undoubtedly beautiful, her body registered as sexualized and raw, omnivorous. Her nakedness meant this to them and perhaps always would.

+ + +

A black woman's body is always overdetermined. Feminist philosophers from Simone de Beauvoir to bell hooks have long argued that all women's bodies are overdetermined. After Descartes, thinking became associated with the male mind and "non-thinking" with women who were solely defined by the body. But the way that Karin and

139

I responded to the performance, what she did and what I didn't do, perhaps speaks to levels of determination. Where was the body in Aaron Young's performance? And whose bodies were interpellated? The missing men of color running from the law? The working class folks of all races and genders living in neighborhoods where helicopters hover every day?

This performance was mechanical and technological, but more than anything it was conceptual. It was conspicuously a kind of art in which thinking about concepts was as important as, let's say, representation or decoration. The performance was material (it certainly cost enough money) and dematerialized at the same time (precisely what, and where, was the performance?). What was created was a visual, sensory, kinesthetic experience. The only art objects were the sunglasses, magically transformed through their use in the piece and, of course, our bodies. And somone used to being objectified—such as a pretty white woman like Karin—would be all the more sensitive to the objectification generated by the disembodiment of the piece. Karin's reaction to the disembodiment, the immateriality of the piece may have been complicated by her ambivalence about objectification. *She wanted, perhaps expected—was used to, needed—her body to make a stir.*

For me, equally material and immaterial in the space, disembodied and hyper-embodied, invisible yet mythologized, the piece angered, challenged and provoked. Who was performing what and why? And what had I been performing: the maid in Manet's *Olympia*? What was the intent of this piece? Who was the intended audience? Would the artist say that the piece was fundamentally for white people? About white people? Or was it the overwhelming white social location of the performance that suggested this to me? Did the piece lack an acknowledgment of its social location—i.e. did it attempt to be pure art—pure light in a pure white room, mediated only by pure color lenses? Or

was the key to the whole piece the way that the helicopter, the light and the sunglasses put various social relationships into relief? It seemed almost like the artist had already predetermined every body in relation to the helicopter, the light, the social dynamic. But how did that predetermination jibe with the actual audience. Had he figured us—certainly not literally—the woman struggling against and toward objectification, the black woman negotiating embodiment and invisibility into the mix. Maybe that's not true. Maybe that's not even fair. Maybe the social dynamic of the gallery, of the art world, of the United States overall, featured a predetermined set of assumptions about the bodies that would be there: able bodies, bodies with working eyes and / or ears, bodies marked by class and education, bodies inscribed in social codes and restraint. What was it that made me feel as if my body didn't matter in the space? What was it that made Karin need to hyper-materialize her own? How did our different responses highlight the allegiances and differences between black and white women?

+ + +

Later, when I talked about the whole thing with my friends, many of them chastised me. Why are you giving this white male artist the benefit of the doubt? Do you really think race and class consciousness were ever a part of his work? Was it mentioned anywhere in his artist's statement or in the materials about the show? And are you cutting the white male artist more slack than the white female one?

+ + +

Overall, I liked how Aaron Young's piece raised questions for me, questions whose answers remain elusive. Maybe it shouldn't have been fun. Maybe it was. My conjecture about my own body was hypothetical not just because I wasn't sure

if the gallery owners would have let me strip, but obviously because I hadn't been fragile or brave enough to try. I still wondered about Karin—what she had done, and my own motives for egging her on. Everything I said to her, I believed. If anything public had jumped off, I would have stood by her. But there was a part of me that wanted to scrutinize up close a command performance of white femininity.

In the end, her private relationships ended up being affected more than anything. And I had no sway over that. Karin returned to me and Bridget, a few minutes after her intervention, looking undone. Her friends had shunned her, saying they were sick of her antics, her desperate cries for attention. Couldn't she just let other people have the stage just once? I suggested she get a glass of wine (apparently my answer to any problems at an opening). Bridget had to head off to a rehearsal. Finally, the helicopter had stopped and the room was once more white on white, without illumination. More people were leaving. I decided to go as well. I gave Karin a hug before I left and we exchanged numbers. Neither one of us ever called.

Later I saw her Naked Stages performance art work, a beautiful piece that showcased her body in various guises—as a nurse, a red dominatrix, a mysterious figure underwater—and highlighted her struggles with chronic pain. Throughout the piece, she kept her clothes on. (In Bishop's poem, a declaration and a question: *you are one of them. / Why should you be one, too?* And is the "you" her or me?)

Before I left the gallery that night, I stole three pairs of different colored glasses. I wanted to do my best to filter pure white light, scrim, protect and see different colors in the city. I gave two pairs away as gifts.

AUCTION
after Samuel Beckett's "Play Without Words,"
with thanks to Anna Dolan.

<u>Characters</u>
Object / Woman
Woman / Woman
Mirror

No words need be spoken.
North.
Kingston, NY.
We see nothing except an object and a mirror and a box.
(An object sometimes called a woman
 —although we shall see.)
The mirror might help us. It makes a little turn in place.
Before it can do more, a woman strolls into the space.
We know she is a woman by her walk.
The woman strolls into the space,
 stretches her arms up into the sun.
She opens a parasol and makes a little turn in place.
She waits a split second.
The mirror rushes to her as a lap dog, snuzzles against her.
Together they walk,
 the mirror's arms around the waist of the woman,
the woman still holding the parasol.
The woman startles, aghast.
She breaks away from the mirror,
her umbrella still open, but now falling low behind her.
At this point, the mirror starts to, well, mirror her gestures.
The woman starts to bring the umbrella over her head,
decides better of it, closes it, then moves purposefully
 toward the object.
She stops only for a moment to gain her resolve.
She shakes her hair and moves again toward the object.

She prods the object with her umbrella.
The object reveals herself as another woman . . .
well another kind of woman, (a negative mirror, elsewhere).
The one we knew first as the woman
 puts her umbrella down.
Again all of her gestures are mirrored behind her
 by the mirror.
She is horrified, then curious, then has an idea.
She looks very closely at the woman-object.
She stands her up properly.
She looks her up and down again.
She beckons the mirror to come closer.
The woman and the mirror look her up and down.
They are quizzical.
The woman turns the woman object around.
Takes out a pair of surgical gloves to inspect her properly.
The mirror turns away.
The woman examines the small of the back.
The woman measures the crinkliness of her hair.
The woman turns her around to test the capacity
 of her stomach.
The woman tests her to see how far she'll bend.
The woman verifies her scrub position.
The woman slaps her hind quarters.
The woman looks at her child bearing spread.
The woman checks her teeth.
She leaves the object in its last position.
The woman turns the mirror away from her.
The woman claps her hands.
Nothing happens.
The woman claps her hands again and points at the box.
Nothing happens.
The woman claps her hands, points at the box
 and stands the object up.
The object starts to slowly sway.

The woman hits the object across the back
 with an umbrella.
The woman claps her hands, points at the box
 and lifts the umbrella.
The object goes to get the box.
The object carries it to the woman and drops it before her.
They come closer and closer to each other.
For a moment, they are nose to nose, almost a mirror,
 but not quite.
The woman pushes the object up onto the box.
The woman-object stands on the box.
The objecting woman starts to look down on her.
The woman is horrified.
She whistles for the mirror who comes again like a lap dog.
They snuggle together and sit under the object-woman
 at the box as if at a picnic.
The object woman steps down off the box.
She looks both ways and grabs the umbrella.
She hugs it to her like a baby.
The object-woman thinks of leaving the stage.
Thinks better of it.
The object-woman steps back onto the box,
makes the pose of a tree or a Greek statue.
The woman and the mirror move out of their snuggle and
look up at her.
She raises the umbrella up over her head
 like a mighty sword.
She opens it against the sun.

END.

I would have made it painstakingly slow.
I would have made it achingly embodied —
painfully obvious in racial terms,
but it was not my production.

POSTSCRIPT (HANDS ON HANDING OVER)

"Auction" was written in 2005 at Bard College where I was teaching in the Summer Language and Thinking program. My colleague Anna Dolan invited me to bring my class to a session she was doing on playwriting without words. "Auction" was what came out of me.

In 2008, the play was produced in the Bedlam Theater Festival of Ten Minute Plays in Minneapolis. We had a hard time finding a director. There was no real budget and the festival had to accommodate at least twenty different works. It was a labor of community and love. The artistic director and I put in a number of different calls, and the first to respond was a very talented, young white woman. We talked briefly about the work and she told me how excited she was to direct the piece.

I was excited too. I had never seen one of my plays produced before, having had to miss the production of "Body Dander, Dust" in the aftermath of 9/11. Weeks of rehearsal passed and I gave the director free rein. I never peeked to see what she and her actors were up to. To be honest, I was busy developing another work for the festival, a performance art collaboration with Ellen Marie Hinchcliffe based on S. E. Hinton's *The Outsiders* (I was Ponyboy and she was Johnny) and another longer half evening of performance art as well. Along with teaching and work obligations, I didn't have a lot of time. But it was more than that. After doing so much deeply embodied work, it felt like a relief to leave this play in a director's hands. Being hands off could also let me test how well my ideas and language would be interpreted

by someone else, by an intelligent, articulate young white woman. What would happen to the racial dynamics of the play, the gestures toward history?

Due to my crazy performance and work schedule, I didn't see "Auction," on opening night. Preparing for *The Outsiders*, other folks in the theater told me how good it was and congratulated me as the playwright.

Finally, bristling with excitement. I was able to sit down and watch the show. It was spectacular, literally. It was loud, slick and fast. A thick black woman with glasses (good choice), a white woman and a white man in faux nineteenth century clothes with cabaret touches—spangly black tulle, a black top hat. The actors were strong and the vision of the director was vivid.

It wasn't my vision.

In this production, a vocabulary of gestures was established and repeated. What the white woman (Woman/ Woman) and the white man (Mirror) do, the black woman (Object/Woman) ends up doing in reverse and in exchange, so that what starts off as a series of images about a black woman's oppression gets turned into a show of all the characters, all people, oppressing each other, using the same gestures with increasing speed. (A 10-minute arty version of the movie *Crash*?)

This was an interesting experience to say the least.

I had left it to someone else, to interpret the relationship of bodies. Now I was seeing one version of what that meant. It was a play without words, and so it was all about the body—the traces of my body translated into words on the page that were written to be unheard. (A stab at rendering Toni Morrison's "unspeakable things unspoken.") Whatever was there needed to be strong and bright enough to shine through—and had instead become a different kind of light. Audre Lorde reminds us, "The quality of light by which we scrutinize our lives has direct bearing upon the product

which we live..." This director had brought a different quality of light from her different body of experience. The product here aimed toward something deemed more universal, while I had been thinking, albeit abstractly, in specifics: slavery, history, the oppression of black women.

The day after this director agreed to direct the show, an older, more experienced, black woman director called me back. I let her know with some regret that we'd already found someone else. What would have happened if her call had come in just a little earlier or I had given into an overriding black feminist impulse? It's not automatic that her vision would have been identical to mine or that her production would have been better. She too would have worked from her body of experience, although in key ways, this at least, would have likely been closer to mine.

At the end, I thanked the young white woman director for her efforts. She had clearly worked hard. Her production was polished and well done (*I would have made it painstakingly slow, achingly embodied, painfully obvious in racial terms*) and it made me think a lot about writing and interpretation and bodies of experience and racialized vision and what it means to be present and what it means to let things go and how I wouldn't do that so lightly again.

black licorice twists

Brown Skin, Brown Bag

I was responsible at the same time for my body, for my race, for my ancestors. I subjected myself to an objective examination, I discovered my blackness, my ethnic characteristics; and I was battered down by tom-toms, cannibalism, intellectual deficiency, fetishism, racial defects, slave ships, and above all else, above all: "Sho' good eatin'."
—Frantz Fanon, Black Skin, White Masks

(a forum for presentation & a time to eat.)

The black woman (artist) professor lays out lunch . . .

Hey Molly—

I hope your holiday season is happy and not too hectic.

It was a real blessing to see you at Micol's going away benefit. And I'm so excited that you're interested in working with me on a new performance piece.

I'm calling it Mammy and I'm starting now on the conceptualizing and writing. Before I get too far along, I wanted to touch base with you—to make sure you're still interested / available and also to start considering our process.

I'm basically interested in exploring what it means to be a black woman professor in a predominantly white female school: general issues of racialized caretaking and nurturing. What's the boundary between being open, compassionate, helping to make the world a better place and subordinating my own spirit, body, mind, sexuality, presence to white womanhood?

I've been thinking about this a lot because I read Harriet Jacobs and Sojourner Truth and Meridian last semester in my teaching. And also because I'm up for tenure and it's made me think a lot about my work at St. Kate's over the last 6 years.

Anyway, I need a smart white woman performance artist with a malleable and expressive face (i.e. YOU)—to help push me and keep me honest. I want to think about developing an interesting process that would allow us to build trust, ask you to do some things in my work, and also

allow you to have a stake and ask me to do some things as well. What questions might you want to explore about race, gender, caretaking, knowledge? Forced or organic "teaching moments"?

I think this could end up being something really cool and possibly a longer work, etc. but for now I'd like to start small—aim for 10-15 minutes—and see what we can make / do. I hope to show our work in progress at CIA as part of a collaborative showing with friends and guest stars on Thurs. Jan 26 and Fri. Jan 27.

If you're available, I would love to get together sometime on Tuesday 1/17 and / or Wed. 1/18 to do some writing / talking / exercises and then book space in Patrick's on Thursday 1/19 and Friday 1/20 to work in the body and start making the work. (There might be some time later the following week for us to keep working as well, but we'll see how it goes.)

Okay Molly V-A—
What do you say?
Are you in?

Merry Christmas,
Gabrielle

Molly arrives early. She has just finished her shift baking bread, and she exudes the floury heart of the morning. A young white woman with glasses and short sandy blonde hair, she excels at playing the rube, a skill that will come in handy for the piece we will make. We make tea and talk about our lives, what's happening, what and how we are doing. R.S.V.P., the performance event where we will show the work we make, will happen in a week. This will be the first time we come together to work on it. Still we aren't in a hurry. I put beets in tin foil and set them in the oven (most likely the most cooking I've done in weeks). I tell Molly about a long letter I wrote in response to my shrink. I was angry at him for challenging my fearfulness about love. He needs to give me some credit, I say. It's not like I haven't been burned. Molly checks on the beets slow roasting in the oven. The healing heart is the open heart, she says. She tells me about her girlfriend and a great church she's been to and how anything is possible. This energy of exchange became the heart of our work, camaraderie, positivity and an open heart. Also helpful was Molly's great indulgence of me, still in my pajamas, standing in my dusty kitchen, daydreaming about the million things we could do.

HOW'S WORK?

My friend Molly has the perfect combination of attributes for an artist: the wisdom of a sage, the heart of a child, and the sense of humor of a clown. She has directed plays, run an urban youth farm, and developed her own performance art work. We had met in 2002 when we both developed and premiered new performance art through the Naked Stages program. Her work in the series with Margot Bassett had been a complete collaboration from concept to action. "How's Work" was a little more blurry. The concept was mine, and she called it my piece, and yet the work was shared. I offered a construct, and then we made it together.

While "How's Work?" draws directly from my experience as a black woman professor, Molly brought to the table her own experience of whiteness at South High, a racially diverse high school in Minneapolis. She recalled the adulation and ache for connection to blackness that she felt as a teen. That insight led to the starting image of the piece: me in a rocking chair minding my own business with Molly on her knees at me feet, staring up at me adoringly. Molly also helped move the piece into the arena of live music. I was having a love affair with Kathleen Battle at that time (songs from *Honey & Rue*, her collaboration with André Previn show up in two of my pieces from that era, "Berlitz" and "ghost / gesture"). But as we discussed the concepts of black female caretaking, racial appropriation and consumption, I mentioned that "Lift Every Voice and Sing," the so-called Negro National Anthem was one of my favorite songs.

"Let's use it," she said.

"I can write out the lyrics for you," I offered.

"I already know it," she answered. "We used to sing it in my high school choir."

And that revelation was wondrous to me. It showed me the nature of my own assumptions and how much knowledge

a fellow artist can bring into a room if there's room and opportunity for her to share it.

In our work together, Molly was generous, focused and clear. She was able to listen to my pie in the sky ideas with an open ear and greet it all with yes. This didn't mean that she was merely a yes woman: she would immediately say when she thought something didn't work. But the mutual attitude of possibility is the key to successful transfer of ideas and artistic collaboration. Moving from our starting points, we were able to deepen into the piece, clarify the key dynamics, and then start to put the work on its feet. We worked that day and then in a studio space for perhaps another half day before doing the piece at R.S.V.P. Our work time together was relatively short, and yet we were both so grounded in what we were doing, that the piece emerged smooth and clear.

"No wonder they wanted our Mammy's milk. . .
Gabrielle Civil's post-modern depiction of the trials of all
us Mammies of Academe is an historical self-serve leche
league of Black folk. Civil's Mammy production quells
colonizing repetitiveness with a sole stream of fluid from
her left bosom—bare—and she civilizes the current pallid
savage's curiosity to know the Other (us mod-Mammies)
through touch. In this case of performative representation,
this Mammy, Gabrielle, has made 4-year liberal arts white
girls her namesake: Civil."

—LISA ARRASTÍA

HOW'S WORK

1/ a black woman pulls a rocking chair onto the stage.
almost a porch, almost enjoying humming, breeze
her long crème skirt rustling gently below her knees

a white girl kneels at her feet
sings lift every voice and sing in earnest tremolo
snap into history, the song takes its effect
the black woman unties the top of her salmon
glittery shirt, slowly, but slowly pulls out
her breast. squeezes it, prepares it for feeding,
which is to say for the white girl to be fed
once victory is won, she taps her knee
the white girl scrambles up
on her lap, curls up to take
the black breast in her mouth.
 (by then, the audience is in full moon laughter.)

in antebellum voice:
the mammy says:
C'mon girl, drink up.
I got as much as you need.
The mammy rocks her charge
says: *Thaaaaaaaat's it.*
Soon you'll be FAT just like me.

 A beat.

2/ Molly drops from my lap
I get up from the chair—
retuck my breast into my top of the mind
walk around the chair—turn—

 We see each other and hug.

"Molly!" "Hi, Gabrielle."

"How are you?" "Fine."

"How's work?" "It's fine."

 "How's work?"
"Great. "

 How's work?

Well you know, I'm teaching
Literature of Black Education
and International Black Women Writers
and The Reflective Woman
and I'm up for tenure—
and I think I got it, but you're
not supposed to say it and it's fine.

 How's work?

I FUCKING HATE IT. How's work?

 I see my tom toms,
 racial defects and
 "sho god eatin'"

 How's work?

5% of your grade is participation. How's work?

The question of the day. How's work?

Let's take a moment of silence.

 How's work?

{singing}
Sum-mer time and the liv-ing is
eeeeeeazy

How's work?

Fish are jummmmping
(body jumping like a catfish in a pan
arms shimmying from shoulders to wrist
across the floor)
and the cotton is hiiiiigh

3/ The student sits in the chair.
She waves her hand in the air.

Yes, can I help you?

Um, my boyfriend is black—
and he's my boyfriend—well,
my black boyfriend has heard
a lot, well we talk about your
class, could he maybe come
and sit in?

Well your Mama's rich
and your daddy's good looooooooo-king

 The student waves her hand in the air.

Yes.

 I'm studying to be a social
 worker and was wondering,
 what's the most important
 thing about being black?

HUSSHH little children-
 The student waves her hand in the air
 with even more insistence.

You know, I'm kind of doing something here.
Can I help you?

 WILL YOU BE MY ADVISOR?

DON'T YOU CRYYYYYYYYY!

 The black woman professor arrives to class

Welcome class, it's an honor to serve
as your professor this semester.
Glad to see you class, I'm so excited
that we can both be here today.
Great to be here class, I'm excited
about all I can teach you and all
you can teach me. Fin.

onion skin

and they just need and need and need and need and need and
need and need and need and need and need and need and need
and need and need and need and need and need and need and
need and need and need and need and need and need and need
and need and need and need and need and need and need and
need and need and need and need and need and need and need
and need and need and need and need and need and need and
need and need and need and need and need and need and need
and need and need and need and need and need and need and
need and need and need and need and need and need and need
and need and need and need and need and need and need and
need and need and need and need and need and need and need
and need and need and need and need and need and need and
need and need and need and need and need and need and need
and need and need and need and need and need and need and
need and need and need and need and need and need and need
and need and need and need and need and need and need and
need and need and need and need and need and need and need
and need and need and need and need and need and need and
need and need and need and need and need and need and need
and need and need and need and need and need and need and
need and need and need and need and need and need and need
and need and need and need and need and need and need and
need and need and need and need and need and need and need
and need and need and need and need and need and need and
need and need and need and need and need and need and need
and need and need and need and need and need and need and
need and need and need and need and need and need and need
and need and need and need and need and need and need and
need and need and need and need and need and need and need
and need and need and need and need and need and need and
need and need and need and need and need and need and need
and need and need and need and need and need and need and
need and need and need and need and need and need and need

and need and need and need and need and need and need and
need and need and need and need and need and need and need
and need and need and need and need and need and need and
need and need and need and need and need and need and need
and need and need and need and need and need and need and
need and need and need and need and need and need and need
and need and need and need and need and need and need and
need and need and need and need and need and need and need
and need and need and need and need and need and need and
need and need and need and need and need and need and need
and need and need and need and need and need and need and
need and need and need and need and need and need and need
and need and need and need and need and need and need and
need and need and need and need and need and need and need
and need and need and need and need and need and need and
need and need and need and need and need and need and need
and need and need and need and need and need and need and
need and need and need and need and need and need and need
and need and need and need and need and need and need and
need and need and need and need and need and need and need
and need and need and need and need and need and need and
need and need and need and need and need and need and need
and need and need and need and need and need and need and
need and need and need and need and need and need and need
and need and need and need and need and need and need and
need and need and need and need and need and need and need
and need and need and need and need and need and need and
need and need and need and need and need and need and need
and need and need and need and need and need and need and
need and need and need and need and need and need and need
and need and need and need and need and need and need and
need and need and need and need and need and need and need

pencil shavings

"In the fall of 2006, Gabrielle's visit to Mt. Holyoke began with a guest lecture in my class. My students and I were discussing Suzan-Lori Parks... Gabrielle arrived wearing a zebra-print dress with a plunging neckline and her favorite red Chanel lipstick. The students were intrigued, as they always are when they see someone else like me—someone who doesn't 'look like a professor.'

They immediately responded to Gabrielle's request for several volunteers to stand on top of their desks. Gabrielle then led us through an exercise in perspective whereby the students who were seated were forced to observe and comment upon those who were now up on display. Afterwards, Gabrielle asked the students to describe the experience of watching and being watched; many expressed discomfort, but one or two young women admitted they enjoyed being the center of attention.

Later that day, in a much more intimate space in the Theatre Department, Gabrielle reproduced the exercise but with a twist. After saying just a few words—Gabrielle took off her dress and mounted the low, round coffee table around which the attendees were seated. Behind her, on a flat-screen TV, scrolled a definition of the word 'display.' My white male colleague, Roger, stood in a corner of the room and called out, 'Step right up, step right up!' and then every thirty seconds he barked, 'TURN!' Gabrielle immediately obeyed his order, assuming another position in her black bra and panties until the performance ended three minutes later. Roger said, 'Next!' and then sat down. Gabrielle stepped down from the table, pulled her dress over her head, took up her notes, and led us through a discussion of Saartjie Baartman, Adrian Piper, and her own work as a black woman performance artist.

I remember feeling a number of emotions during my friend's provocative presentation. I was then, and continue to be, awed by Gabrielle's intellectual and artistic audacity. Yet I must confess that there have been many times when I've been tempted to throw a blanket over my friend and drag her from public view."

— ZETTA ELLIOTT

DISPLAYS (AFTER VENUS)

a black woman arrives
at an advertised academic talk
at a white woman's college.
she is wearing a long zebra print halter
dress over jeans
there is only one white man in the room.

he says
step right up.

she pulls down her jeans
unties the zebra halter dress
and throws it aside.
she stands up on a table
in black high waisted underpants
and a black brassiere
then just standing
her body, on display.
words scroll behind her
but does anyone see them?

turn.

at each instruction
she strikes a pose.

turn.

body builder
figure model.

next.

gorilla.
video ho.

turn.

she steps down.
the talk begins.

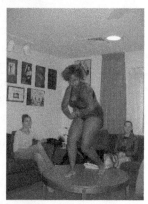

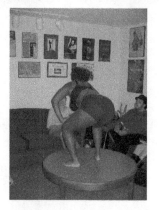

charcoal

Truth burns up error – Sojourner Truth, circa 1882

chicken bones

TO VENUS AND BACK

THE CHORUS OF THE COURT.
One more question, Girl, uh:
Have you ever been indecent?

> THE VENUS.
> (Rest.)
> "Indecent?"

"THE CHORUS OF THE COURT.
Nasty.

> THE VENUS.
> Never.
> No. I am just me.

THE CHORUS OF THE COURT.
"What's that supposed to mean?!?!

> THE VENUS.
> To hide your shame is evil.
> I show mine. Would you like to see?

—from *Venus*, Suzan-Lori Parks (1996)

Sometimes I wonder what Celie Mae would have thought of all this? The shiny pictures of Janet Jackson in dental floss on the cover of every magazine, Condoleezza on CNN, Lil Kim on *Count down to Lockdown*, Kara Walker's daguerreotype in-your-face silhouettes. What she would think of me, her granddaughter, a poet with a Ph.D., a tenured professor at a women's college, the first black one in its history, who routinely exhibits her own body in various guises in public all in the name of *performance art*? "You should be *ashamed* of yourself!" she might say. Or maybe she'd call me a *fallen woman*. And maybe I am. Maybe there's no way around it. In the eyes of the world, I was always already fallen as black woman from the moment we got off the boat... in fact, from before the boat was built. Still

that would have been no excuse for my grandmother. That would have been her whole rationale. As a black woman, one's body—and more importantly the *image* of that body, must needs be safeguarded at all costs. After everything, how could you let yourself be *seen*? Since when is it right to have your body on display?

These were the key questions of my three-minute performance "Displays after Venus," a body art piece that attempted to link literary and visual culture for students and faculty at Mt. Holyoke College. The second half of my November 2006 two-part presentation "displays: black women, experiments, performance and the body," the performance responded directly to three main things: first, the actual story of Saartjie Baartman, the so-called "Venus Hottentot;" second, Suzan-Lori Parks' 1996 play *Venus*; and third, my own trajectory as a black woman poet and performance artist. Engaging and intersecting these three imperatives, it became clear to me that the major link between visual and literary culture is always the image. And for black women's art and culture, the specific image is that of the black woman's body on display.

Exhibit A. The so-called "Venus Hottentot"

Looking at an image of Saartjie Baartman, the famous, so-called "Venus Hottentot," these questions again come to mind. Offering one of the most notorious incidents of a black woman on display, her story also helps point to key links between visual and literary culture, the problematics of my own work and black women's body art overall. A famous figure in diasporic black studies, her case has been invoked in literature, history, anthropology and art. Still, if you don't know the story, here it goes.

Curtain up. In 1789, ship doctor William Dunlop convinced young Saartje Baartman to leave Africa and come to London. Once arrived, she was installed as an attraction in freak shows due to her large buttocks and genitalia—and of course the fact that she was a black woman. She toured in this way in England and later in France where the scientist Georges Cuvier got in on the act. As a part of the larger 18th century experiment in "Enlightenment" and Western scientific "humanism," Cuvier poked, prodded and measured her endlessly. At her death in 1815 at the age of 25, he pickled her brain and genitals as scientific curiosities where they remained on exhibit at the Musée de l'Homme in Paris for the next 160 years until 1974. Finally, in 2002, the South African government successfully pressed for the return of her remains. *Fin.*

Again, as feminist scholars such as Coco Fusco, Paula Giddings and bell hooks have discussed, the body of the black woman was designated as the ultimate Other in order to codify a normative "I" as white, Western, Christian and in its highest order male. This "I" is inseparable from the "eye" of sight, the gaze, which turns the Other into a site or dislocation. From the moment, Saartje Baartman stepped foot in Europe, she was an endless object of attention for European audiences, scientists and doctors. Law, science, medicine, anthropology, business, art and entertainment all colluded to use her black woman's body on display in order

to construct and reinforce white supremacy, civilization, subjectivity and power.

Interestingly though, Baartman's live body on display functioned in incredibly contradictory ways in the white world. For example, her moniker "Venus Hottentot," simultaneously denied and deified her as an object of desire. Even though the name Venus, an allusion to the classical Roman goddess of love and beauty, was meant to be ironic, the level of attraction that these audiences had for her body was real and actualized. Deemed unattractive, she was an attraction, an exotic titillation. She served as a muse for poems and songs. And while she was officially disregarded as a woman, she was, by all accounts, actively regarded, discussed, and sexually molested by white spectators, audience members, scientists, writers, physicians.

As a black woman performance artist who necessarily has had to come to terms with the spectacle of my own body: I wonder: What kind of authority did she have over her body? How did she move? What made Saartje Baartman decide to come to Europe in the first place? Did she feel shame? Did she feel resignation? What were the parameters of her agency over her body, over her life? In the 26 years that she lived in Europe, was there no way that she could go back home? How did she tell the story of what was happening to herself? Did she see herself as a freak, as a captive, or as some kind of "performance artist?" Was she somehow assimilated into her role as Other? Did she merely lack any other options? And to what extent was she—or are any of us—complicit in our own exploitation?

Exhibit B. Word as Flesh: Suzan-Lori Parks' *Venus*

The subject of literary treatment in her own time, Baartman's story continues to have potent power for African American women's literature in all genre. Elizabeth Alexander's "The Venus Hottentot" (the title poem of her 1990 collection), Barbara Chase Riboud's 2003 historical novel *Venus Hottentot* and Suzan-Lori Parks' 1995 play *Venus* are but three examples. Parks' play, though, especially raises intriguing questions relative to contemporary black women's body art. When the Chorus of the Court (a satirical representation of the English judicial system) asks "If she's ever been nasty," The Venus responds "Never, I'm just me." This line speaks again to the implicit indecency of a black woman's body. When pressed, Parks' character adds an interesting nuance: "To hide your shame is evil. I show mine. Would you like to see?"

The logic of this three-line speech is worth rehearsing. The first line about hiding shame speaks to the Christian idea—especially prevalent in nineteenth century Europe—that it was necessary to admit or confess one's innate shame as a human being—a descendant of Adam (deceived by Eve, the original fallen woman). The twist is, of course, that *she*

is their shame. And because of the Western Christian need to exhibit this shame, ostensibly to ask forgiveness and repent, it is necessary for her to be on display in this way. The line can be read in the opposite way though, in the sense that turns shame against itself. "To hide your shame is evil" can become a subversive rebuke to a Western legal and judicial system (the Chorus of the Courts). The line can suggest Western complicity in Venus' exploitation—and that any attempt to deny this complicity ("To hide your shame") would be "evil." Finally, the line can also be read as an indictment of sexual repression, a call for sexual and corporeal liberation.

The next line is similarly complex: "I show mine." What is she showing? Grammatically, it's shame, but in her unapologetic statement about her body, the Venus seems shameless, turning shame inside out. Instead, the "mine" that she's showing is her body, the black woman's body on display. And in the world of the play—and perhaps in the world at large—that body is always already shameful . . . Still the gesture of claiming this display not as evil, but as the counterpoint of evil, is compelling.

Her third and final line is the most important for the practicing artist: "Do you want to see?" Here the character of the Venus offers an invitation to the system, offers herself as experiment, as agent of practice. It's impossible to know whether the real Saartjie Baartman saw her display in this way—but Parks' description resonates in part with the logic of my own display. It's wrong to hide one's shame—the historical reality of black women's exploitation. We need to claim it, explore it, understand it—just as we need to claim, know and understand our own bodies. Because of our history, this raises new questions about the relationship between public and private. The offer to see one's shame, to see one's body becomes a public display of private intimacy— a scenario especially prevalent in the performance art form.

Exhibit C. Food for the Spirit

The blur between public and private has been a major theme in the work of one of my heroes, black feminist conceptual and performance artist Adrian Piper. A trailblazer in the art world, she is also a distinguished professor of Philosophy and has worked extensively against racism, sexism and xenophobia in the art world. The image above is documentation of one of her early works, the 1971 private performance *Food for the Spirit*. For this piece, Piper was in an ecstatic phase of her life, discovering the work of German moral philosopher Immanuel Kant and reading him so feverishly she was almost forgetting to eat. So during the period of the piece, she read philosophy, meditated, and took pictures of herself every day to document that she was still alive.

I love this piece—the fact that she has the authority over her own body, that reading became a mechanism for a kind of transportation of the self, that she holds the photograph in her own hand. In that way, the work is oppositional to Western white notions of black women as forever subject to only the white gaze, or as being only body as opposed to mind. This also offers a powerful counterpoint to the

situation of the "Venus Hottentot." Rather than documentu ing and enacting a process of objectification, the image above seems to document and enact *subjectification*. Piper's insistence on the body is literally and metaphysically a *reflection*. She is not just being seen, she is seeing herself and thinking about her own image. The image above, more than just an image of her body, is a kind of reminder to the artist that she even has a body. That she is not just a mind and that she can't just live or exist on ideas alone. In this way, the artist is insisting on embodiment, in subtle resistance to the force of Western European philosophy. At the same time, the image suggests the allure and assimilative power of those powers. The idea of "food for the spirit" suggests that ideas can be more nourishing and important than "food for the body." And in fact, the body can become so negligible that the artist forgets to eat. The work has an ascetic quality that perhaps reinforces the hierarchy of mind over body, even as it attempts to repress it.

Still, the idea of the black woman as a mind and not just a body is profoundly radical in the history of Western thought. The "Venus Hottentot" was exalted not for her intellectual powers, but for her prodigious posterior. Moreover, when her brain was preserved, it was to highlight its supposed inferiority (as opposed to its capacity to imagine another way of being in the world—which clearly this brain had done.) Piper's body here is less object than subject to a process of self-documentation and self-understanding, a process of being in the body, seeing oneself in that body, thinking about one's image, and recording via photographs and writing her own embodied experience.

While scholars such as Maurice Berger and Audrey Nicoll have discussed the power and provocation of Piper's bodyworks like *Food for the Spirit*, none of them have raised what for me is a major aspect of the image above. When we look at the work, we can see everything that I've mentioned,

all of the counterpoints to the "Venus Hottentot" in authority and intellectual presentation. We also see literally, we see her, the black woman performance artist, as young, light skinned, thin and conventionally beautiful.

What would it be like if she were fat and coal black, I wonder? The most well-known women performance artists —and I love them, but I have to go here—the most well-known women performance artists—Marina Abramović, Sophie Calle, Karen Finley—even the ones of color like Adrian Piper, Ana Mendieta, Yoko Ono, Coco Fusco —are thin, light and conventionally pretty. (*Dreamgirls*, anyone?) Would it be less art then, if the body in performance wasn't deemed aesthetically pleasing? What would have happened if a fat black woman had smeared chocolate all over her body instead of Karen Finley? Or had her clothes cut from her snip by snip instead of Yoko Ono? Or stood with an arrow strung ready to pierce her heart instead of Marina Abramovic? When we read the body on display as a part of critical analysis, we have to read the specific body—the same way that we do in real life. Because while academic criticism may attempt to address race and gender at the same time, it doesn't always accommodate for more specific aspects of body like skin color, size and shape. Even while discussing race, gender, class and sexuality, these specific aspects of the body on display are the most active parts of black women's conversations about ourselves, our understanding about our bodies, their associations, expectations and interpretations. (Flash back to my pediatrician sister as the only black woman with straightened hair at the writer's conference.)

**Exhibit D. from "Displays (after Venus)"
(Would You Like to See?)**

The so-called "Venus Hottentot," Suzan-Lori Parks' character of "The Venus" and the specter of Adrian Piper's image from *Food for the Spirit* all greatly informed my piece "Displays (after Venus). The work was very short and very simple. The audience arrived expecting a conventional academic lecture or artist talk. They sat in chairs around a small table in an informal conference room and chatted with me wearing a zebra-print sundress and black sweater over jeans. Dr. Zetta Elliott, Visiting Assistant Professor of African American and African Studies at Mt. Holyoke and the friend who helped arrange my residency gave a brief, conventional academic introduction. Then the piece started when Roger Babb, a Professor of Theater (the other co-sponsor of my residency), and the only white man in the room, said the words "Step Right Up!"

At that moment, I slid off my jeans, my exotic dress and black sweater, and stood on a small table in my bra and underpants. A running series of projections with definitions of the word "display" started to scroll in the background. I struck a pose and held it. Then when Roger said "Turn," I

175

turned on the table, struck and held another one. Roger, as Barker, bid me turn 4 times and in that way, each person in the audience had a front, side and back view of my body. The piece ended when he said "Next!" and I got down from the table, slid back on my jeans, dress and sweater and forwarded to the next slide—an image of the "Venus Hottentot" with the title of my talk "Displays: black women, body, performance, experiments" and my name and title, Gabrielle Civil, Ph.D.

Clearly, the crowd needed to process all of this. A couple Theater professors and a professor of Women's Studies were there along with students from diverse backgrounds. All women except for Roger. What did it feel like to look at me? What did you see? The responses were very telling. The professors felt I was so comfortable in my body that they could feel comfortable. The younger women were far more uncomfortable and concerned. One older black student told me that when I took off my clothes and stood on the table, she felt overwhelmed with shame.

"Why?" I asked?

"Because I felt like it was me up there with you."

"Were you ashamed of me? That I would do such a thing?" I asked her.

"It wasn't that. It wasn't about you. It was thinking about it being me... And how much shame I would feel."

Exhibit E. To Venus and Back — at Mt. Holyoke after "Displays"

The power of identification is very strong in art and so is the power of alienation. The experience of the "Displays (after Venus)" depended not only on your level of identification or alienation with my disrobed body in the room, but also with your own body as well. The black woman student who experienced shame told a story about living in a big Southern city (maybe Memphis or Biloxi, I can't recall) and having a white co-worker suggest that she come to their Halloween party as the "Venus Hottentot."

My friend Zetta, herself a thin, conventionally pretty, light-skinned biracial black woman squirmed throughout the whole performance. Although she calld the performance brilliant, she confessed she almost couldn't bear to watch me. As I was packing my things after the performance, the artist talk and Q & A, she confessed that she feared for me.

"I look at your work, the different performances you've done and I fear that something will happen to you. That you'll put yourself out there—and that people will see you and think—that something will happen to you." The unspeakable. Zetta K. is a scholar of the unspeakable, specializing in black women and violence, lynching and

assault. In her work, the black woman's body is always already a provocation, an invitation for abuse. For her, to flaunt the body is to court personal annihilation.

"Who knows what will happen," I responded. "It's hard to say. But at least I know that if something goes down where I'll never be able to do this work again, I can at least say that at some time in my life, I had a relationship with my body where I wasn't afraid to show it, to use it, to claim it—fearlessly."

+ + +

"Displays (after Venus)" took place just a couple months ago. The work is fresh in my mind and I have to say that I'm proud of it. It was risky what I did—taking off my clothes at a professional talk. (Although it likely would have been worse at a co-ed or men's college.) Still those three minutes of looking at my body did more to evoke the complex dynamics of Saartjie Baartman's experience and Parks' text than anything else ever could.

Only three minutes long, the performance also highlights some of the specific aspects of my artistic style: the links to pedagogy and black women's cultural history; the links to literature; the activation of a particular place—in this case a classroom; the overlap of voices—that of the Barker / Professor who keeps the time, my own silent voice and the gasps or whispers of the audience; the use of language— in this case the scrolling definitions of the word *display*, projected on the wall but in other instances typed on the spot, given out as cards, written in chalk—and finally the exhibition of my own body.

This corporeal exhibition has not always been fearless. I've often been afraid, tentative, fretful, avoiding—but of course, there is another part of me. The part that feels neglect and invisibility in the world and wants to be more

in your face. In my development as a performance artist, I've had to deal with these sensations—and more. And the form has emerged as a gift in my life, strengthening necessarily my relationship to my own body. It's true, I am much more fearless, but mostly due to the artistic urgency I feel to represent, enact and document new presentations and representations of my black woman's body in language, image, art and life.

It's funny though. For years, I thought of myself as a mind person—an intellectual, a brain. (Another reason why Piper is so compelling to me.) In school, in writing, my mind was on display. I wasn't ashamed of my body and have always liked colorful, flirty clothes. But I often would have a frisson of surprise looking into a mirror: Is that me? That black girl with the big eyes, frizzy hair, pendulous boobs, the expanding waist line? Is that me? The dreams that I had, the life I wanted to lead, the things I wanted to do, the loves I wanted to have, the poems I wanted to write—I had never seen a person who looked like me have those things. And I wasn't the only one. Often others were surprised to meet me when they heard my voice over the phone or put me together with some of my ideas. This wasn't necessarily just about being a black woman. I'm talking about being a dark skinned, size 14-16 black woman. Is that the projected image of an intellectual that you know? Or an artist? In fact, how many performance artists do you know who look like that? (Certainly not Piper, Mendieta, Fusco, Ono, Finley, Antoni, etc....)

My performance art work arrives at the intersection of conceptual art, installation and most importantly poetry; and, in this way, my journey to the practice is quite unusual. When I started making performance art pieces, I wasn't an athlete or routine yogini. And other than dancing in clubs and parties—which I have always loved to do—I didn't routinely take dance classes. I was completely untrained

in any body practice and in some ways unprepared for the work ahead. Still as a poet, a person, a black woman living in Minnesota, it was necessary for me to reckon with my body and performance art became an aesthetic means to do so. A work like "Displays (after Venus)" showcases that perpetual reckoning as well as my increased performance skill.

The ability to be fully present, fully in the body—is the fundamental hallmark of good performance—whether in performance art or theater or debate or anything else. Over the last several years, I have often asked: What does it mean to have a body, to be in one? What does it mean for me to have this body, to be in this body for itself? This remains a big fish, a *rippling wound*, to swallow: to be fully present, conscious, deliberate, aware in performance—public and private. To acknowledge and claim the past of black women's exploitation while allowing for the liberty and possibility of my own. What I said to Zetta reflects my desire to enjoy, play, provoke, make art with my body, to claim comfort and pain—despite, through and because of having my particular black woman's body in this particular world.

Indeed, the particularity of my body is the strength and specificity of my performance work and the key to the form itself. Many compelling scholarly definitions of performance art exist but my favorite comes from acclaimed practitioner Guillermo Gómez-Peña. In his 2003 essay, "In Defense of Performance Art," he writes:

> "[P]erformance art is . . . neither acting nor spoken word poetry. . . . We theorize about art, politics and culture, but where academic theorists have binoculars, we have radar. We chronicle our times but, unlike journalists or social commentators, our accounts are non-narrative and poly-vocal. [. . .] [O]ur main artworks are our bodies, ridden with semiotic, political, ethnographic, cartographic and mythical implications.

. . .We are what others aren't, say what others don't,
and occupy cultural spaces that are often overlooked or
dismissed."

To expose, engage and embrace my body with its "semiotic,
political, ethnographic, cartographic and mythical
implications" was a main aim of "Displays (after Venus);"
it is a main aim for making work in a world that exalts the
Venuses and exploits and exoticizes the "Venus Hottentots."

I don't know what my grandmother would have thought
of "Display (after Venus)" (although I can guess) or even
much of how she thought about her own body. I know that
she wore bright dresses and lipstick and had her name sewn
in red thread on the inside lining of her coat. I also know that
her collars went straight up to the neck and her dresses past
her knees. I also know a couple weeks after my residency at
Mt. Holyoke, the older black student who felt overwhelming
shame at my talk had a breakdown. She talked about
recovering repressed memories of sexual assualt. The local
police who found her wandering in a parking lot believed
she was delusional. She had to take a medical leave from
school.

My sadness at this story reinforces my sense that black
women need to deal differently with their bodies, that art
is a powerful force, and that my performances have been
for me a saving grace. I know the unspeakable danger of
black women's alienation from our bodies, our sense of
ourselves as being disconnected, unknown, disembodied,
ashamed. I look at pictures of Saartjie and Parks' *Venus* in
production; Piper and me in performance; my students,
my grandmother, and BET. I look in the mirror, aware of
the multiple frameworks in which I'm trying to intervene.
I send blessings and strength to that black woman student
and pray that she can find her way out of shame and into
her body. I offer to her and to the rest of us: my work,

imperfect, emerging, my mind and my heart, as generation and regeneration. To Venus and back: at the end of the orbit, when we round our way home, all we have left is this: this body, word and flesh, a corpus of writing, a birthday suit.

yes i'd be happy to

yes i'd be happy to

yes i'd be happy to

yes i'd be happy to

yes i'd be happy to

yes i'd be happy to

yes i'd be happy to

yes i'd be happy to

chalk

artistic inspirations: glenn ligon, adrian piper, frantz fanon's *black skin, white masks*, fred wilson & mona hatoum.

"Brown Skin, Brown Bag" was inspired by the practice of the brown bag lecture as a forum for presentation & a time to eat. It was a simple installation consisting of five brown paper sleeves, about two inches wider and significantly shallower than brown paper lunch bags. On these sleeves were printed: a Fanon quote, a phrase attributed to Sojourner Truth, the repeated phrase "and they just need and need and need," white chalk markings, and a name tag from my home institution with a tiny sticker photo of my face beneath it. Inside each bag was a specific element: black licorice twists, pencil shavings, onion skin, charcoal and powdered sugar. Above each bag laid out on the table were sections of cut grocery bags. These bags were cut five and a quarter inches down, about two inches lower than the bottom of their handles. On the front of the bag you could see the instructions "Please hold both handles" and an arrow pointing up. Below that, the insignia of the grocery store "**rainbow foods®** **the *friendliest* store in town**" (I'm sure Pope.L would be proud). Due to its cut, this larger brown bag was impossible to fill, while the smaller brown one was full of material. Next to this were headphones connected to a black shoebox tape recorder with the cheerful message: "Yes, I'll be happy to... Yes, I'll be happy to..." looping into infinity.

Conceived as a rumination on the experience of being a black academic, "Brown Skin, Brown Bag" premiered at a Teaching Learning Network conference at my institution on "Making Transformation Visible." How visible was my transformation? In the midst of the panels, a few colleagues looked at my work and signed a comment book. Most people walked by it without realizing it was there. At one

point, one of my few fellow black women colleagues actually set a bunch of hand-outs on top of it. "That's my art!" I said. "Oh, I'm sorry," she said. "I couldn't tell." Apparently, my transformation wasn't made visible enough. Still they were there, my brown bags, my brown skin. And unlike my 25 Targets, I have the originals of this artwork still. The work lives as a reminder, at least to myself, that I can materialize my presence in poetic ways. As a black woman artist and teacher, that I can transform and preserve my experience.

KINDS OF PERFORMANCE OBJECTS I'VE BEEN

after Adrian Piper's "Kind of Performing Objects I Have Been: Notes for Rosemary Mayer's "Performance and Experience"

1. younger sister, the charmer ("she's got the looks, I've got personality"), the goldbricker, pretending to sleep so as not to have to wake up and help with housework—and once laying it on thick with fake snores and hearing my sister say, "Mom, she's making these weird noises—something must be wrong with her."

2. Francine the Frog in pre-school, and I was so excited because "My name is Gabrielle Francine!" I got to wear a green leotard and tights and my godmother made me amazing green pom poms for my hair, perhaps my first time on stage

3. the real Harriet Tubman (in pre-school or kindergarten?)—my first lesson in simulacra (or perhaps authenticity)—that there could be three Harriet Tubmans in competition but only one was the "real one" (and that got to be me)

4. winner of the kindergarten reading contest (105 books), I still cherish the certificate with its black and white cartoon of a hen reading a book

5. "Gabby Civil"—this natural nickname, jaunty, unthinking until I reached for more dignity – my last name, "pronounced like the Cadillac, spelled like the war"

6. a talker, my Uncle says, what always made me different from the rest of the family, my asking questions, wanting to tell and hear stories

7. "skipped the first grade, have a late birthday," always the youngest girl in the class

8. singing "Good Night Donna Jean" with my mother while she played the piano and also "Balloons" which was written by Ollie McFarland, a woman my mother knew who had put together a music book called *Afro-America Sings* and whose grandson was in my class

9. "Mrs. Civil's daughter," being the daughter of the assistant principal in the second and third grade

10. a student in public school, a student in private school, a college student, a graduate student—each with its expectations and actions of achievement, reading, writing, speaking, class participation

11. being one of the few black kids in "Track One" at Shrine school and how when I came to there from Detroit public school, Sister Patricia Marie, the old, mean, white principal, wanted to put me in "Track Two"—i.e. contested in intelligence (a relatively rare but powerful experience that did recur later at Michigan when the head of the Honors College told me how pleasantly surprised she was at how well I was doing seeing as they only took me due to affirmative action—despite my strong high school grades)

12. black in America

13. a Catholic-school girl—from grades four through eight in a dark green plaid skirt with yellow and red stripes and then later from grades nine through twelve in a lighter green plaid skirt with yellow and blue stripes—why today I never wear plaid (or even argyle)

14. made to sit in the farthest back corner of Miss Losevic' seventh grade class and forced to walk across the room to make a comment because she couldn't hear me, feeling on display, silenced and miserable, never wanting to raise my hand

15. one of the last 15 spellers in the eighth grade spelling bee—which still meant winning nothing

16. a black girl at a white all-girl's high school

17. the only black girl in the Honors class

18. socially successful, not popular (which required looks, money, boys and, most likely, whiteness) cheerful and happy with school friends and Detroit friends; Class Secretary, Second Vice President of the class and of the National French Honors Society, a speaker at the National Honors Society induction ceremony where my theme was "you can't trust anyone but yourself"—this arrived after Senior

Year betrayals (a girl saying I didn't deserve my scholarship to Michigan because it came from affirmative action and she had had more trouble with Polish jokes than I had being black)

19. an activist (going to the Principal St. Mary Margaret O'Hara, a Grey Nun, and demanding to go into the class where the prior comment had been made and making a speech about the black experience)

20. a loner, eating lunch in the library alone for most of the rest of the year (*oh how heavy the crown...*)

21. voted "Most Likely to Succeed"

22. a girl who wore glasses, never called four-eyes, but to this day afraid of my eyes failing

23. a girl who stopped wearing glasses and now is often called a woman with big eyes

24. disembodied, a book worm, a daydreamer, a nerd, a brain

25. an overachiever (went to high school at twelve, graduated at sixteen, graduated college at 20, had a Ph.D. at 25)

26. a black girl in 1980s Detroit, which is to say always in a preliminary state of teenage pregnancy ("books vs. boys")

27. Señor Civil's daughter, the daughter of the French and Spanish teacher at the all-boy's high school next door (how one of his old students, now rich in a long cashmere coat spied me in an airport and asked questions about me and my sister, nodding as if checking off some prior speculations about who we would be)

28. a non-Catholic in Catholic School, for many years going to church twice a week—once to mass at school and the second time at our Congregational Church with my mother and sister

29. a believer in prayer, in Jesus (although my friend Mankwe says my version of Jesus is "more like a weary Ogún")

30. native informant, Oreo cookie

31. the big girl in the tutu in the center of the dance recital—this was outside school, still in the elementary years, at a place on Livernois, which is to say black Detroit. At one point I didn't do the step just to see what would happen. Would the dance continue? How would it feel to be not dancing when others are dancing?

32. The first one on the dance floor, the life of the party

33. The girl who lay on the bed with the coats at the party

34. The girl who sat in a corner and didn't socialize with anyone else at Alicia Lupo's birthday party in ninth grade, the second one I went to in Ann Arbor, where everyone was hip and cool and white

35. a person of double consciousness, a person also of split consciousness, living in two worlds, the one at home and the one at school, feeling different bodies in different places

36. intellectual race dissident, young adult race complainer

37. diasporic, black hybrid, daughter of an African-American mother and a Haitian father

38. non-Kreyòl speaking / wannabe Haitian-American

39. a girl who had to boil an egg and pour her father glasses of milk and juice each morning for him before he went to work

40. black feminist (and proud of it), proponent of gender rights, human rights

41. a citizen of Detroit, and an apologist for it at my Catholic all girls Suburban high school where the Mother's Club refused to have the prom in the city

42. girl who didn't go to the prom, who went instead to hear Mary Helen Washington read from *Invented Lives: Narratives of Black Women 1860-1960* at Marygrove College (making lemonade from lemons)

43. a black girl at the mall wearing woven knitted leggings and hearing a guy call out and start singing "Fishnets/ black panty hose" by the Time

44. a sheltered girl, relatively isolated from men, who had a string of deepening crushes that took place only in her head, in the tinglings of her body

45. a girl who went to a homecoming dance with a guy and was steered around the room, my date's hand never leaving my wrist, a show pony, a poodle

46. a participant in Susan Lupo's drama workshops the two summers before high school, where I first heard Rickie Lee Jones' "The Unsigned Painting" and Kate Bush's "Under Ice" and performed original monologues (the first one about my godsister tying me to a tree when I was a kid)

47. a slam judge one time, picked at the door by Bob Holman at the NuYorican Poet's Café (who when I gave a low score to a callow poem accused me of being a "Heaney lover")

48. polylglot—a lover and speaker of languages, a student of French—and the way French deepened in my year abroad in Aix-en-Provence, France; a student of Kreyól, and the shame I feel when my language is so poor; a student of Spanish—and the funny mistakes I still make my in Mexico

49. "doesn't embarrass easily," what my godsister once said about me (I'm not sure she thought it was a compliment)

50. seemingly straight girlfriend of lots of cool queer people, poets, writers, artists, pals—"fag hag," (although I hate this term), ally, supporter and sidekick to their first visits to the bar, wondering about my own sexuality, living vicariously through their angst and exploits

51. a New Yorker, wearing snug boot-cut black pants, or purple pleather, with a shiny bag from Canal Street, walking around, taking the subway

52. a visiting intellectual worker, a temp, editorial assistant in New Mexico, dissertation fellow in Ohio

53. invisible/ hyper-visible in snowy Minnesota

54. New World ghost in Africa

55. *morenita, negra mujer de color* in Mexico

56. traveler, desirous of seeing the world (Trinidad, Montreal, Iceland, Senegal, Spain, more . . .)

57. black woman professor at a predominantly white women's college

58. "Teacher of the Year"

59. poet, sharing work, then later organizing readings, first in College and then later in New York, poetry circles in Minneapolis

60. scholar, academic, presenter at conferences (always wanting to make this more dynamic, find a way to circulate ideas in new ways)

61. performance artist, conceptual artist, body artist, playing with objects, video, material and the body

62. "and my sexual growth and development as a woman which all women know about"-Adrian Piper, "Kinds of Performance Objects I've Been"

"In touch with the erotic, I become less willing to accept powerlessness, or those other supplied states of being which are not native to me, such as resignation, despair, self-effacement, depression, self-denial."
-Audre Lorde, The Uses of the Erotic: The Erotic as Power

Cotton Candy on a Rainy Day
The Dream of a Common Language
Exits and Entrances
Collected Poems Edna St. Vincent Millay
Loose Woman
My Wicked Wicked Ways
Troubadour Lyrics
Desiring Discourse
Performing Virginity and Testing Chastity
in the Middle
Ages Cleanness: Structure & Meaning
Uncontainable Romanticism
Expecting
A Baby in his Box
Her Baby's Father

White Lies
Lost in My Dreams
Walt Whitman
Memoirs of a Beatnik
Paris When It's Naked
Nappy Edges
Closet Space
The Politics of Sexual Myth
Sex and Single Girls
Heterosexuality
The Art of Love
Angel of Desire
Nora Roberts' *Irish Rebel*
The Judge and The Gypsy
Hot Rain
Where the Island Sleeps Like a Wing
for colored girls who have
considered suicide /
when the rainbow is enuf

A Doctor in Her stocking
Passion's Treasure
Beth and the Bachelor
Surprise Delivery
The Soft Touch
Starlight
The Elusive Flame
Petals on the River
A Season Beyond a Kiss
Danielle Steel's *Secrets*
Danielle Steel's *Wanderlust*
Danielle Steel's *Zoya*
A Stranger's Love
One Intimate Night
Enticed
The Latin Affair
The Rancher & The Nanny
Sealed with a Kiss
The Women & the Men
Solitudes Crowded with Loneliness
e.e. cummings *Complete Poems*

Vice
Tug
Spells of a Voodoo Doll
Love's Instruments
Hand Dance
Pink Ladies in the Afternoon
Menacing Virgins
Feeding on Infinity
Gender Roles & Sexuality in Victorian
Literature
The Current of Romantic Passions
Courtly Contradictions
The Playboy's Own Miss Prim
A Baby for Mommy
Just a Wedding Away
Unexpected Family

My Romance

"Just as human beings have faculties of speech, sight and hearing, so we have erotic faculties, which are largely underdeveloped. Erotic faculties enable amatory thought, acts, and activism. [E]rotic faculties affect all connections that human beings make with other species and with things invisible and visible . . . As a person's erotic faculties develop, so does her lust for living."
-JOANNA FRUEH, EROTIC FACULTIES

193

THE SECRET GARDEN (A DREAM)

Characters
DICKON *(a young black man, kind of thuggish)*
COLIN *(a young white man in a wheelchair)*
GABRIELLE *(a young black woman)*

The set is simple and yet sumptuously romantic. Gilded and ornate things, an overstuffed chaise longue, an antique mirror, a portrait with a cut-out face. COLIN sits in his wheelchair with his back to the audience. In his pocket, he has an old fashioned key. DICKON is on his knees, digging through an enormous mound of dirt. A worn, leather pouch of seeds is attached to his belt. GABRIELLE enters, crosses COLIN and DICKON, and sits in the chaise longue. She rummages underneath the chaise longue to find covers and turns the chair into a bed. . .

GABRIELLE: Ow! (reaches under the chaise cushion and finds an old copy of *The Secret Garden*). Oooh! New school clothes and my purple monogrammed sweater that was my favorite thing in the world. And Sr. Kevin Patrice who was more than mean, she was calculating mean, but loved books almost as much as I did. And books about love. What is it about nuns and romances? Especially about gardens. Llilacs and hyacinth

DICKON: and primroses and daffodils

GABRIELLE: and tulips and secrets and old lost rooms.

DICKON: There were sunsets too Mary. And the way I used to slip out before it got too dark.

COLIN: Mary. Is that you Mary? It'll be dark soon and I want to play in the sun.

GABRIELLE: I loved that book so much. Mary was so proper and prim and lonely.

COLIN: Mary was a little lamb. Her fleece as white as snow.

DICKON: That's not what I heard. Son, what do you know about little lambs? I know everything there is to know about the little lambs. All the animals come to me. They know their own.

GABRIELLE: Oh Martha, will you let me go out maybe one day with Dickon. He's so strong and canny. I can wear your leather apron and go down on my knees and fill my fingers with earth and worms—

COLIN (*wheeling around*): No! You belong to me! Don't you remember, you came to my house in the dark. My house! All the rooms were empty except for me. You helped me.

GABRIELLE: Oh you're right Colin. I forgot. We found the garden together, as cousins, and maybe we'll marry one day.

DICKON: No! From earth you came, girl, and back to earth you go. Africa. My sister brought Mary to me like a stray dog or a lamb.

GABRIELLE: Mary used to get flush when she thought about Dickon, get flush and blush when she thought about Colin too.

DICKON & COLIN turn to her.

COLIN (*coldly*): So which is it, Mary?

DICKON: Mary you know what you want.

GABRIELLE (*flipping through the book all the while, trying to speed read*): Wait, I can't remember. Wait, let me see Mary to

the end. I—

COLIN *(scoffing)*: You're dreaming. You know exactly what the end is.

DICKON: Girl, you know how it ends. You know what's coming to you. *(Opens the pouch, pulls out a handful of seeds).* See this. *(He sprinkles the seeds on his mound of earth.)* That's your secret garden. Right here.

COLIN: You plan to listen to him. That—that—

DICKON: That what? Look at my legs. Look at my seed all around me.

COLIN *(snarls)*: So what. Look at this *(he pulls the old fashioned key out of his pocket.)* This whole place is mine. And look Mary. *(He stands up from the wheelchair.)* This is what you do to me. This is how it ends. You give me legs. We walk and see our kingdom. It's our garden, and it's not a secret anymore.

GABRIELLE: Oh, Mary, Mary, quite contrary. How does your garden grow? How will it end? Your heart beats when Dickon comes to the room. But Colin, so pale and so calm. He stays with you into the morning. He doesn't leave. Oh what should I do?

GABRIELLE jumps up from the chaise longue, and runs to the plot of dirt. She buries the book in the dirt.

COLIN: And so?

DICKON: And so?

GABRIELLE: And so quite contrary, her fleece as white as snow. *(She smudges her face with dirt.)* [Fin.]

"Here you go:
I remember being astonished and a little concerned, perhaps misguidedly, that Gabrielle would open her home—her bedroom closet, that intimateholy-of-holies, walk-in girl-space supreme—to a randomly invited, unknown audience. But I need not have feared. All of the audience knew each other. We were an intimate and warm crew. We sat on Gabrielle's bed and watched. Her closet is a space of wonders, just like Gabrielle herself. She had all those fabulous clothes, some of which she changed into/out of...romantic long slips, etc. Against the backdrop were cutouts of Black porn images, very voluptuous ladies. [note: *actually there were men too*] Later DT asked her where she got them. The show was about private bookish-girl romantic/sexual longings and the wild spaces inside. It was quite touching as I recall and I related to it a lot. I also remember the landlord's flower and small-tree garden as a thing of extravagant if contained beauty, complementing externally the beauty of the inner sanctum closet in the downstairs apt bedroom. It occurs to me just now that her landlords, an interracial gay couple, have in their own

way turned a potentially claustrophobic closet-situation into a secret (?) garden of delight, desire and beauty just like Gab's clothes closet. I remember Gab swooning dramatically as part of the performance. Then afterwards we sat around and talked for a while, and D and his gfriend and Gab and I went to a Somali restaurant. I enjoyed the *gemütlichkeit* factor very much. I felt that the performance brought us into a friendly, if somewhat ephemeral, intimacy that was borne out in the post-performance sociability. It is in the retelling that I discover the many layers of intricacy of sensibility that Gabrielle was working with: the girlish yearning, the importance of reading in identity formation and in the development of a life of the mind of romantic and intellectual aspiration, and how that development is inflected by social location with sometimes ominous undertones. it was handled delicately and somewhat obliquely, or it struck me as oblique at the time, now not so much in the paraphrasing i'm doing. xo, md"

—Maria Damon

> *"I've stayed in the front yard all my life.*
> *I want a peek at the back*
> *Where it's rough and untended and hungry weed grows.*
> *A girl gets sick of a rose."*
> -GWENDOLYN BROOKS

THE SECRET GARDEN (CLOSET)

> *"I'm gonna take you to my special place"*
> -JONI MITCHELL

"The Secret Garden (Closet)" started off as a kind of joke. My walk-in closet in Minneapolis was almost the size of my entire New York City bedroom and I said, "I should do a performance in here." At the thought of performance art, it became something else. I started to think—what does the closet mean to me? Inspired by Frances Hodgson Burnett's classic children's tale (with a dash of Eve Kosofsky Sedgwick thrown in), the work became an experiment, playing dress up in different clothes, in different postures, found text and images, alternate reading.

I've always loved *The Secret Garden.*

It's wrapped up with my mother telling me how much she loved *A Little Princess* as a girl, revealing a detail from a childhood she has largely kept secret. ("What's there to say? We were poor." And she would turn back to the future—a new computer gadget, a new Nordstrom's catalogue or what should we have for dinner.) I imagine her then, dreaming, because I did get that from her. Dreaming and reaching for a book and being captivated, rapt. The secret garden of her childhood and also my own.

The first day of the sixth grade in my new school outfit. So excited, I woke up with blood on the pillow, the capillaries in my nose broken from the excitement of the new first day of school. And I had a new outfit to wear. A brand new purple

sweater monogrammed just for me in the style of that day. *GCG* which I always thought was strange because it should've been *GGC* but I guess in the traditional style your last name was the most important. And on that first day, walking into the gloomy classroom of Sister Kevin Patrice and the split between all that expectation and reality, what would become familiar in performance art practice.

It was a grey year, uninflected, like that room—except Sister Kevin Patrice making us all memorize Emma Lazarus' "The New Colossus"—give me your tired, your poor, your huddled masses yearning to breathe free"—and then that day having all the children recite it one after another to check to see that they had done it. This was both boring and weirdly satisfying.

The only other good thing in the classroom, right across from where I sat on that first day, a phalanx of windows just right for daydreaming, and more importantly under those windows sat three tall rows of books, spanning the whole length of the room. And on that very first day of school, she told us that it was a library and that if we were good, you could take out a book. And on that very first day, I saw a book with a leather, emerald green cover. It looked soft and inviting to the hand and it beckoned to me like a secret. It told me to be good so that we could spend special time together. And I knew that would be my book and I would jump through the hoops and get a special card from that Sister, my homeroom teacher, and check out that book and take it home and read it and love it. And the title of that book was *The Secret Garden*. No, it was *A Little Princess*. Wait, somehow it's both. In the economy of memory. they have become fused,

A secret garden and a closet.

Double images of memory and sexuality.

For me, there's always been something of sexuality in *The Secret Garden*. The discovery of a place, stifled and neglected,

that a girl needs to reclaim and tend with the help of a wild, gentle boy. This place was outside, but I internalized it. And Mary herself, in a kind of triangle between Colin, the crippled, controlled scion and Dickon, the boy who could live with the animals, knew bird calls and could tame wild things, although he always remained wild himself. The desire for both of them, the split between the two. Between past and present, childhood and adult longing, early and late twentieth century, England and America, the wild moor and Detroit, whiteness and blackness, girls and boys, I saw this split in Sedgwick's *The Epistemology of the Closet*:

"secrecy/ disclosure, knowledge/ ignorance, private public, masculine / feminine, majority / minority, innocence / initiation, natural / artificial, new/ old, discipline/ terrorism, canonic / non-canonic, wholeness / decadence, urbane / provincial, domestic / foreign, health / illness, same / different, active / passive, in/ out, cognition / paranoia, art / kitsch, utopia / apocalypse, sincerity / sentimentality and voluntarity / addiction."

In performance art, I wanted to mine the split.

How funny to be a seemingly straight black girl and to turn to the closet as a structure of my sexual desire. How strange, but true. (I remember loving when Sedgwick described herself as a gay man trapped in a straight woman's body. But what did this mean? Back then, I didn't have a clue.) So much of my young adult life had been surrounded by beautiful gay men and their blossoming, fecund sexuality. I watched my friends struggle, break free of the closet, break out from yearning, daydreaming and longing, stifledness and repression. I suppose I felt left behind. I wasn't sexually in the closet, but somehow I was. The closet as a fixture of burgeoning, arrested adolescence. As a black girl, growing up in Detroit in the 1980s, there had been so much fear of

teenage pregnancy, my body had felt so restricted and policed. The dichotomy of my early years—"books vs. boys"—and how the forays into romance in my twenties had always been so disastrous, my desires so unsatisfied. Despite the overwhelming, pervasive narratives of romance in heterosexist society, the image of the closet resonated most to me as a structure of unrequited desire, secret pleasure, loneliness and covert longing of the body. My gay friends weren't alone in that, although it seemed like while they had moved on, I was still stuck there.

What kind of closet does a straight black girl have? What does it mean to have sex all around you, unpeeling on the bottom, and the edges, and you want it and fear it and read about it under covers at night, although it is not called sex in these books but roots digging into the earth, seeds cracking open in bloom, and you want to cultivate it but also order it on paper and over time? How in this closet in the bedroom, every day, the body makes the transition from nocturnal dreaming into daydreaming, an array of apparel and attire. And getting dressed goes from "how do I look?" to" will I be loved?" This closet a garden of borrowed, forbidden flowers, an installation, a library, a peepshow, a shrine, a dump...How this closet transforms into something else, an open secret...

My closet: a site of books and pornography and wire hangers, that image, so campy in *Mommie Dearest*, but also the symbol of backroom abortions, romance gone wrong, a snow globe and boots, a flashlight and fashion. My secret garden: a space of revealing, recovering, trying to articulate myself in disparate images of loneliness and desire and wackiness. My closet garden: an opportunity to be witnessed in this strange state of budding. The performance: an action to force discovery, the recovery of unknown things. In "The Secret Garden (Closet)," I was trying to connect and show and be and work out different things, about my body in space and time and memory and action and about what a performance is and can be.

"Do you think this is good?" my friend Daffodil asked me recently about another performance (her name such a lovely garden-y coincidence). About "The Secret Garden (Closet)," I'm not sure. As a performance art work, there may have been too many ideas, too many images, too many actions, some cryptic and deeply personal. I would have liked for the piece to have lasted for hours or days as a kind of installation, a site for people to drop by. Maybe one day, I will make another version of the work. At the time, this performance was transitional, formative, revealing to myself and the audience. It was my practice in process, an attempt to integrate reading, image, installation and action. It was exhibitionist shyness meeting daring appropriation. It was a continuing invitation into the intimacy of my house, my body and mind.

On Saturday, the room was packed to overflowing — twenty odd people witnessing this strange display. On Sunday, just three or four people showed up. (This happened to be the day I propped up a video camera and although there were fewer people there, one guy's head is constantly in the frame. Male gaze indeed. . .) At the end of the last show, we all ate pink strawberry cake, a gift from my fantastic gay landlords.

Under cushions, in the kitchen, tiny toys, slips of paper, packets of seeds—what the audience left from the performance—started to turn up. For months later, I was finding strange things, not just in the closet, but all over the house.

For Immediate Release
to City Pages Calendar Listing **[NOT-ACCEPTED]**

The Secret Garden (Closet)

a performance piece by Gabrielle Civil

<pre>
 to enclose t
 o o
 d c
 i l
 g in
 to recover g
</pre>

An exploration of hidden desire, interiority, and delight
in the space of a bedroom closet.

Come with a trinket to abandon, bury, hide.

Saturday June 22 & Sunday June 23, 2002 2:00 PM
2311 22nd Avenue South, Minneapolis

For more info: call (612) 728-xxxx or e-mail gfcivil@xxxx.edu

The Secret Garden (Closet) is a site-specific performance art
piece exploring hidden desire, sexuality, interiority and
delight in the space of Gabrielle Civil's walk-in bedroom
closet. All who come should bring a sense of humor,
wonder and a trinket to abandon, bury, hide.

Event Name: *The Secret Garden* (Closet)
Performer: Gabrielle Civil
Genre: Performance Art
Price: Come with a trinket to abandon, bury, hide.
Contact Information: (612) 728-xxxx

THE SECRET GARDEN (CLOSET)

1. The Garden
It begins in the actual garden in full bloom.
Resplendent tulips, bleeding hearts, jack in the pulpits.
The audience walks through this outside space,
spying hangers with text planted into the ground.
These hangers have messages handwritten in green ink.
Some have quotations from Francis Hodgson Burnett's
classic children's book *The Secret Garden*, others have
messages about desire and love.

This garden sits against the side of a house;
its trail runs right against a window. In that window,
a black woman stands in a black slip reading *The Secret
Garden*. At a certain moment, the audience passes her by.

2. Overture
The audience gathers at the front of the house and enters
together, taking off their shoes. They walk through a living
room, a middle room with art and turntables. They are
walking over clothes spread out all over the floor through
a path made out of shows. They arrive at the bedroom, sit
on a bed, facing a large, walk-in closet now transformed
into something else. A scrim of lavender tulle hangs in
the closet entry way as a curtain. In front of it, on the right
hand side, a small brown table with books and a vase of
purple hydrangea. In the living room, the artist puts on a
record. "Memorandum" by Datach'i plays.

3. The Closet
The artist enters and pulls down the lavender curtain.
The closet is full of clothes but the top shelves
running on all three sides are stacked with books.
There is a tall green plant inside.
The black woman stands with a book in her hand.

She begins to read aloud.

4. Initiation
from Eve Kosofosky Sedgwick's *Epistemology of the Closet*:
"The passage of time, the bestowal of thought and necessary political struggle since the turn of the century have only spread and deepened the long crisis of modern sexual definition, dramatizing, often violently, the internal incoherence and mutual contradiction of each of the forms of discursive and institutional 'common sense' on the subject inherited from the architects of our present culture...

But in the vicinity of the closet, even what counts as a speech act is problematized on a perfectly routine basis. As Foucault says: "there is not binary division to be made between what one says and what one does not say; we must try to determine the different ways of not saying such things..."

The black woman hangs the book on a hanger.

5. Cleaning Out the Closet
The black woman starts pulling clothes down off the hangers, considering them and then throwing them to the audience. "I Am a Very Stylish Girl" by DJ Dmitry from Paris starts to play. This becomes a kind of dance.

6. Playgirl Romantics
Soon, the space of the closet changes.
It becomes more empty, wire hangers outlining air.
As the clothes get thrown out, pornographic images
are revealed taped at the bottom of the walls.
Pictures from *Black Tail* and *Hard Knocks*.
Brown-skinned women with big asses and augmented breasts.
Hard, erect, jocular black men. Everyone naked and glossy.
At one point, the black woman picks up a skin magazine
and starts to thumb through the pages, holds up the images
for the audience to see. She passes it around into the crowd.

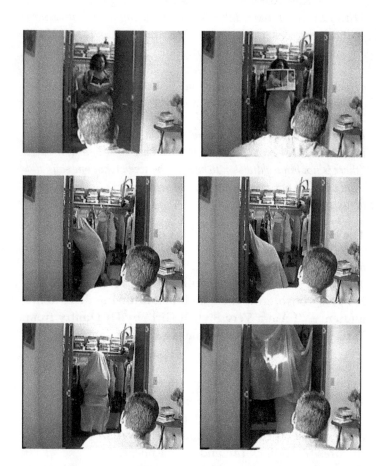

7. Swoon

She throws down the magazine,
emits a cry and falls into a swoon,
the back of her left hand on her forehead,
her right leg giving way as if she has
slipped on a banana peel.

8. Library Catalogue

From the bottom of the closet, lying down,
the black woman reads out the titles of the books
stacked above her head. These are a combination of
romance novels (bright red Silhouette desires and Danielle
Steel), scholarly books on medieval courtship, collections
of contemporary and classic poetry.

9. Lavender Climb

From the bottom of the closet she crawls up
into a lavender dress still hanging on a hanger.
Her body moves up through the material,
turns her into a worm, a snake, and she tries to fit
herself into this elegance. The tussle takes a minute.
When she is finally erect, she pulls the hanger out
from her back, throws it down, zips up the dress,
splays her hands, does a twirl and asks,
echoing Audrey Hepburn and George Peppard
from DJ Dmitry's song, "How do I look? /
I must say I'm amazed."

10. 27 Questions

The black woman speaks casually to the crowd in the closet.
She is 27 years old and so offers in the closet
27 questions about her future love life.
These include: When will it happen? How do I look?

11. Actions in Installation
The black woman eats marshmallows in the closet.
The black woman moves slowly to Miles Davis' version
of "Someday My Prince Will Come."
The black woman pulls down more hangers—reads more
quotes taped on some hangers' white paper.

*"Closetedness itself is a performance initiated as such
by the speech act of silence—not a particular silence,
but a silence that accrues particularity by fits and starts,
in relation to the discourse that surrounds and constitutes it. "*

*"Knowledge, after all, is not itself power, although it is a magnetic
field of power."*

*"I'll argue that the now chronic modern crisis of homo/heterosexual
definition has affected our culture through its ineffaceable marking,
particularly of the categories: secrecy / disclosure, knowledge
/ ignorance, private / public, masculine / feminine, majority
/ minority, innocence / initiation, natural / artificial, new /
old, discipline / terrorism, canonic / non-canonic, wholeness /
decadence, urbane / provincial, domestic / foreign, health / illness,
same / different, active / passive, in / out, cognition / paranoia,
art / kitsch, utopia / apocalypse, sincerity / sentimentality and
voluntarity / addiction."*

The black woman circles the space with a flashlight.
The black woman shakes a snowglobe of the city
and Detroit. When she winds it up, it plays
"The Locomotion." The black woman puts on grey snow
boots, and a winter hat. The black woman changes clothes,
takes off the lavender dress, is back in the black slip.
She changes into a plant print top with a frilly, pink lace
apron.

12. Abandon, Bury, Hide
The black woman artist says:
"You all have come here with something.
I'm going to cover my eyes, and now I ask you
to leave it here, abandon it, bury it, hide it for me."
She covers her eyes, stands still there while
the audience members complete their tasks.

13. Closing
The audience lets her know when they have all returned.
The black woman hangs things back up in the closet.
She reads last lines from Burnett's classic book.
She closes the door still inside.

A R T I S T N O T E S (from my notebooks)

The Secret Garden (Closet)

```
        to enclose t
        o           o
        d           c
        i           l
        g           in
        to recover g
```

a performance piece by Gabrielle Civil
6.22-6.23.02 2 PM *chez elle*

influences / inspirations: *the secret garden-*
frances hodgson burnett, *poetics of space-*gaston bachelard,
eve kosofsky sedgwick, playgirl, *l'empire de sens*

possible music: (at the end)
room with a view soundtrack
michael jackson "in the closet"
secret garden-quincy jones. .
hidden place-bjork
gardening at night-REM

extras: delta of venus-anaïs nin, tristan & isolde
catherine millet's *the sexual life of catherine m.*

Special Thanks: Flávia Müller Medeiros,
the danish girls Maria Damon & Madhu Kaza
(literalization of metaphor lunch), Rosamond S. King,
my extraordinary landlords / gardeners David Naugle
and Ty Neal and No. 1 Gold Collective

performance: enclose
improvisation <-> installation

212

THE SECRET GARDEN (CLOSET) SCHEMA

garden path
the outside garden
(words & objects)
me in the window
opening instructions:
take off shoes
my clothes strewn on the floor
a path made out of my shoes

*start with this
memorandum-datach'i
(my favorite record)

performance
the closet draped in net
some books on hangers
plants on the shelves
where is the sod?
already down?

opening gesture:
pulling out clothes
come in with Sedgwick in my
hands / start reading
put sedgwick on a hanger
start taking clothes out
and then say some memorized
lines

the titles
reciting the first found poems
transition?
burrowing into the dress

**reading from playgirl—
improvise**
or have some text memorized

snow scene **movement**
boots mittens
holding the globe
putting bachelard at my feet

reading from bachelard
reciting Sedgwick

mermaids
making the curtain fall again?
changing the light
burrowing hiding
looking for something
finding the poems
(are they all in one place?)
turning on the flashlight
reading mermaids with a
flashlight

venus de milo-prince
playing Prince?
on a tape recorder?
returning the space

abandon, bury, hide
/ *enclose* **repetition**
(after Flávia)
[27 questions. . . .? bury?]
[new poem . . .?]

reading from *the secret garden*
**putting clothes back
on the hanger
closing the door
end. . .**

there's something I want to say something to get to the meat of it
something for the end something to bury or unwind or take out
like a speculum I think of Carolee Schneemann unwinding words
from her vagina and wonder if I could have my mother in the
audience for that close the door I just can't sleep with the doors
open even in the heat and I can't stand the wind blowing I like it
warm and I like the idea of a closet beach or a little place to pray
like Amy in little women when Beth had the scarlet fever and she
had to stay with Aunt March Laurie came to see her every day
and promised to kiss her before she died. where are my kisses? so
sweet to yearn from them. (Madhu calls three times and ask three
different questions: what is art? what's a dissertation? (that's
one question) what is the real relationship between bees and
honey? can bears swim?... I have a dream of a poem silver and
comforting (throw a toaster in it) and warm and rich and dense
and conceptual like those I've read by Maria Negroni or Paul
Laraque but when I sit down to write one I think of closed rooms,
molds of things, Rachel Whiteread, light boxes, Alfredo Jaar..

...The central question for me with this performance is about
performance time. Struggling between installation and theatrical
event... Presentation and interaction and just being versus
actively performing something—also my desire to integrate /
work with "find" found texts and create new work—my desire
to create environments, my interest in "installation" if it can
be called that, my desire to transform spaces, the smallness and
innocuousness of my pieces, the way they don't hit the radar
or the screen and yet fill the whole of my consciousness and
purpose... the way I rush into them, the way I'm interested
in the design of it, the way at times the idea is better than the
reality of it—or the way I can't be sure what the reality is... How
different different performances can be—how different I can be
in performance as much as / equally so / even more than the
audience.

my landlords remind me
that day, the garden held:

hibiscus, nicotiana, nigella, bloodroot, lady's
mantle, sweet william, ajuga, anemone, may apple,
bleeding heart, turtle head, violet, wild geranium,
trillium, love lies bleeding, amaranthus, coral bells,
lilly of the valley, hostas, indigo, lily, tulip, snow in
summer, plume poppy, milk weed, butterfly weed,
joe pye weed, day lily, clematis, moon glories, fern,
asters, Mexican sunflowers, sunflowers, beard
tongue, bellwort, black-eyed Susan, shooting
star, columbine, Solomon's seal, gentian, Indian
paintbrush, lady's slipper, Dutchman's breeches,
Pasqueflower, prairie smoke, spiderwort, hens and
chicks, sedum, thistle, trout lily, wild tulips, yucca,
prickly pear, California poppy, astilbe, phlox,
sage, lungwort, spurge, zebra grass, periwinkle,
sweet woodruff, thyme, chives, wild ginger,
yarrow, moss, jack-in-the-pulpit, morning glory,
calendula, cornflower, gladiolus, allium, angelica,
bee balm, borage, dill, catnip, lilac, nasturtiums,
primrose, Queen Anne's lace, trumpet vine,
raspberries, love-in-a-puff, bean runners, African
daisy, irises, asters, kale, chicory, horse radish,
rhubarb, Canterbury bells, salvia, ballon flower,
Indian grass, Siberian iris, squill, fescue, daffodil,
hyacinth, penstemon, narcissus, liatris, bergania,
foamflower, delphinium, bellflower, foxglove, moss
rose, pineapple lily, lenten rose, calla lily, Peruvian
lily, hollyhock, bearded iris, balloon flower, blanket
flower, peony, speedwell, gayfeather, coreopsis and
lamb's ear and all of this performance.

The sky blue mesh cloth with original graffiti by Ernest Bryant III was one of my favorite performance art materials. After serving as my train after Hieroglyphics," *it appeared as an aquarium veil in "heart on a sleeve" and major threshold element both nights of the No. 1 Gold performance art event RSVP. When I was packing for sabbatical, I placed this cloth with my favorite pair of platform-heeled shoes, books by Adrian Piper, Karen Finley and notes for the first version of this book. When I got to Detroit, every other box had arrived except for this one. I had a tracking number, but no insurance and despite multiple calls to post offices around the country, the box, the books, the notes, the shoes, and that magical cloth were never seen again.*

BEULAH'S FISH

In Rita Dove's "Dusting," Beulah is cleaning her house.
In the poem, the black woman is a housewife,
but her secret life is performance art.
"Every day a wilderness, no—" every day a stage,
her home offers encounter. Through her work
she becomes an agent, a site of transformation.
"Beulah / patient among knickknacks."
She takes her time, standing within the furniture
of her parlor and her mind.
Her central action to wipe and polish clean,
recovers and transforms objects and herself:
"her gray cloth brings / dark wood to life."
She reanimates, rubs soft fabric against hard nature:
"Under her hand scrolls / and crests gleam /darker still."
This too is erotic, writing, her body in this space,
the motion of her hand moves her mind to question.
"What / was his name, that / silly boy at the fair"
She unearths sweetness "with /the rifle booth"
tinged with implicit violence.
What will be the prize? "Each dust /
stroke a deep breath and / the canary in bloom."
To learn this bloom is a fine layer of dust.
To swallow the fish, return to the text,
and remember ourselves. For this
we can get "the clear bowl,"
"the rippling/ wound!" "his kiss."

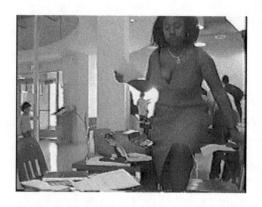

There she was, at an old typewriter,
dressed in striking red,
Poetry, ideas, jokes, passion, wisdom,
streaming out of her head.
For twenty five cents to a dollar
these instant poems she would sell,
All of it, one hundred per cent, Gabrielle.
 —ZARAAWAR MISTRY, FOUNDING ARTISTIC DIRECTOR, DREAMLAND ARTS

economy – thick description

a black woman sits. steno book
in hand, she is your love
secretary, transcriber, librarian, clerk
on her desk, a blood red typewriter,
a dictionary of poetic forms,
instruction manuals,
joy harjo, lucille, a few Nortons on hand
would you like a villanelle?
how about a haiku?
she is there for you
to tell lies, make poems, in a low
red dress, plunging cleavage,
sublimated desire, financial exchange
do you do birthday parties?
let me file it for you?
make black magic
and he'll be tall and strong
the one I conjure
for two dollars,
I'll write a love letter to you,
one for you, for three,
I'll pay you a dollar
to write one to me.

gabrielle civil	**economy**
whisper	50¢
lie	50¢
chant	75¢
poem (read)	75¢
poem (recited)	$1
story	$2
song	negotiable
instant poem	**$1**
haiku (on sale!)	75¢
fancy poems (2 business days)	
cento	$1
villanelle	$2
pantoum	$2
sestina	$3
sonnet	$3.50
other	negotiable
love letter (to you)	$2
love letter (from you)	$3
love letter (to me)	-$1
polaroid	$1
gift certificates	$5

you—business man—tell me
 about the one who got away
 how you weren't ready then
 how you see her with her new minivan
 and don't have the strength to say
 or want to spare her for
 had she known you had a heart
 she might have stayed, how you pay
 me for this, for listening to you
 and writing this down, how proud
 we both are of your capacity for feeling
 I take it down shorthand—
 with mercy, bury it away.

you—ethiopian painter across the way
 I like a figure with blood red hands
 later, I'll go see your computer etchings
 an alphabet of insects in women's forms
 and mine, how I'll lie to you about
 body and blood, and how after, in the sheets,
 you'll show me that sordid picture of her,
 tell me naked how you love some else,
 later still, you give me the painting with blood
 red hands, you call it a gift, but for sure
 I'll pay for it later.

ARTIST NOTES (performance flashback)

I remember being beautiful that day at CIA. Low cut red dress, pressed hair, red kitten heels. Sexy poetry secretary. And also that I was happy to be back in the swing of things. I'd been sick for a few months and now was able to ply my wares, make more performance.

It was a marketplace, a kind of artist sale—and I was selling myself as writer, reader, envisioner. The idea here was not that original—Miré showed me an article about a Brown alum who also wrote letters for people in a secretarial guise influenced by Latin American scribe traditions. Yesterday, I was talking to an ex voto painter who told me about evangelistas who still work in the Centro of Mexico City. They used to write cards and love letters, now they do bureaucratic forms. Invention, Reinvention. In performance art, it's not always originality that matters. It's doing it. Making something happen in real time and real space and being present. Action as transaction.

I remember reading Joy Harjo's poem about fear for one dollar. And the client—the drummer in my Haitian dance class saying— closing his eyes and saying that he really heard and felt the words. "That was totally worth at least a dollar," he said. And the parents of the small child who asked if I were available for birthday parties. Being a clown. Being also a spirit woman. Two white women in their late thirties had me write love letters to them. These letters were from the men they knew were out there but for whom they had been waiting for so long, they had become tired. ("I miss you, but I haven't met you yet"-Björk)

And there was a weary hope and desire in their eyes, in their bodies. They asked me to wait a while before dropping the letters in the mail, so it would a surprise, a relief when they came.

As always, it was a piece about love.

So perhaps it was right that there would be a lover. If he hadn't come, I would have had to invent him. His painting that I loved. And asked if I could buy. And I ended up receiving that painting for a gift. Another kind of transaction. Even though later, he was

drunk and remote and snarling. And later too, he asked me for the exact amount of money of the price tag. No—it's not that you're paying for it. The painting was a gift. It's yours. It's just that right now—I've been laid off and I need the money to help me with my show. And so, I chalked up the account in my ledger. For love, for art, three hundred bucks.

AFTER THIS YOU WILL LOVE ME

I live in a cold place.
This is as good an answer as any when people ask me:
"Why performance art?"
I arrived to Minnesota, young, gifted and black,
to teach at a women's college.
I arrived to Minnesota, more beautiful than I knew at the time.
I look back and see shining,
radiance exuding through brown skin,
twinkle of excitement, flush of expectation,
desire for the first day of school, those burst capillaries
the night before, gleaming hope for love affairs.
And as happens, perhaps, for every girlchild,
for every woman in the world,
those deemed beautiful and those not,
it didn't happen the way that I thought.
("and my sexual growth and development as a woman
which all women know about")
It matters too that I was dark and brown and plump,
although these are not tautological distinctions.
The world I was moving in was white and cold. My body covered
up in sweaters and coats and gloves whose mates I kept losing.
I wanted what I felt was my glorious destiny,
("New York and Paris and love"), what I expected to be,
if not effortless,
then seamless, organic,
the natural process of life.
("there's no such thing as natural."
My mother had to roll her Afro in the sixties.
For me, also artifice, fabrications, concoctions.)
In Minnesota, I felt invisible, ignored, sexually bereft.
I wanted attention, affection, for once to be seen,
to be visible and undeniable
as beautiful as poetry as intelligence as image

as a way to transform my life
and the way I felt in it, in my body, to gain presence,
fully there in space and time,
to contradict one kind of present, to stop waiting
for another future and manifest it myself.
Love. (Is this what the "Venus Hottentot" wanted?
Or Josephine shaking her banana tail?)
It's difficult but important for me to confess this wanting
as a part of my performance impulse.
In so many of my early pieces, it's painfully clear
in my yearning, frustration, isolation,
dejection, desperation and wry, resilient desire.
This flush of heat through cold, this opacity made transparent.
To keep a sense of humor about my quasi-pathetic quest for love,
to push through shame or embarrassment or pride
into something aesthetically to mine.

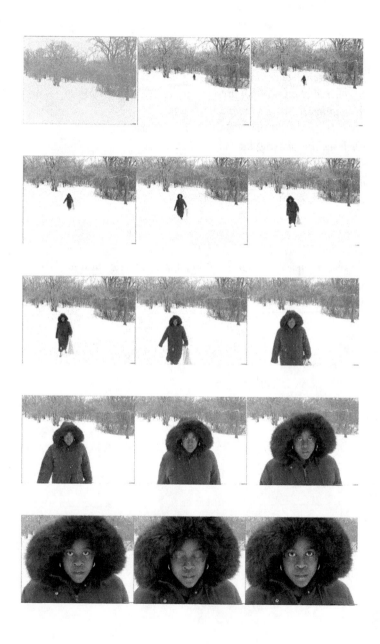

227

(from "Yawo's Dream" video, with Ellen Marie Hinchcliffe)

229

"I would like to make a case for a new occupation for artists...I will call the occupation I have in mind "meta art."...By "meta-art" I mean the activity of making explicit the thought processes, procedures and presuppositions of making whatever kind of art we make...
[Meta-art] requires an epistemic self-consciousness... namely, viewing ourselves as the aesthetic objects we are, then elucidating as fully as possible the thoughts, procedures, and presuppositions that so define us."
-ADRIAN PIPER, OUT OF ORDER, OUT OF SIGHT, VOLUME II

Heart on a Sleeve

"My body delights in work"
-DEBORAH HAY, MY BODY, THE BUDDHIST

Don't go to a performance by Gabrielle Civil if you don't want to be changed. Ms. Civil, herself, is an artist of transformations.

I remember attending one of her Ovidian performances at the Center for Independent Artists and being moved in ways that I hadn't known I could be.

It wasn't the first performance by Ms. Civil that I had seen. The surprise wasn't her weaving of music and dance and storytelling and video. The surprise was that Ms. Civil manipulated her voice and body in so many ways to say so many things that I was responding with every sense and at almost every moment.

The title of that show signaled her aims. She calls it "after Hieroglyphics." So of course it marks a space of time. It catatlogues history and the history of abstraction, and visual ways of communication.

The work felt Platonic, a philosophy of being and knowing shadowed in a dark room. The projected images were a television screen and a girlhood in Detroit and a fantasy of

dancing. Each aspect was drawn to a different scale. The piece shifted scale; Ms. Civil shifted scale, repeatedly. The long trail of blue tulle was a tethering garment for the artist and a way of marking movement through the forests of languages.

If the work were hieroglyphic, it might have been less fluid. It might have been more fixed and less emotional. In the work of this Ovidian artist the very possibility of change is mourned for and celebrated at once.

Music can change the way water moves in the body. Pitch and vibration are related. The mind can move through theory and through narrative, but how often is it invited to move both ways at once?

Gabrielle Civil invites every movement the mind can make. She offers the multiple movements of her own mind to her audience. She offers them as a call. The response is—has to be—the history of being changed.

—G.E. PATTERSON

"It's been a while since you've done something here," Greg said. "People are starting to forget you." And so after everything, showing and making work in the Twin Cities and New York, getting sick, almost dying from "massive, bilateral pulmonary embolism" developed on a plane ride home from France, recovering, going and making new work in Puerto Rico, I came back to this. My desire to be loved, a joke: passion, passive-aggression, self-loathing, racism, wacky sweetness, cheesy movies, collage, comedy and absurdity. I wanted to play with form, materiality and silhouettes. Somehow, the art training letter cropped up again as a ghost of my romance. "after 'Hieroglyphics'" underlined my developing practice of creating fantasias, sequences of imposed images and layered ideas (often in clothing). It was the first performance I did without wearing a slip. Performance art as personal ad.

AFTER *HIEROGLYPHICS*
directed by Miré Regulus

When the audience arrives, they see the tail end of a long blue train made of sky blue tulle. This train, scrawled with black graffiti, extends the whole length of a long hallway from the box office booth to the theater. This graffiti is beautiful, hieroglyphic with both faces and lines. The train is both romantic and sullied, delicate and hard. At the end of a long hallway, turn a corner, to see the other other end of the train attached to the black woman artist standing by the stage door. She is wearing a sky blue princess dress with a tiara. She is smiling beatifically, mouth shut. This is the threshold of performance. You must pass her to enter the space.

Threshold

Can you carry me across the threshold?
Will you take my shoes?
I made the wrong choice. . . Can you replace the shoes?
Who are you presenting to me?
Give me a kiss
Sing me the first verse of "Some enchanted evening"
kiss my hand
change the record for me
make a toast

At the end of the hall, where the theater entrance would normally be stands a silver ice bucket filled with fake champagne. As the audience arrives, the black woman smiles and asks the arriving audience for help. At one point, she asks an older gentleman, *"Will you please, take off my slippers?"* He bends down on his knees, adjusts his glasses to unbuckle the small silver straps on the transparent high heels. *"Oh! Can you please take them over to the champagne? Oh thank you*

235

so much." To a young woman who arrives, she says, *"Oh I don't have my slippers. Will you go get them for me?"* To a few students, she says, *"Oh can you help me put my slippers on?"* *"Will you bring me a glass of fake champagne."* And so on. With her demands, she is playing with the power of helplessness. No matter the bother it may cause, she is making them fulfill her fantasies.

Once the entire audience has arrived, the black woman princess enters the space. She says: *"Oh no, I don't have my train. I can't do the show without my train. I need a knight in shining armor. Could someone please go get my train, gather it up and bring it me?"*

She waits until a member of the audience volunteers—to gather up all the yards of fabric, all the way from the box office down the long hallway all the way to the theater space itself. She stands still and waits, interlaces her fingers, places them under her chin, smiles at the audience, bats her eyelashes until the audience member comes back, arms full of fabric. *"Oh, could you lay it out for me. It needs to be nice and smooth."*

And so this audience member spreads it all around, makes a nice clear path of the fabric upstage behind her. And once this has all been done, the black woman princess smiling, not lifting a finger, she says: *"Thank you. Let's give this fine person a hand."*

The audience claps.

The black woman then throws off the train and gets on with the show. The whole thing has become an elaborate schtick. She takes off her tiara, slides off her long blue, taffeta princess skirt to reveal a sky blue patterned knee-length skirt below.

The performance space is relatively spare. The sky blue train now has become a cloud trail on the stage floor. Midstage right, a column almost shoulder-high painted royal blue, with a record player on top. A portable record player sits in a brown wooden chair next to it. In front of the tall blue column, a small brown folding table holding red and white gloves, a pair of glasses with a pink nose and moustache attached, honey, a tin of chocolate and silver stars. In front of this table, a record stands: *World's Most Romantic Waltzes*. On the cover, an illustration of elegant white people in formal clothes dancing under the stars. Over this environment, two long cords hang with empty hooks.

Upstage left, a microphone in a black stand.
The black woman artist gives herself an intro:

"Wacka wacka wacka, wacka wacka wacka, wacka wacka wacka Waa-uh-aaaaaah!"

A spotlight emerges around her in front of the mike. She begins her comedy routine. Halfway through the monologue start bursts of canned laughter.

Comedy 1
What rhythm would he set when he finally made love to her? Would he be so anxious to have her that he'd be unable to find his usual finesse? Would there be tenderness, or just an all out blinding push to completion? When she climaxed would she moan or scream? I love this woman, but when I try to make love to her she pushes me away and tells me not to touch her. Have you heard about the new black French restaurant? Chez what? Meinhof gasped as his murderously, slow even strokes became vicious, meaty jabs. Again and again, he pierced her core. Even as she flinched, she couldn't hold back her appreciation. "I'm sorry you're taking it so

hard. You may not think you're black, but have you looked in a mirror lately?"

"Wacka wacka wacka, wacka wacka wacka, wacka wacka wacka Waa-uh-aaaaaah!"

Romance
> *pedestal record: Black Orpheus*
> *Vestax: Something Wonderful-Nancy Wilson*

The black woman dreamer walks upstage to her little world. She puts the needle on the record on the blue column's record player. She is playing music from the film *Black Orpheus*, a film her parents saw on one their first dates. She picks up the portable Vestax record player, sits down on the chair and places the record player on her knees.

She starts to speak.

chiffon.

twirl.

Knock knock.

Twinned & star crossed & lots of heat
So beautiful I can't get over them
My parents' first date: what I'd like to eat

romeo y julieta. mango & cheese. they wouldn't cheat
the proper business of charm.
Twinned & star crossed & lots of heat

My father powdered fresh off the boat
No wonder my mother thought he'd do no harm
My parents' first date: what I'd like to eat

Popcorn, black Orpheus. Barbancourt neat
My mother's synthetic fall, dead glamour, a celluloid drum
Twinned & star crossed & lots of heat

Razor itch goose pimple irritation sweet
snow and skin. the blizzard outside wasn't the only storm.
My parents' first date: what I'd like to eat

And repeat and repeat and repeat and repeat—
Knock knock. romance. cataclysm.
Twinned & star crossed & lots of heat
My parents' first date: what I'd like to eat

At some point in the villanelle, she pulls out a Nancy Wilson record and starts to play "Something Wonderful," on the portable Vestax record player on her knees, the sound overlapping with *Black Orpheus*. She mixes the sounds in and out, the voice of her poem and the music of these songs now connected. When she is done, she stands, sets the record player back on the chair, picks up two stars from the brown table and hangs them on the hooks dangling from the black cords above. She puts on a pair of short white gloves.

"Wacka wacka wacka, wacka wacka wacka, wacka wacka wacka Waa-uh-aaaaaah!"

This time canned applause greets the black woman comedian. This time the spotlight fits only over her mouth.

Comedy 2

Ah his manhood, throbbing, juicing, enticing, rising. All that she had been taught not to desire, all she had ever wanted, all she had never known could exist. Her dry sobs caught ragged, hung like full bodies on the trees. Because I have a Southern accent and grew up eating fried chicken and grits rather than eating spa food and drinking expensive wine, everybody assumed I couldn't possibly learn about those things, much less review them. I found a bisexual video hidden in my boyfriend's apartment showing two men and a girl together. Is my boyfriend gay? Why do blacks always have sex on their minds? Because of the pubic hair on their heads. On the dance floor, Tony let the low moan of saxophone wind its way around his senses. Candlelight flickered across Francesca's golden skin, exaggerating the darkly romantic mood. *Ooooh la la.* What are three French words all blacks know? Gabrielle Francine Civil. No, Coupe de ville.

Interlude: *Ice Quartet: Venus as a Boy*

A cheesy, string quartet version of Björk's "Venus as a Boy" plays. The black woman comedian dreamer does a little bunny dance across the stage. She goes to the little brown table and picks up the glasses with the pink nose and moustache.

She says: *"I'm sorry our canned laughter is broken.*
I need for you to do it for me. Let's try it.
When I raise my hand, I need for you to laugh. Let's try it."
The audience tests itself as a laugh track. *"Very good."*

"Wacka wacka wacka, wacka wacka wacka, wacka wacka wacka Waa-uh-aaaaaah!"

Throughout the next monologue, she raises her hands at strange, set points to make the audience serve as her laugh track.

241

Comedy 3

What do you call five blacks in a 57 Chevy? A blood vessel. I am a married Asian woman with husband that is a bad lover... should I have a fling with this attractive and funny Black man at my job? I trust you with my secret no question. What do you call a black woman millionaire Nobel Prize winner? Nigger. You don't love yourself. But what does that mean? How is that possible? I like you bubba. . . I respect your dedication. I'm a handsome, successful 25 year old black male. Why can't I find someone who wants to call me their boyfriend? And to their passions, their attachments, In short, a total fiasco. Why do black women wear high heels? So their knuckles don't scrape the ground. Like a flame enclosed in an upside down glass, struggling to burn within its constraints. There was a black couple that already had eight fine children, and finally the wife implored her husband to have a vasectomy. After much cajoling, he made an appointment, and the morning of the operation his wife was astonished to see him leave the house dressed in white tie and tails and head for a big black limousine waiting at the curb. Responding to her quizzical look, he explained. *"Honey, if you gonna be impo'tant, you gotta act impo'tant."*

At the end of this monologue, a stage hand comes and hits her in the face with a crème pie. The black woman artist takes off the glasses, wipes her face with a black cloth. She puts on the tiara, goes centerstage.

flashback to Hieroglyphics

While the following monologue is voiced over, the black woman lover makes a mess, smears herself in honey and chocolate.

… art training letter (love)…9.21.01 My dear mk…
green how i love you green—if I say that this is an art
training letter—does it mean even more that art is life.
Or if I tell you that it felt like a Marguerite Duras novel—
that I felt like I was in a Marguerite Duras—would that help
you better understand, better able for me to understand.
If I tell you that he calls me honey—that he said I want to
get inside you are you sure you're bleeding or even
before that when I stopped struggling / to parallel park
on the left side and just did it and walked 3 short
blocks in the surprisingly bashful sun looking beautiful,
would you say like Kristin that I'm distancing myself,
that I'm treating him like an experiment, that I've been
physically intimate but am guarding myself, focusing on
exteriors—or like Alpha would you say—
stop thinking so much—let yourself desire.
But what if I wanted it, I want him but
somehow it's desireless or I split myself in two and
touch him and order him to show me his chest and
then show him mine and he looks at my bra (with
a little wonder "that's pretty") and I laugh but at the
same time am outside of it. I pull down his pants and have
his really lovely cock in my hands, under my lips,
but I'm still outside of it—and I'm quiet—and I stroke
his body and look up at him and I say (with some wonder)
"you're really beautiful" and he doesn't say anything.
And he wants to get inside me and I don't let him. And now
we're speaking of things we haven't before + now—
in this moment on this green—I want to—I'm not sure—
weep—there's a sob in my throat but then I just pull off
the rest of my dress and look for a minute at the map
of the world on his wall with thumbtacks in places
I think he's been: Morocco, France, Chile, Turkey I think
in the side of my eye, but all of that's just a glance
and I turn back at him to him and he pulls me down

between his legs and he looks at me and he kisses me
and his tongue is in my mouth and I can't believe
I'm there and I want to feel more than I'm feeling
and I'm not sure what I really feel because my wits
are about me but I'm kissing him up his chest
to his chin and he's strangely silent saying again—
I want to be inside you honey. (Am I telling you too much
Is this too much information) and his testicles
(which are perhaps my favorite part of him)
are so purplish red blue—and he pulls me close
to him and is very quiet and I think touches
my hair—while what I really want is more kisses—
and what I will demand for my birthday is 27 kisses
and he comes on my belly, a little on my breasts, my cheek—
and jumps up, long and lanky to grab a towel and
lays it on my breasts and grabs a comforter—no
a sleeping bag—and pulls my head on his chest
and I think okay here goes
here's the part where he's the man and he gets to sleep
and I'm the woman and I get my cuddle but I'm
supposed to want to talk so I say to myself—stay
quiet—just be here with this man holding you and
don't shake—just be here—and he says—what are you
thinking now. And me—who has always been suspicious
of people who are silent and when you ask them what
they are thinking say nothing—stumble and I say I-I
don't know. nothing. I guess I'm just glad to be here
with you and he doesn't say anything for a minute
and I touch the vein in his neck and I say,
"What about you—what are you thinking…"
And he says: "The bombing. I'm thinking
of the bombing. And all the Arabs that live here,
not like me, but the ones with families, kids
who are Americanized. And how they're scared now.
And he told me how yesterday,

one of his co-workers had said, "Hassan,
do you have a bomb in your bag?" And I felt
so outside and so fucked up and so sad and
so amazed that he was telling me this
in his big bed, in his small bedroom, in his
incredibly rumpled, messy, smoky, bachelor pad.
And all his travel posters of Morocco + his poster
of Matisse in Morocco + his cookbooks and his huge
plastic jar of change. I write this and I wonder am I
aestheticizing him? I write this and I want to kiss
him into oblivion almost—until he's not a man
but something I can trust. He told me he took
his sister to Hooters because she wanted something
truly American. I think randomly of Yoja w/Bilal
in Niagara Falls. I think of how when Hassan licked
my nipples, held my breasts in his hands—
I didn't feel anything. How quiet he was. How tired.
How sweet when I first arrived. mk, I showed
him 4 or 5 pictures from Yo's wedding and
he said "what a beautiful family you have."
How he laid his legs around mine. How he did sleep
for hours after we'd—but what did we do? He wanted
to be inside me but he wasn't. What is sex?
Forgive my Catholic school/ Monica Lewinsky
issues but when I think about what we did,
about his taking my hand and laying it close to
his heart, almost spooning, I wonder—
is this the euphemistic sleeping together?
Is this all he wants—for me to come to his house
and hug and kiss and touch him between sleep?
I really don't know what I want except to strut
in the sun, I guess. And to be kissed everywhere.
I left him sleeping. There was mud splattered
on my car when I returned. [heart pronounced love] gfc

Loveline

A phone rings.
A record plays: "Your Love Is Like a Beeper..."
The black woman artist is splitting into parts.
She tries to clean herself up.
She starts to speak in different languages...
Are you out there? Is anyone out there?
Do you love me? Will you love me? Could you love me?
Entiende? Comprende?
...find it in ancient Greek, in Amharic, in Norwegian...
The black woman artist goes off in the wings, returns with a
trombone, blasts a few notes, the gold loop of metal moving
back and forth over her shoulder.

Seahorse

It falls apart => Turns into something else. Dissolution.

Wonder. Ether.

Amniotic naiveté.

Trombone.

Mesh.

The Blue Lagoon.

A projection of *The Blue Lagoon* starts to play filling the entire
back wall of the stage. We see images. A washed-up black-
and-white photograph of people in antique clothes. A nubile
white woman in a loin cloth. A young white man trying to
spear a fish. In front of this, the black woman dances with the
blue mesh train, riddled with graffiti. It has become a dream.

Still in the stupor of this dream, she walks to the microphone for the final monologue. Her voice becomes rounder and slower until the very end.

Comedy 4

This black guy walks into a bar with a beautiful parrot on his shoulder. "Wow!" says the bartender. "That really is something. Where'd you get it?" "Africa," says the parrot. I took a few acting classes, which focused on diction, but I didn't change me. And after a while, I realized the advantages of the act. How do they manage to feel so clear cut? so simple? Is a 69-year-old man too old for a 29-year-old woman? My boyfriend is married and feels if I date other guys I am cheating on him? What qualms if we wounded someone who was already wounded? Let's throw all that on the scrap heap then...Let's forget about it. The possibilities roll through his mind like a gathering storm, stretching his nerves taut, turning his gut to Jell-O. And suddenly he comes up close to us, he leans over us, towards us, he looks deep into our eyes and allows these words to escape him, words trembling with anxiety, with distress..."*Do you too...Do you know what it is? There are people...have you known any? I believe they're what's called slippery...When you're unlucky enough to come across them...When you become fond of them...*"

thick description "after *Hieroglyphics*"

my desire for love
a princess dress cut-up joke
crème pie in the face

A TEACHING MOMENT (MY USUAL ROMANCE)

It's over and has gone pretty well. I've shown fifteen minutes from the "Comedy" sections of my new piece after "*Hieroglyphics*" here at Patrick's Cabaret. These are my cut-ups, collaged text from internet love advice, an experimental romance novel called the *Baader-Meinhof Affair*, a grocery store romance, Nathalie Sarraute's classic *nouveau roman, You Don't Love Yourself* and, the crème de la crème, racist jokes from Blanche Knott's *Totally Tasteless Jokes 2*. Inspired by *Cunt-Ups*, Dodie Bellamy's cut up homage to William Borrough's cut-ups, the monologues are weird, unsettling and to me funnily fucked up.

The conceit of the routine comes from my trigger—at arbitrary points in the text, I ask the audience to become my canned laughter. I do this by raising my arm. This forces them to laugh at things that maybe aren't so funny, a betrayal at times of their bodies' own instincts or of their own sense of political correctness. Other moments, people laugh unexpectedly at the words or my delivery and I can hear a tint of surprise in the timbre of the laughter. Something bubbling up or wrenched from the audience as response. Between the monologues, other actions occur. I toot on a trombone, force dissonant sound, an absurd act trying to "be funny," trying to be loved, trying to do something I don't know how to do.

At one point, a projection of *The Blue Lagoon* comes on. I'd wanted actually to use old footage from a French documentary on sea horses that I saw before an Eleni Sikelianos reading at the Walker Art Center, but after the show, the documentary cost over twenty bucks and I didn't have the money to buy it. The vision of the sea horses wrapping their tails around each other, dropping, hanging upside down, mating was beautiful and strange. And at one point, the French scientist sticks a needle in the belly

of a male seahorse, ripping it open to show the tiny baby seahorses that come out inside. The cruelty of science, the strangeness of nature, unusual gender formations. *The Blue Lagoon* ended up actually being better. I'd seen the movie as a kid but didn't understand it. Brooke Shields and a young blonde boy get shipwrecked on an island. They start off just kids but then end up coming into their sexuality. She starts to bleed inexplicably. He starts to quiver at her breasts. He picks up a spear and starts stabbing it into the water. Fishing. They both wear loin cloths and become white savages. This was a better fit.

The overall work was still in development. I hadn't added the white gloves, the pie in the face and I wasn't showing the romance sections (me in an ice-blue princess dress with a long train covered with black graffiti.) But what I showed was good. Provocative, unusual, unsettling and with clear aesthetic aspects—the image of me lifting the trombone onto my shoulder, the projection of those savage white bodies behind me as I said racially fucked up things about love.

I was heading home from the event when a young white woman stopped me.

"Hey, can I talk to you a minute about what you just did."

"Sure."

"That was really intense. I mean it made me think about a lot of things."

"Great. Thanks so much for coming."

"I mean, am I racist?"

"What do you mean?"

"The work you showed, with the jokes and the laughter. You were saying that I'm racist, right?"

"But I don't know you. I can't say whether or not you're racist."

"But that's what you were saying. I just want to make sure. I'm racist."

Ah ha, so back again to my romance, my life as a teacher of young white women, who look to me to tell them who they are.

"Well, issues of race are intense and personal and no one else can tell you how you feel. I think you should look back at your own life and experiences and feelings and think the question through for yourself. Whether you're racist, and if you find those attitudes within yourself, what you want to do about it."

And that was it. I can't remember if she said okay, if she walked away dazed or annoyed or dissatisfied or on a new quest. I hope I was kind. At least, I wasn't in a hurry. I'd finally learned that much. I remember slowing down and taking a breath and trying to say something real to her. I wasn't trying to be dismissive, although it may have come off that way. Maybe I sounded condescending, imperious, one of those older black women who look down from the front porch, from their perch and basically tell you your faults and then say, but really it's all up to you.

Later, I tell my friends Evie and James what happened.

"You were wrong," James, a lawyer said. James doesn't like performance art. He calls it masturbation. This comment hurt my feelings a bit—not because I think masturbation is bad but because from his tone it seems that he does. And also because it's the form I've been working in for many years. Still he's right—performance art does offer an erotic charge. It's just not solely self-gratification or for the gratification of others. It is something for both and neither.

"You had an amazing opportunity to help a young woman think about race and confront her own racism."

"So you think I should have said to her: "Yes. You are racist. We are all racist. We live in a racist society and the aim of my work is to come to Jesus and understand that."

"Yes. Some real good could have come out that."

"James, this girl comes to me as a black woman and wants

me to do it for her. Name it, fix it. It's not my responsibility to be her conscience. I'm an artist, not her servant."

He shakes his head.

"Besides," I continue, "If she's already asking the question. She knows the answer."

"But Gabrielle, you're a teacher. If one of your students came up to you and asked you if she were racist, you're telling me you would do the same thing."

"She isn't my student. And even if she were, she would need to claim it for herself."

In this, I know I'm probably different from some of my colleagues. Some would respond immediately, off-handed, like saying the sky is blue: the world is racist and so are you. For me, issues of race are jumbled with issues of identity and love. Why is she asking the question? How does she love? Why is she asking me? What life is she leading that all that she saw led her to that question? Had she ever approached a black woman before with this kind of question? Had she ever been turned down? I refused to be her race confessor, to have the whole work collapse to her one question. If my "Comedy" had become a diving rod leading her to new water, she would need to strike the spring. The work was an offering to her and to everyone else to consider and explore again what Karen Finley calls "a different kind of intimacy." (Finley's own work raising knotty questions of race and gender to untangle.)

My refusal to answer this young woman's self-interrogation stakes a claim for relationships between artist and audience, between black women and white women, a different kind of courtship. It is, of course, gratifying for the audience to come and clamor. I do want the audience to respond, but not this way. This moment points to the true logic of racialized rhetoric. The joke in the end is on all of us.

ARTIST NOTES (from an e-mail)

Sun, May 20, 2007 at 4:48 AM

My dear Laura,

How lovely to receive your message. As I've been thinking about my return to the Twin Cities, you have definitely been in my thoughts! […]

In terms of your inner battle—let me tell you a story. A couple years ago, I did a performance called "after Hieroglyphics" at the Center for Independent Artists. It featured me dressing up as a damsel with a veil that was at least a yard long and I required people to take off my shoes and get me other ones and there was (fake) champagne and me playing records and a trombone and reciting poems and doing a fake comedy bit where I cut up racist jokes and language from romance novels and had people laugh at inappropriate times. Clearly, it was a performance about love and race. Or more accurately, it was a show about my love life. (I have another one in mind that riffs off the movie *Carrie* but that's another story.)

Anyway, [my sister] Yolaine came in for the show and all of my friends saw it and the very first night, I loved it. I was euphoric. I thought I could be happy doing nothing but that show night after night after night. I had enjoyed it so much— I had so much adrenaline and I felt like I was doing what I meant to be doing in the world. The second night—the last night of the show—I had a different experience. Miré, my director, had given me no good notes about the show the night before—only told me what I'd done wrong. And I felt such shame and embarrassment that I'd made mistakes and was more nervous. And then, there was a technical glitch and one of my favorite parts of the show (where I showed projections of Brooke Shields and her weird brother / lover in *The Blue Lagoon*) failed and I felt completely shitty. I felt

like the show was terrible, like I was terrible, and who was I to think I could make performance art pieces and really it was all cut-rate and shoddy and shameful and embarrassing.

And the next day? a couple days later?, I had breakfast with G.E .at Maria's—remember that tasty S. American place not far from my old house where they have amazing regular and corn pancakes. Anyway, I went there with him and he told me how much he and a couple of his friends had enjoyed the show. And I went into this whole kind of apology thing—saying how it really wasn't that good, but at least Mankwe's show (which had gone first in the bill) was better because she has this amazing voice and natural singing ability and was a real pro and mine was like a kind of exercise or foray and certainly maybe one day I would get better and maybe be as good as—

and he was PISSED! What's wrong with you? he said to me. How dare you say such things to me who loves you? Who do you think you are saying things like that about yourself? Your performance was good. And you know it. And he started talking about bonsai and the way people "twee" bonsai, cut it back. And he said: don't you realize that when "twee" yourself, you're "tweeing," disrespecting, putting down all the people who love you. Isn't this just another way of wallowing insecure and claiming excess attention?

So I learned something important. I realize at times that I don't get enough emotional support and validation around my performance art pieces and I need people to be both strong and kind to me in my times of weakness. To me, all of this about self-doubt and the possibility of love to cause pain...

Your struggle between hope and resignation/ numbness reminds me of my own struggle for love and connection and a place to be. I don't know if people can tell, but every day I deal with loneliness and isolation and waiting and boredom and disappointment. Every day, it's there. . . in differing amounts, but there all the same.

And it's been there my whole sabbatical experience. This year, I've been to Montreal, Boston, New York, Minneapolis, Chicago, Detroit, Iceland, Mexico, The Gambia, Senegal, Morocco and now Spain. I'll visit Flávia in London for a few days, visit Madhu in New York before heading home, have trips already planned for the fall and on and on and on. It sounds glamorous and exciting. And it is. And even though it's been hard, I've loved every minute of it. But even though I've loved every minute of it, it's been hard.

No matter what, we bring ourselves with us... And although Spain is pretty and the people in the residency are nice enough, I would go home to be with my family and friends right now if I could. (Or how different it would be if you all were here with me? ;-))

At the same time, all of these travels have reinforced for me the strength of welcome. The places where I have felt most happy were the places where I felt most welcome, invited, seen, nurtured, supported, loved—not merely by my friends, but by the places themselves. How many times have I been in Paris? And yet how many Parisians have offered me their friendship or conveyed excitement about me wanting to be there. Zero. Paris is pretty and romantic. It is also expensive, cold, distant, hard to get to and when I'm there, the place doesn't seem to celebrate or care that I'm there. So why should I keep going for it?

Walking around Barcelona, I realized that Europe has very little appeal for me right now. It's pretty and nice and there's art and relative safety and infrastructure, but who cares? In my two months in Mexico, I made more connections, felt more welcome, than in 14 years of dallying with Europe. So that's it. I'm trying to torque myself to the places that want me as opposed to trying to shoehorn myself into places that are so-so. This is about Paris but it's about the Twin Cities as well.

On to lighter matters… On Friday, I looked very beautiful in Barcelona. I was wearing some amazing black espadrilles with red yellow and green markings on the front and long red ribbons for ties. Mucho sexy. They hurt the hell out of my feet which was a shame. I actually took them off to walk through the Frontiers exhibit at the Centre de Cultura in Barcelona which had some cool images of conflicted places and a crazy series of video projections about North Korea. (WE ARE HAPPY!) I met a guy named David who had tattoos of vikings on his arms and as I was waiting for the bus a guy in a truck stopped to give me a ride (No gracias.)

I've been doing exercises for my plantar fasciitis and "sacral" pain and have been doing either yoga or pilates with DVDs every day. I've lost a little weight and even better feel more upper body strength. Don was with me when I bought the DVDs in Detroit (he and I bonded over Rodney Yee).

Have you ever made a list of fantasy things? Just all the things that you could ever imagine doing with absolutely no pressure to try to get them done. Just an articulation of possibilities. Well that's one of the things that I did on my first days here at Can Serrat. And going to Brazil to study capoeira was one of those things. (I also had making movies, having a baby, doing a camel trek in the Sahara—Rosa and I actually met a woman who did this in Morocco!) Upper body strength is the key for capoeira (and maybe the other 3)—so I've been trying to work on it—just in case. Poco a poco as they say in Mexico. I'll get there poco a poco.

Okay Laura, this was long long long. Drop a line when you can. Starting tomorrow I have to really crank on this book if my real goal of having a draft by the start of the school year has a prayer of coming true.

Love,
Gabrielle

"Been around the world and I-I-I-"
-Lisa Stansfield, sampled by Puff Daddy & the Family
(featuring The Notorious B.I.G. & Mase)

BERLITZ

"I am so hip / even my errors are correct"
-Nikki Giovanni

"Berlitz" was commissioned by the Organization of Women Writers of Africa for their Yari Yari Pamberi: Black Women Dissecting Globalization conference. It was my first solo performance art work in New York City; the first time I got flown in, paid, and put up in a hotel as an artist; the first time I got to do a workshop on performance art as part of an international conference; and, although the two remain very linked, the first time I really led with a performance art identity as opposed to a poet one.

"Berlitz" was also the only performance work of my early oeuvre to address hip hop head on, something that seemed required for a piece about black women and globalization. No matter where I would go in this whole wide world, moving images of half-naked, fake-haired, glazed-eyed black women in hip hop videos would already have preceded me. I remember sitting in a bar with new friends in Europe while a muted video in the background showed a close up of a black woman's ass shaking. The woman to whom that ass belonged and I were the only two black women in the bar. (Been around the world, indeed.)

Debates about hip hop and feminism are quite old hat now. And it's clear that black women's relationships to and in hip hop are quite complex. As are our relationships to sexuality, exhibitionism, and money. Even then, the intention of "Berlitz" was not to demonize women who listen to, love, or appear in hip hop videos. It was to embody and contrast

257

different figures of black women: the black woman carrying the box on her head, the black woman rummaging through the rag pile, the black woman opening a huge birthday surprise full of festive balloons, the black woman throwing down dancing by herself, the black woman scantily clad, gyrating stiffly in a hip hop video. All of these figures raise questions about black women's objectification through global capitalism. Archetypes, stereotypes, global realities. How does one person's burden become another's pleasure (and vice versa)? As black women, what would be our new *lingua franca*?

"Berlitz" was chock full of dense images and ideas—I played language lesson tapes in Haitian Kreyól and French, I recited a letter to my Haitian grandmother in Swedish, I offered an original poem name checking powerful black women writers and artists—still, the thing most people remember is the striptease. I wanted to contrast the way a black woman's body could feel to herself, dancing joyfully without many clothes, to the way a black woman could look objectified in the same attire in a different (global) context.

Interestingly, as I was working on the striptease, I had no shame or concern about my body at all. When did that happen? My colleague, psychologist Dr. Linda Siemanski, told me that American women have something like a 96% dissatisfaction rate with their bodies. Whether they're thin or fat, tall or short—their normal state is to believe that something is wrong with them. In fact, a mark of assimilation for immigrant women is their rising rate of body dissatisfaction. More than trying to fight body dissatisfaction, somehow, through the process and practice of making performance art, I was just overcoming it without thinking about it. Making and doing "Berlitz," I wasn't feeling bad about my body. Not for the first or last time, I took off my clothes in front of the audience. This time, I put on high heels, pretended to be vacant, screwed my finger into my cheek, gyrated and found

myself trapped in a box. Literal, perhaps. But evocative.

I built "Berlitz" in Patrick's Cabaret in Minneapolis which had no mirror (Deborah Hay would be proud) and I didn't use a video camera. I worked on instinct, with key images and ideas in my mind. I tried to go on feeling more than appearance. Overall, with "Berlitz," I learned more how to work on my own. How to go alone into a space, wake up the room (as Lois Weaver would say), and materialize something from thin air. How pleasant to realize that would materialize would be my own brown flesh.

what strikes me: This work ["Berlitz"] makes you wanna shout "Give me Body!" It's sassy, smart, and fully exposed.

—Pamela S. Booker

BERLITZ

1.Dyalog
A Kreyòl language lesson tape plays.
Lesson 4 Dialogue

A black woman walks in the back door, wearing stretchy
black pants and an old red t-shirt that says HAITI. She is
carrying a very large brown cardboard box on her head.
Listen. The tape says in English
Gaby and Tomas meet on the way to Pòt-o-Prins.

O Gaby.
Sak pase?
Ak ou-mem?

The black woman walks into the space from the left side of
the audience, turns the corner to stand still before them, a
large box on her head.

M'ap kenbe.
Ak ou-mem?
Ak moun-o?

She kneels on one knee, sets the box down before her with care.
Now repeat the dialogue.

Gaby. Sak pase?
Gaby O Gaby
Gaby sak pase?
Ak ou meme?
ou kenbe
map map kenbe
Ak moun yo?

2. To Market, To Market

She runs away from the box. She smiles at the audience. She picks up a striped mesh market bag, sets it down, rummages through it. A few tiny balloons, not fully inflated, pop float out of the bag like bubbles. She grabs the bag from its bottom, holds it up and pours the entire contents over her head. A cascade of balloons falls over her head. Some have never been inflated. Some look deflated. Some seem to hold just a few breaths before they have been tied off into small balls. Her head and face are completely covered by multi-colored plastic.

She stands for a minute with the market bag over her head, obscuring her face. Her arms are stretched up, her palms open. She bends down, knocks the bag off her head and throws balloons up in the air. It is either a celebration or chaos or both. She gets down on her knees, begins searching through the rubbish pile.

3. Import/Export

The perky sound of a French accordion signals a change. She pops up, begins to smile and dances with arms akimbo. Runs to the big brown box that she has carried on her head. Presses her arms to her heart, cocks her head and smiles with her mouth closed to the audience. For me? She seems to ask. She saunters up to the box, eyes glittery with excitement.

This is not a language course. It is a simple way to learn these phrases with simple effort and in a short time. It is for those who have not the time or inclination to study the language. This is Marjory Powell. I will speak each phrase in English. The other voice you hear will give a French translation.

The lucky black woman opens the box and vibrant, fulsome, fully inflated balloons pop out. She burrows through the box, using her handfuls to pull out more and more of them.

Such celebration! Such joy! Such richesse!

Oh no! In her hurry to get to the bottom of the box,
one of the balloons POPS!
It's a shame. But there's always more.
There will always be more.

She will speak each French phrase twice.
What is at the bottom of the box?
The black woman finds a record with images of houses
from a different city. The title of the record:
"Swedish for Travelers"
This is her present.

Now to begin. Here are some expressions you will use most
often.The black woman walks with her present ("Swedish for
Travelers") to stand between the rubbish pile of dead balloons
and the now empty box with juicy, balloons around her feet.

Can you speak English?
Parlez-vous anglais?
Parlez-vous anglais?

4. A Birthday Party
The black woman birthday girl starts to sing:

*HAPPY BIRTHDAY TO ME / HAPPY BIRTHDAY TO ME /
HAPPY BIRTHDAY DEAR GABBY / HAPPY BIRTHDAY TO
ME*

Her singing drowns out the language tape
which remains playing throughout the scene.

She says:
October 12 was my thirtieth birthday.
Yaaaaaay! She jumps and screams.
October 12 is Columbus Day.
Booooooooooo.

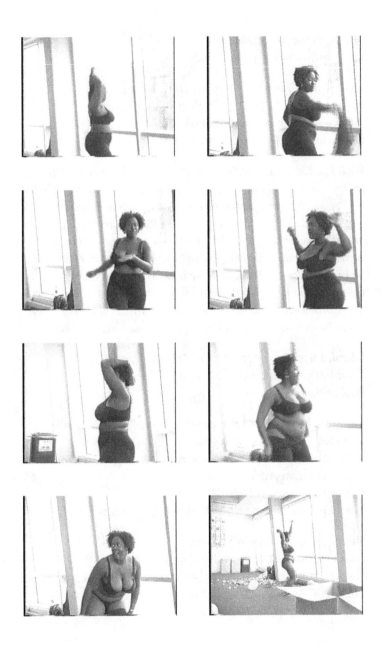

She pulls her arms down
and shuffles herself backwards.

The first time I went to Haiti, my Uncle's friend
CURSED THE DAY COLUMBUS WAS BORN.
(She covers her face with her hands.)
Good Morning. Bon jour. Bon jour.

Well, I do like McDonald's cheeseburgers, but I have concerns
for the rainforest. Jesus saves. (She presses her fist to her heart
and raises up over her head.) *In honor of this auspicious*
occasion, I decided to write my grandmother a letter. Well because
my father never taught me his mother's language, I decided to do
something a little different. You see, I've been to Paris, New York,
San Francisco, LA, Barcelona, Sienna, Geneva, Hamburg (on
the way to Hanover), Pisa (for a half an hour), to see the leaning
tower. I've been to Santo Domingo, Port-au-Prince, Port of Spain.
Noooo Nooo. (Now her hands on hips.) *I've never been to Dakar.*

I decided to write my grandmother's letter in Swedish.
Do any of you speak Swedish? Anybody?
Well neither do I.

From the large record sleeve which says "Swedish for
Travelers" she pulls out a small 45. With one hand she
holds it and with the other, she runs her fingers around it
like a record needle.
She begins to speak Swedish.
Travel phrases in French still play in the background.

She pauses and says in English:
I had more to say, but I just didn't have the vocabulary.
She kisses the record sleeve that says "Swedish for
Travelers" and says: *Ciao Mémé.*

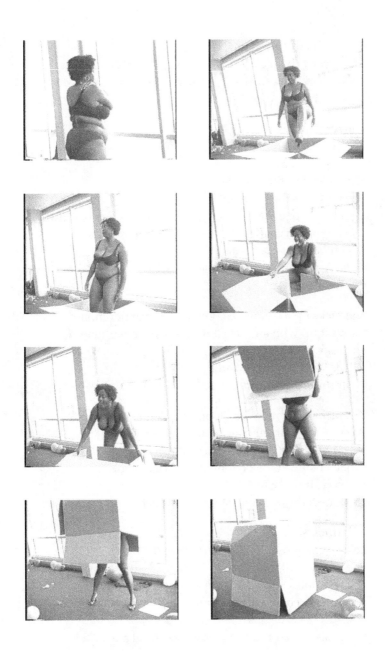

5. Lost Teeth Kingdoms. Clichés.

The record changes. We hear The Last Poets chanting: "New York New York—The Big Apple! New York New York—The Big Apple!"

She screams:
WE LOVE YOU STOCKHOLM!!!!!!
She says: *You feel me.*
She snaps her fingers several times.
She becomes the Blaxploitation diva.
I got a new one for you. I'm gonna take this one worldwide.
She intones in characteristic spoken word style.
My exotic erotic black body.
At the Yari Yari Yari Yari. Yaaaaari.
Clichés. Lost teeth kingdoms. Clichés.

She picks up a yellow balloon. Places it in her mouth.
Blows it up with air. Lets it fly away from her mouth.
She asks: *What's really at the bottom of the ocean floor?*
All the languages of the world.
What's really at the bottom?

She picks up a yellow balloon. Places it in her mouth.
Blows it up with air. Says with it in her mouth.
of the ocean floor? (sounds like *hrg hzm rugyh mrun*n)
What's really at the bottom of the ocean floor?
She spits it out...
She blows up a pink balloon, spits it out.

6. Striptease

Fela's "Chop & Quench" starts to play.
She begins to dance. Enjoys the tempo of the music.
She shimmies and struts, gives herself an embrace,
plays peek a boo with her top.
The striptease begins.
She pulls off her red Haiti t-shirt to reveal a black bra.

She rolls down her stretchy black pants to reveal black underpants. She walks over the brown box discovers black kitten heels bedecked with purplish blue metallic paillettes. To the beat of the music she puts on each shoe.
At the end of the song, her arms are around herself in embrace. A new song starts: "Been around the World" by Puff Daddy & the Family (featuring The Notorious B.I.G. & Mase).

7. Worldwide

She goes over, pulls out high heeled shoes from the box and puts them on. She steps in the box and pretends to be a video ho. She dances with complete mechanical movements as if in a hiphop video. She leans over the side of the box, presses her hands on the ground and begins to push her body up and down the side of the box.
The box tears.

She leans over, holding the edges of the box.
She dips her breasts low. She sashays her behind both ways.
She pulls the box close, lifts it up over her head
Slowly, surely she lowers it down over her body.
Until she is nothing left but a box gobbling up brown legs and high heels.

Been around the world and I I I
And we been playa hated [say what?]
I don't know and I don't know why
Why they want us faded [ahuh ahuh]
I don't know why they hate us [yeah]
Is it our ladies? [uh-huh]
Wanna drive Mercedes
Baby Baby Baby
The box engulfs her completely.
The music stops.

8. Dissolution

The black woman pokes her head from the crack in the box.
She stands and says:

WHAT THE FUCK WAS THAT?!
Nigger you messed up my hair.
She picks up her clothes from the floor.
She grabs a couple balloons.
You know today, she says: *today is my birthday.*
Dammit. And I was born in the Congo.
You know that shit. And Nefertiti was my first baby.
And Hannibal Lecter was my son.
And he gave me an elephant.

She is picking up balloons one by one and throwing them
back in the box. A few she pops in her hands as she speaks.
And I blew my nose. And there was oil in the Arab world.
She takes hold of the box and drags it across the space.
She shakes her head and is speaking but they are not real
words. Just that ageless, timeless sound of black woman
fussing. She stops dragging the box, would be standing still
if she weren't shaking. Her head, body, mouth shaking.
The clothes in her hands shaking. Kathleen Battle & André
Previn's "I Am Not Seaworthy" begins to play.

Slowly she begins to relax.
Pulls her pants back on.
Pulls on her shirt.

9. All the Languages
She speaks and as she speaks, she passes out
some of the small dead or partially inflated balloons.

they say we are dying. condoleezza rice. will die soon.
they say we are flourishing.
the gap between black men and black women
is the widest it's ever been.
news week is this worldwide?
do black men still want us? essence.
if you have to ask you already know. my mother.
lick and blow. janine antoni mouth feathers
sequins and horns. jayne cortez.
ectoplasm boogaloo. wanda coleman. if this were papyrus what
lacunae what fragments.
abbey lincoln picking up the tiny shards of glass.
nothin but a man.
concrete poems in call numbers. a slave ship. a sugar cube.
all the scientists find. blues a kente cap for sale.
a circling song. nawal el saadawi.
a song I learned as a girl. balloons balloons.
come and buy my pretty balloons.
six women in hot tub. what do they say? rosamond s. king.
blood and salt. high stepping body.
all the languages.
all the languages
all the languages
in the world.

She takes a red balloon puts in her mouth and blows,
holding its full body attached to her lips.

ON AUDIENCE

"Berlitz" was performed in New York, but made in Minnesota. Because the turnaround time was tight between my arrival in the Big Apple and my actual performance, I decided to stage a Minnesota run-through at Patrick's Cabaret, where I had been building the piece.

Around twenty people showed up, friends and colleagues from my workplace. Miré was there (and perhaps another woman of color?), but the audience was overwhelmingly white. This was nothing new for me in Minnesota. Most of my work had been performed before majority white audiences and I'd received diverse feedback from people who phenotypically seemed the same.

Multicultural audiences do exist in Minnesota (although it can take work to get to them when you do the work that I do—i.e. not spoken word). And race is not the only, and in many cases is not the most important, prism of identity.

Still, the cultural specificity of the particular white Minnesota audience that afternoon did not jibe with "Berlitz." My jokes were met with stony silence. My tongue-in-cheek spoof of nikki giovanni's "ego-tripping" received quizzical looks and it seemed people were a little embarrassed for me during the striptease and the hip hop transformation. They looked completely at a loss when I talked about Abbey Lincoln or of Wanda Coleman. And at the end of the piece, after letting go a newly inflated balloon, clenched between my teeth, I stood there looking at the audience looking at me. Dead silence.

Dear Sweet Lord Jesus, I needed to show this piece in just a day or two in New York City. Was it so terrible, so oblique, so inscrutable that it would flop?

All of my pride and excitement at having been invited to create and present new work turned into panic, a feeling I associate more with the development of a new work than

with the actual reception of it. And yet, I wondered if I should rework the piece completely. But how? And with what time? I considered my elements. The babel of languages. Competing mother tongues. The box on the head. The dead balloons. Live inflated ones. Deconstructed afrocentricity. hip hop. These were things that I wanted to explore in the piece. Maybe it sucked. But it was what I had.

The afternoon of the performance I was jittery, but looking into the crowd at all of the bright, shiny, accomplished black women, something in me felt hopeful. As I performed the work, I could see the glint in their eyes, hear *Uh huh* and *Lord*, the chuckles at my jokes that turned into warm chortles. The hooting and hollering when I did my striptease. The Yari Yari audience died laughing when I became the "video ho." They hung on every word of my last poem/monologue. And many of them, including the writer Sapphire (who wrote *Push* which inspired the film *Precious Inspired by the Novel Push by Sapphire*) gave me a standing ovation. Carrie Mae Weems winked at me when it was over. Another woman came up and asked if I had ever performed the piece for the community and if I was interested in doing it at a Boys & Girls Club where she worked. So often people say that performance art is insular and oblique, and here she was saying that my work was positive and educational.

Such is the power of audience. Maybe the work was insular and oblique, but she felt empowered to understand. And so she embraced it.

Actors, dancers, performers of all kinds can all attest to the ways that audiences can change a work. Even if the steps, the lines, the actions are the same, the people in the room are different, which makes the way that you are understood among those people different. And particularly if you—your body in time and space—are the main material of the work, then this makes the work different. This raises an important

point for performance art history, circulation and reception: To understand what happened, we have to think not just of who the performer is and what she did, but also who was in the audience, what was their context and how did the work resonate with their cultural references. As artists, we have to consider the audience relative to our intentions and our expectations about feedback and response. This doesn't mean that we should cater to the audience *per se*. Or that we should dismiss audiences different from us in terms of their capacity to relate. It merely means that we should take into account the specificity of audiences in relation to the specific meaning generated by a work performed before them.

I don't believe that my performance in Minnesota was of substantially lower quality than the one I did in New York. Or, if I did manage to embody "Berlitz" more fully at Yari Yari, it was because of the rich, juicy, diverse, specific bodies of the black women in the audience. Despite the non-linear, layered, abstract quality of the form, their understanding of my context and their familiarity with cultural representations of black women's bodies allowed them access to my performance art work that the Minnesota audience lacked. Their vocal affirmations and responses to my work spurred me on and let me know that the black women in the audience were on my side. I forever aim to be on theirs.

ON DOCUMENTATION

"Berlitz" does not appear on the official Yari Yari Pamberi DVD. Here's why.

The room where the performance happened had two sides. One was completely dark and the other was flanked by windows. I had planned to do my piece in front of those windows, to interpellate the city and to emphasize the outline of my body against the Manhattan skyline. A few minutes before "Berlitz" began, the conference videographer heard of my plan and told me that there was no way he and his team could videotape me there. He suggested that I do what Pamela S. Booker, the previous performer, would do: conduct the performance in the "front" of the room which was dark and academic. He said the documentation of the piece would look better there. I told him that the live performance would be better on the opposite side and I refused to move. He shook his head.

"That won't work."

"Can't we just try it?" I asked.

"It would look so bad; we'd just be wasting film. If you do it over there, we won't videotape it."

I paused for a split second. It came down to the experience of the current live audience –which would last 20 minutes— versus a record for countless audiences in the future.

"Fine," I said. "But I'm still doing it in front of the windows."

"Doesn't it matter to you that no one might see your piece in the future?" he asked.

"Well, I guess it will have to be legendary," I rejoined.

Pam overheard this exchange and laughed. "Girl, you're really a trip," she said.

The tussle with the videographer highlights key tensions in performance art documentation. Decisions about the preservation of a performance often must be confronted even before the making of the performance itself. Present and future reception can sometimes be pitted against each other.

Moreover, as Jane Blocker and other performance studies scholars have noted, documentation has increasingly become fetishized as the official record, the sole material artifact of the performance. Videos of Ana Mendieta and Theresa Hak Kyung Cha are all we have left of their brilliant actions. Marina Abramović sells glossy prints of her performances for $50,000 or more. Performance documentation is what gets exhibited, taught, studied, sold on the art market, and codified as art history. Documentation has come to stand in so much for the performance that it has de facto *become* the performance, a substitute memory for those who weren't there—or even at times, for those who were.

This is especially true for video documentation. How many times have I left a performance with a particular feeling or experience, only to watch the video and see an alternate reality? Gestures that felt poorly executed can look charming. A camera angle can create an untrue sense of the dimension of the performance space. And most performance videos only show the performer and therefore miss a major aspect of the performance action, the energy and responses of the audience (something which would become especially important in "Berlitz.") Video documentation of my work can make me squeamish because, even though I know I was there, did what I did and felt what I felt, the video can tell a different story. It can be very convincing. But that doesn't mean it was right.

More than photographs, sound recordings, oral histories, interviews or writing, videos can make you think you're seeing what happened in the performance, but it's only really telling you what some of what happened in the performance looked like. This is not the same as being there or really getting a sense of how it felt to be there. And that difference was at play with the documentation of "Berlitz." Perhaps the performance would have looked better to the videographer's camera in the darker space, but it was better for the live audience in front of the windows. For me, the live audience was the priority. (This makes me think of an Ishmael Houston-Jones video

that I watched in the Lincoln Center archives which seemed pitched black for the first half of the piece. He was dancing in very, very low light and quipped on camera, "I know the videographer will love this.") The subjective, embodied nature of performance art is meant to undercut the purported objectivity of technology. In part, aren't we supposed to make work that can't be so easily captured, that has to be experienced best in real space and time?

Yet, in this day and age, documentation is vital for performance artists. Beyond practical considerations (grants, research, teaching), I also have to confess my own love for documentation. It does offer access to future audiences who weren't there and—until they fix the tricky problem of the space-time continuum—couldn't be there. I'm deeply grateful for the video footage of Katherine Dunham's dances and Adrian Piper's "Funk Lessons." And what I would give to have a video of a performance by Maudelle Bass... In the dearth of past documentation, I generate and hoard my own flyers, images, photographs, videos. Documentation is crucial not just in a general sense, but specifically for the preservation of black women's creative expression in multiple forms. Documentation of our work can offer insight and inspiration. It shows that we exist. We just have to be clear about what it is and what it isn't. Documentation is not the live work. It signifies the work but cannot embody it.

I said no to the official Yari Yari videographer, but I was lucky to have my friend Ellen there, herself a videographer. She was willing to record "Berlitz" for me. And although she says some of the light values are blown out (whatever that means), her video documents the whole work and me in my jiggly brown glory. There is now an official record for posterity, albeit one sitting in a red plastic storage container in my studio. When someone is ready to unearth it, it will be waiting. In the meantime, the piece will be legendary for myself and for those who witnessed it live or for those who find it reconstituted here in words.

ON A CONVERSATION

One night in Chicago, my dear friend Michael and I went to see some work at Links Hall, an art space with a good reputation on the snowy Northside. It was one site for an experimental sound and image festival and, although the place was just around the corner from Michael's house, neither of us had ever been. It was lovely inside. You walked up a couple flights of stairs to enter a raw space with light-colored wood floors, tall, light-colored walls and bleacher style seating. The performance space was cozy, large enough to realize distance from the audience, but still exuding intimacy. I looked around and was enchanted. I knew immediately that I wanted to do a performance there.

Michael and I were about a third of the audience and we were the only people who had actually paid to get in. The rest were festival organizers, artists showing work or their friends. Video light, sampled sounds, chopped up syllables (*eep*, *op*, *up* soundtracking multiple projections) filled the empty spaces between us.

At intermission, I went out to talk to the balding, white man passing out programs.

"Excuse me, I really love this space. What is the submission policy for showing work here?"

"Well, this is an *experimental* venue. We don't do slams or spoken word. Sometimes there's multicultural stuff in February."

WTF? (*Bam! / Nigger sees stars.*)

I spoke slowly and deliberately.

"I know it's experimental. I came here with my friend and paid for a ticket to see the show. I am a performance artist. My own work integrates installation and conceptual art and has been called experimental."

He squirmed for a split second, then recovered. "Well, you know it depends on the curator."

"And so I can just send a proposal to the curator for a performance or what?"

"Yes, that could work. I mean, excuse me—"

And he dashed off to hand out programs to no one.

At community town hall meetings or on the boards of art spaces, I have heard curators, managers of art spaces, artists themselves defend the small size and homogeneity of their audiences. *Those kinds of people just don't like this kind of art. (Experimental.)* At these same events, I've heard other curators, managers of art spaces, artists fumble for ways to increase and diversify their audience base. Here's a thought—don't have assholes at the door.

This white man, likely a volunteer, but still a representative of this art space, looked at me and immediately decided, from my body, my gender, age and most especially my race, that I was somehow there by accident, that I didn't belong. When we talk—or don't talk—about exclusivity, racism in the art world, we are talking about moments like that. Small slights that help maintain a status quo: Northside equals experimental, high art, important, exclusive, white while Southside—unnamed but lurking in our conversation— equals *multicultural*, low art, popular, slams, spoken word, black and maybe with a winning lottery ticket, an L trip uptown during the exalted month of February. Dude, no wonder Detroit don't like Chicago. And Minneapolis may have its problems—I'd certainly often been the only black person, sometimes even the only visible person of color in a space—but no one had ever said such blatant bullshit to me.

It didn't ruin the night. I walked back and told Michael what had happened. ("What?! You've got to be kidding. What a boob.") We continued to enjoy the weird, spectral pieces. When it was over, we walked back to his place, while the other folks there headed off together without so much as a backwards glance. I didn't see the white man with the programs again. It didn't matter. I'd already decided that

one way or another, I would come back and do something in Links Hall. People like that asshole needed to encounter the work of people like me. If you put it out there, the universe will make it happen.

A month later, Rosa sent me a notice about the Chicago FIELD putting on a FIELD Trips "Performance Marathon." The venue? Links Hall. It would become the site for my performance art work "heart on a sleeve."

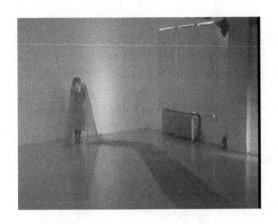

"What stands out to me about "heart on a sleeve" is its tremendous playfulness and wit. This is NOT your mama's stodgy old performance art; it's fricking kick-ass FUN!"
—JUDITH HARDING, CHICAGO, IL

"heart on a sleeve" started in New York City at a dive bar near Madhu's apartment. I don't remember what I was doing there in New York City, but we were hanging out and it was the day magician, and I would argue performance artist, David Blaine emerged vanquished from the giant bubble of water he had set out in Lincoln Center. His plan had been to stay submerged underwater for ten days, but after only a few, he was rushed out drenched and dripping. The New York Post mocked him cruelly. In the quote that most moved me, Blaine himself said: "It's been a difficult day. This was a failure, a complete and total failure." Even in that bar, people were laughing and jeering at him. And drinking a G&T (with lots of ice), we talked about altered states of the body on display.

I asked Madhu, "If you are submerged in water for that long, what happens to your mind and your body, where do you go? Are you really there that whole time or is there a kind of out of body experience? And what happens if you try to get to that experience, but you don't make it." There was a bravery to what David Blaine was up to—along with his usual desire to show off. And something in that combination made me think of performance art. How there's something so outrageous and over the top that if you can pull it off, it's amazing, but when you can't, you become the complete subject of ridicule. My heart went out to him and his words made me think too of my own heart. What it takes to make art and also to love— submersion, immobility, holding your breath and letting go...

HEART ON A SLEEVE

When one submerges oneself for so long and so deep,
one wonders what one is looking for?

"heart on a sleeve" happened in Chicago, a city I'm supposed to love but don't. Still I was happy to be going there to be showing new work as an artist in a performance series. Swoon and shake. I remember putting records together for the show and wanting to emphasize the two different impulses, different manifestations of a black woman's quest for love: "My Romance" from that ballroom dance record I bought at Hymie's and used in "after *Hieroglyphics*" and also "Getti'g Some" by Shawnna, a booty hip hop record that aimed for male tropes and swagger. I was interested in playing with soft and hard, being inside the bubble, but also dealing with its break.

I originally had a lot of tech cues for the piece but we didn't have a lot of time. The sound engineer was an old pro named Daedalus with hippy tendencies. I remember writing out this long, complex series of instructions. And he didn't glance at them once. I forgot—or perhaps had never really thought about it—that's not how tech guys work. They learn it with their hands. I remember him yelling at me and far from it bumming me out, it actually liberated me. Fuck him! I thought. And it made me want to giggle and it gave me an extra little swagger in my step. (I think that's why this version of the piece was a little better than the second version Michael and I did a few months later at Intermedia Arts.)

Working with my friend Michael was a dream. We had almost zero time to rehearse, but still he rolled right up, grabbed a pair of sunglasses (filched from the Aaron Young show) and held the reins of the sky, blue graffitied fabric, now lost in the annals of time. One of my oldest and dearest friends, Michael was the handsome masculine presence who

strode in and out of the frame, who tied me up into a sea blue cloud, who took my little red paper heart.

O to be a friend of a performance artist!

Even if you're working for a bank, or an insurance company or a financial services firm, there's always a chance that she will call you last minute to come and join the happy circus or this case the crazy aquarium.

The show took place the same night as the SuperBowl, so the house was small and I was the only one on the line-up who wasn't a dancer. At the end, one guy said to me, "I laughed all the way through this—it felt so familiar. I just broke up with my girlfriend."

Heart on a sleeve indeed...

ON PANIC

"You keep writing these complex things and insisting on doing them, and then saying you can't do it. Why?" Miré asked me with frustration. She had said this when we were working on "after *Hieroglyphics*," but she may as well have been talking about "heart on a sleeve." *Panic*.

The thing that was so wild about making this show was how panicked I was in making it. In performance art practice, that crazy swing from hyper-confidence (*"If it were me, I'd rock this place!"*) to utter desolation (*"What the fuck am I going to do? I don't have a fucking clue!"*) Both alarming and predictable, the feeling of panic starts to overwhelm the initial spark of creativity. It emphasizes the logistical ("I've been accepted to the festival. The postcards are out. The date is set. I'm going to a different city to perform in a venue I barely know—and where I've already had an experience of being rebuffed—and I have no idea what I'm doing.")

Panic distracts with unproductive, histrionic thoughts ("There will be no performance. Those people were right—I'm not experimental. I'm not an artist. I'm just a black girl poser, an imposter, a hack!") Ah yes, panic is chattery—internally and externally. The slight chatter of your teeth from fear of failure becomes external questioning to any and all. ("I'm working on a piece and I have this and that, and what do you think?" i.e 'I'm *LOST*. What do *YOU* think I should do?") This clamoring for answers, this grasping for straws, panic disrupts the internal stillness required to allow vision to unfold. In car factory terms, it halts the line. It shifts attention from the work to the self ("Who am I to think that I can do this?"), leads to "paralysis from the analysis," turns into idleness, the worst kind of artistic self-indulgence, a spectacular waste of time.

What was so striking about my panic before "heart on a sleeve" was how it came after a string of performance

successes. I had been making work under much stricter deadlines and had felt good about the process and the results. Just recently, at R.S.V.P., a two-day No. 1 Gold Collective performance event, I had shown spanking new work and had been completely comfortable crashing and burning and trying new things and facing failure. I had been in my body, languorous and erotic and gloriously present, alive. Now just five months later, I was back in the void, struggling with pernicious insecurities, running smack dab into a creative block that was blowing my mind.

This was a good lesson. As an artist you're never over the hump. If you're really trying to do something new, there's always risk and stress and the possibility of failure or embarrassment. You could make 100 pieces, with 95 of them hits (lucky you!) and at the threshold of 101, you can still feel panic, inability, doubt. Perhaps from burnout, excess internal or external pressure. Perhaps from excess ambition, reach exceeds grasp. Perhaps it's a presage of performance aftermath or even its flash recurrence. It can vary why. But those flare-ups of panic are a part of performance practice that pushes the artist to step back and take stock.

What are my processes? What are my rituals?

How do I work?

How can make this performance art work?

With "heart on a sleeve," I was starting from images of David Blaine's failed attempt to stay submerged in a giant bubble of water in New York City. I knew which elements I wanted to use—the sky blue, black graffitied fabric from "after *Hieroglyphics*," some romance records, hip hop, a flashlight—but I couldn't figure out exactly how to activate and sequence these things. I had been working in my apartment, went with my friend Brinsley to work over in Minneapolis at the Zenon studios. I'd been talking about it, writing notes and was sorting through poems and journal entries, but was still struggling to edit and unify the primary

performance action.

I needed to give myself a start, as Lois Weaver says "wake up the room." I needed to recharge my internal stores, remember my faculties.

I needed to push my ego aside.

Oh yeah, I needed to ask for help.

Some artists, some people depend solely on themselves to face down panic. They are perhaps more introverted by nature. For me, asking for help is not idle chatter. It doesn't try to replace the internal or external work required to conceptualize and execute a performance. Instead, it allows for the aim of the work to come back into view. Other eyes help spy gaps; other hands slap away doubts. No more spinning wheels or wallowing in anxiety. I get help snapping back into reality.

Once again, I called Miré to help me pull it together. It was an intense time for her as she was dealing with her first few months of pregnancy. Her body was changing, her life was changing and these were good, wanted changes, but she still needed support. In the midst of all of this, she agreed once more to come to my aid. Again, I felt like I had run off and started some rash thing and then when I couldn't get it together had run to her to be saved. With grace, Miré helped me put the piece together, helping me break it down into manageable parts, specific actions. She also protested against some of the things I had planned to put into the show that were too explain-y. "Put that down," she said. "That's not what your work is about."

The key to asking for help is asking people who really can help you, who know you well and have a sense of your aim, your aesthetics, your weaknesses and your tricks. In this way, Miré was brilliant. And she did it without any big credit and certainly without payment because we were both working for free. Some things I knew that I wanted to do—booty dance to Shawnna's "Gettin' Some" or getting tied up

in a fabric and having only a tiny red heart come out—and I couldn't even fully explain to you why I wanted to do them. Miré took what I had and helped me forge and form it. She helped me gain confidence and direction. Even as she brought her own inimitable self to it, she helped me make my work my own.

We didn't always agree. At one point, we had terse words about my idea to be hog-tied in the fabric. "It's too dark," she said. "That's not what this piece is about." "It isn't?" I countered. "Are you sure that we're still talking about the piece—or are we talking about my feelings about love?" Even in our disagreements, I was able to feel calm, secure in the knowledge that someone had my back, that I was actually in the work and not in the terror of my mind.

Rarely in my practice have I proceeded completely alone from the spark of conception to the final performance. My artist pals have offered me their challenges and conversation. Camaraderie, an indispensable boon, becomes an antidote for performance panic, which for me comes again and again.

And in the middle of everything, I put the show out of my head. We were outside of KPAK and Miré started talking about being pregnant. We were inside the car and I was about to head into the space to work on the show when I stopped. This was important. More important than the show or anything. Miré was talking about her life and the life of a person we didn't know yet but would come to know soon. And that's a part of making work too—having a moment, taking a moment, to be fully present for someone or something else. In that moment, no panic. I was her friend and was listening to her. And when I think of the work, I think of this too.

HEART ON A SLEEVE
FIELD Trips @ Links Hall Chicago
with TECHNICAL NOTES

Entrance
A black woman sits in the audience
with a handsome young man.
He is wearing a pair of reflector sunglasses.
She is wearing a salmon pink chiffon skirt
and a matching salmon top
tied with a knot on the right. An epic overture plays
[the theme music from Twentieth Century Fox]

BLACKOUT
Two flashlights strobe the darkness for 10-15 seconds
MUSIC CUE: Track One (a remix of "My Romance"
from *The Arthur Murray Ballroom Collection*)
An orchestra swells. The beams of the two flashlights come
together.
LIGHT CUE: Light starts to rise on the stage.
They start warm, then get cooler, underwater blue.

Fucked Up Swim
The black woman rises from her seat. Her head and the
front of her body are covered in an ocean blue cloth covered
in black graffiti. She moves down from the stadium style
seats into the audience. She moves in slow motion, the
flashlights tucked down into her bra making submarine
beams. The handsome man next to her holds the two ends
of the cloth, creates tension that stretches the fabric taut
against her movement. She moves forward against it—
looks like something submerged or amniotic. The music has
changed—the sound of the record has slowed way down. It
is starting to mix with something more electronic.

The effect is something burbled. The black woman moves diagonally across the stage to far upstage left. Once she arrives, she takes out the flashlights, lifts them up under the cloth and makes a Strong Man pose.

MUSIC CUE: If the track doesn't finish, it fades out
LIGHT CUE: tight bright light around her body like an underwater bubble

David Blaine Moment
The black woman turns off the flashlights,
stops and makes bubbles noises.
Glug glug glug glug glug glug glug
From the audience, the handsome man pulls the fabric three times. The black woman falls to the ground. Tries to stand back up. Upright, she makes a perfect "swim" gesture, falls again.

LIGHT CUE: underwater, a litle more transparent, lighter, softer than before
MUSIC CUE: CD Track 2 (Reggie Love Remix)
("how do I love thee, let me count the ways")

Total Failure
To the sound of DJ Reggie, a black man friend from Chicago, reading Elizabeth Barrett Browning's famous sonnet "How Do I Love Thee?" the black woman in love does a crazy swim across upstage left to upstage right. She pulls the blue fabric to her, moves in and through it. This swim is the attempt and the failure to stay submerged. By the end of the poem, the black woman is at the wall, on the ground, gasping for breath. She says (quoting David Blaine): *"It's been a difficult day. This was a failure, a complete and total failure."*

Gettin' Some

The black woman turns so her behind faces the audience.

LIGHT CUE: bling bling / commercial interruption
SOUND CUE 3: CD Track 3 (Shawnna "Gettin' Some")

She takes the cloth, pulls it tight against her behind and begins to booty dance across the floor. *(Is this what you want? Is this what waits on the other side?)* The handsome man comes up the stage pulls the sea cloth back toward the audience. Center stage, the black woman is still shaking her ass with wild abandon, trying to get the shimmy out of the cloth. The handsome man walks up and ties a knot with the blue fabric around the black woman's foot. He does the same with the other foot. He pushes her down to the ground and then ties another knot.

The black woman says:
"Are you sure you don't want me for my mind?"

LIGHT CUE — back to the soft transparent underwater — even more intimate perhaps?

Language Blur

The handsome man pulls out from his pocket a text of love. He reads this language [three times] while the black woman listens and responds in improvisations. She is moving in and out of the fabric as she hears these words, until finally, she pulls another piece of paper from his pocket. She reads: *"When one submerges oneself for so long and so deep, one wonders what one is looking for?"*

LIGHT CUE: It brightens to more and more light...

Cocoon

The black woman keeps reading about submersion and love. As she reads, she and the handsome man engage in a battle of push and pull, using bodies and fabric. By the end, he has wrapped her in a sea blue cocoon. She surrenders. She finds a way to reach inside, pull out a small, folded, red paper heart. She unfolds it, hands it over fluttering to the handsome man.

Heart on a Sleeve

The black woman closes her eyes and tries
to hold her breath as long as she can.
She does this for five counts. She doesn't see what the handsome man does with the heart. He can do whatever he wants. She won't look or know until closer to the last moment. By the third count, he should be done and will just be watching her with his back to the audience.

LIGHT CUE: By the fourth breath, the lights FADE OUT.

In the darkness, the last thing the audience hears is the black woman, after vain attempts to hold her breath, finally exhaling.

ooooooooooooooooooo

"And now, O Muses, dwellers in the mansions of Olympus, tell me- for you are goddesses and are in all places so that you see all things, while we know nothing but by report- who were the chiefs and princes of the Danaans? As for the common soldiers, they were so that I could not name every single one of them though I had ten tongues, and though my voice failed not and my heart were of bronze within me, unless you, O Olympian Muses, daughters of aegis-bearing Jove, were to recount them to me. Nevertheless, I will tell the captains of the ships and all the fleet together."
-HOMER, ILIAD, BOOK 2, TRANS. SAMUEL BUTLER

the catalogue of ships

Swallow the Fish

PRODUCTION HISTORY

"Body Dander, Dust," Casita Torres, Arroyo Seco, NM, July 1997; also produced in "Voices From the Edge 4" Festival, New Perspectives Theatre," NY, New York, September 2001.

"Art Training Letter (Love)" (a performance rumination on intimacy and catastrophe after September 11) from *Hieroglyphics*. Premiered at "Many Voices: An Evening of Resistance, Ritual & Resilience after 9/11," Babylon Arts & Cultural Center, Minneapolis, November 2001; also performed at Vulva Riot, Intermedia Arts, Minneapolis, June 2002.

"infestation of gnats" from *Hieroglyphics*, directed by Miré Regulus, Works-in-Progress Series, Red Eye Theatre, Minneapolis, February 2002.

"brown skin, brown bag" installation at the "Making Transformation Visible" Teaching Learning Network Conference, College of St. Catherine (St. Catherine University), February 2002.

"The Secret Garden (Closet)," site specific performance installation , chez moi, June 2002.

"economy," Center for Independent Artists + Art-a-Whirl, Minneapolis, May 2003.

"Comedy" from "after *Hieroglyphics*" at Patrick's Cabaret, Minneapolis, February 2004.

"after *Hieroglyphics*," Festival of Solo Women Performers, Center for Independent Artists, Minneapolis, March 2004 Directed by Miré Regulus; Train graffiti by Ernest Bryant III).

"Berlitz," Yari Yari Pamberi: Black Women Dissecting Globalization, Organization of Women Writers of Africa Conference, New York, October 2004.

"How's Work?" premiered at R.S.V.P., Center for Independent Artists, Minneapolis, January 2006; also shown in "Comedy & Other Work," Bedlam Theater, Minneapolis, June 2008. Featuring Molly Van Avery as The Student.

"Yawo's Dream" video with Ellen Marie Hinchcliffe (4.5 min), premiered at R S V P: work / play / process, Center for Independent Artists, Minneapolis, January 2006; also shown at "The Promise of Green: Resilience, Resistance and the Coming Season," Center for Independent Artists, Minneapolis, March 2006.

"heart on a sleeve," Intermedia Arts, June 2006; premiered at FIELD TRIPS, Chicago Field at Links Hall, Chicago, May 2006; also shown at Intermedia Arts, Minneapolis, June 2006. Featuring Michael Abdou as the Handsome Man in Shades, voiceovers by Reggie McKeever, with directorial assistance by Miré Regulus.

"Auction," produced at the Bedlam Theater Festival of Ten Minute Plays, Minneapolis, June 2008.

PUBLICATIONS

"Body Dander, Dust," *Women & Performance*, Performing Autobiography Double Issue, Vol. 19-20, 1999-2000

"Infestation of Gnats" in *XCP 14: Poet's Theater / People's Theater Issue*, Winter 2004

"Auction," *Obsidian: Literature & Arts in the African Diaspora*, volume 41.1-2, March 2016.

"Berlitz," "On Audience" and "after this you will love me" in *Blues Vision: African American Writing from Minnesota*, Ed. Alexs Pate, co-edited Pamela Fletcher and J. Otis Powell, St. Paul, MN: Minnesota Historical Society Press; Feb., 2015.

"On Panic, Failure and Asking for Help" and "Heart on a Sleeve" first published in *Vandal, in: security*, 2011; *Aster(ix)*, March 2016.

NOTES

The triptych *Hieroglyphics* also included the short work "wall/flower," written in Fall 2001. This work has never been produced or performed.

"Art Day," with Ellen Marie Hinchcliffe happened in 2007 and so counts as one of our first From the Hive collaborations.

Fat Black Performance Art, originally written for this book, was later performed as a part of "Comedy & Other Work" at the Bedlam Theater, Minneapolis, June 2008. In order, the artists referenced are: Yves Klein, Yayoi Kusama, Carolee Schneemann, Ishmael Houston-Jones, Karen Finley, Eleanor Antin, Janine Antoni, Andrea Fraser, Adrian Piper, Coco Fusco, and Guillermo Gómez-Peña, Ana Mendieta, Yoko Ono, Mattew Barney, Maria Abramović, and Pope L.

The Secret Garden (a dream) was written during a 2002 Many Voices Residency at the Playwrights, Center in Minneapolis.

Zetta Elliott's remarks on "Displays after Venus" come from her essay "Subversion and Surveillance across Genres "Hoochie No More: Mickalene Thomas Reframes the Blaxploitation Aesthetic."

Sections of this manuscript won Honorable Mentions for the James W. Denny Writing Award at St. Catherine University in 2007 and 2013 and were presented in "Swallow the Fish: Black Feminist Performance Practice," Inaugural Lecture, Women's Art Institute Lecture Series, St. Catherine University, St. Paul, MN, October 2012.

Photos and videos stills come from the collection of the author. Photos of "Displays after Venus" were taken by Zetta Elliott. Photos of "after *Hieroglyphics*" were taken by Chrys Carroll.

This book is a performance. This book is an archive. A product of its time, this book was written over many years. It is the result of my own memory and experience. Others may have a different account. Some names have been changed.

Abramović, Marina. *Artist Body. The Artist is Present.*
Angelou, Maya. "Phenomenal Woman." *The Collected Autobiographies.*
Auster, Paul. *Leviathan.*
Battle Kathleen & André Prévin. *Honey & Rue.*
Bellamy, Dodie. *Cunt-Ups.*
Berger, John. *Ways of Seeing.*
Björk. *Début. Family Tree.*
Bishop, Elizabeth. *Selected Poems.*
Boland, Eavan. *Outside History.*
Breton, André. *Nadja.*
Bridgforth, Sharon. *Love Conjure/Blues.*
Brooks, Gwendolyn. *Maud Martha. BLACKS.*
Brontë, Charlotte. *Jane Eyre.*
Brossard, Nicole. *Fluid Arguments.*
Burrows, Jonathan. *A Choreographer's Handbook.*
Calle, Sophie. *Double Game. Did You See Me?*
Calvino, Italo. *Cosmicomics. Six Memos for the Next Millennium. Difficult Loves.*
Carlson, Melvin. *Performance: A Critical Introduction.*
Cha, Theresa Hak Kyung. *The Dream of the Audience. Dictee.*
Clifton, Lucille. *Good Woman.*
Condé, Maryse. *Heremakhanon.*
cummings, e.e. *i/ six non-lectures*
Dickinson, Emily. *Complete Poems.*
Dolan, Jill. *Geographies of Learning: Theory and Practice, Activism and Performance.*
Dove, Rita. *Museum. Thomas & Beulah. Selected Poems.*
Duane, Diane. *So You Want to Be a Wizard.*
Duras, Marguerite. *The War. The Lover.*
Durham, Aisha S. *Home with Hip Hop Feminism.*
Everett, Percival. *Abstraktion und Einfühlung.*
Finley, Karen. *A Different Kind of Intimacy.*
Frueh, Joanna. *Erotic Faculties. Clairvoyance.*
Fusco, Coco. *English is Broken Here. This Body Which is Not Ours.*
Giovanni, Nikki. *Cotton Candy on a Rainy Day. My House. Gemini.*
Glissant, Édouard. *Poetics of Relation.*
Goldberg, RoseLee. *Performance Art from Futurism to the Present. Performance: Live Art Since the 60s.*
Gómez-Peña, Guillermo, "In Defense of Performance Art." *The New World Border: Prophecies, Poems & Loqueras for the End of the Century. Dangerous Border Crossers: The Artist Talks Back.*

Gonzales Torres, Félix. *Félix Gonzales Torres*.

Hammonds, Evelynn. "Black (W)holes and the Geometry of Black Female Sexuality"

Hansberry, Lorraine. *To Be Young, Gifted and Black*.

Hay, Deborah. *My Body, the Buddhist*.

hooks, bell. *Black Feminist Criticism from Margin to Center*. *Talking Back*. *Art on my Mind*.

Goulish, Matthew. *39 Microlectures: in proximity to performance*.

Gutierrez, Miguel. *When You Rise Up: Performance Texts*.

Jones, Omi Osun Joni L., Lisa L. Moore & Sharon Bridgforth. *Experiments in a Jazz Aesthetic: Art, Activism, Academia, and the Austin Project*.

Kearney, Douglas. *Mess and Mess and*.

Kennedy, Adrienne. *People Who Led to My Plays*.

Kincaid, Jamaica. *The Autobiography of My Mother*.

Knott, Blanche. *Totally Tasteless Jokes*.

Laferrière, Dany. *I Am a Japanese Writer*.

Lemon, Ralph. *Geography*. *Come Home Charley Patton*.

Ligon, Glenn. *Yourself in the World*.

Lorde, Audre. "Poetry is Not a Luxury," "The Uses of the Erotic," *Sister Outsider*.

Maso, Carole. *AVA*. *Break Every Rule*.

Montano, Linda. *Letters from Linda M. Montano*.

Müller, Medeiros Flávia and Daniel Eatock. *It Depends on the Circumstances and the People*.

Ono, Yoko. *Yes*. *Grapefruit*.

Owens, Clifford. *Anthology*.

Patterson, G.E. *To & From*. *Tug*.

Parks, Suzan-Lori. *Venus*. *America Play & Other Works*.

Piepzna-Samarasinha, Leah Lakshmi. *Dirty River: A Femme of Color Dreams Her Way Home*.

Prince. Every single record but especially: *Prince*. *Purple Rain*. *Dirty Mind*. *Graffiti Bridge*. *Controversy*. *1999*. *The Hits (vol 3)*. *Diamonds & Pearls*. *Come*. *Emancipation* (disk 2).

Piper, Adrian. *Out of Order, Out of Sight, vols 1 and 2*.

Rumi. *Selected Poems*.

Sarraute, Nathalie. *You Don't Love Yourself*.

Sayre, Henry. "Performance" from *Critical Terms for Literary Study*.

Scalapino, Leslie. *that they were at the beach*. *Way*.

Schecner, Richard. *Performance Studies: An Introduction*.

Sedgwick, Eve Kosofsky. *The Epistemology of the Closet*.

shange, ntozake. *A Daughter's Geography*. *for colored girls...*

Stricker, Meredith. *Alphabet Theater*.

Toomer, Jean. *Cane.*
Vicuña, Cecilia. *Spit Temple.*
Viso, Olga. *Ana Mendieta: Earth Body.*
Walker, Alice. *In Search of Our Mothers' Gardens.*
Walker, Kara. *Narratives of a Negress.*

ACKNOWLEDGMENTS

Thanks to St. Catherine University, especially the Departments of English and the Women's Studies and Critical Studies of Race and Ethnicity Program; Abigail Quigley McCarthy Women's Center, Sharon Doherty and Sia Vang; Feminists-at-Work Writing Group, Cecilia Konchar Farr, Joanne Cavallaro, Jane Lamm Carroll, Sharon Doherty, Lynne Gildensoph, Cindy Norton; Scholars' Retreat, Dean Susan Cochrane; Teaching Learning Network, Toné Blechert; Faculty Resource Center, Gina Dabrowski and Joseph Lipari; Women's Art Institute, Patricia Olson; Pamela R. Fletcher and Nancy Heitzeg for holding it down at St. Kate's; Rafael Cervantes, Robert Grunst, Gayle Gaskill, Susan Welch, Donna Hauer, Amy Hamlin and Allison Adrian for their kind collegiality; and my fellow performer/artist-academics Francine Conley-Scott and Hui Wilcox for their scintillating presence.

Thanks to the artistic directors, administrators and funders of the places where this work took place: Babylon Cultural Arts Center (Meg Novak), Vulva Riot (Eleanor Savage), Red Eye Theater (Steve Busa and Miriam Must), Playwright's Center (Many Voices Residency), Center for Independent Artists (Zaarawar Mistry and Mankwe Ndosi), Patrick's Cabaret (Sarah Harris), Organization of Women Writers of Africa, Yari Yari Pamberi: Black Women Dissecting Globalization Conference (Jayne Cortez), New York University, the Chicago FIELD, Link's Hall, Mt. Holyoke College (Zetta Elliott) and Bedlam Theater (Maren Ward). Thanks to all those who provided remarks on my work preserved here from my first website. Thanks to all the technical staff, sound engineers, lighting designers and fellow artists who shared stages with me. Thanks as well to Can Serrat in Spain for residency support to work on this book.

Thanks to early readers/ supporters of this book: Catherine Dunn, Jessica Ashley Nelson, Roderick Ferguson, Zainab Musa, and Ebony Noelle Golden. Thanks to Jeremy Braddock for long time friendship, intelligence and love of Prince; Ira Dworkin for his his kindness, smartness and goodness; Chrys Carroll for

resonant photos; Catron Booker for performancera energy; Daniel Hernandez for living writing is fighting; Daffodil Altan and Marco Villalobos for smart feedback and sharing the process.

Thanks to Michelle Naka Pierce for her encouragement and continually asking: "Where's your book?" and for saying "Book is better than no book." Thanks to Flávia Müller Medeiros and Daniel Eatock for camaraderie and artistic inspiration. Thanks to Donald R. Harrison-Detroit techno forever! Thanks to Bev Bell for mentorship in New Mexico. Thanks to David and Carolyn Sutherland, Eric Schwerer, PK Harmon, Stacy Morgan and Jeremy Webster for friendship in Athens, OH. Thanks to Aravind Enrique Adyanthaya, Maria Damon, Sarah Berger, Therese Cain, Justin Cummins, Valerie Tremelat, Anita Ho, Corey Hamm, Reginald McKeever, Juliet Patterson, Ronnell Wheeler, Marcus Young, Jean Ann Durades and Omise'eke Natasha Tinsley for good times in Minneapolis.

Thanks to Nicolas Daily, Deanne Bell, and Kevin McGruder for Black Power Power Hour and Dennie Eagleson, Raewyn Martyn and Louise Smith for art merry-making in Yellow Springs, Ohio. Thanks to all my Antioch peeps who aren't in this book but are in my heart, especially my performance students who got excited to read this.

Deep thanks to Cecilia Konchar Farr and Rosamond S. King who read the manuscript more than once and to Moe Lionel and Sam Worley for editorial attention. Abundant thanks to the miraculous Peter Park Nelson who, at the end, pored over every comma, name, and word.

Heartfelt thanks to Sharon Bridgforth, Miguel Gutierrez, and Douglas Kearney for their rich words and especially to Janice Lee and John Venegas for their hard work and believing in this book. We're doing more than coping. We're thriving!

Thanks to God, all my family, godfamily, friends, teachers, students, artists, poets, pals.

In remembrance of my grandparents David E. Smith, Sr. and Celia Smith, my Haitian grandmother Olivia Ciné, my aunt Mary L. Smith Ugwuzor, and my godparents Walter Jones, Jr. and Myrtle Jean Jones who would have all gotten a kick out of this book (when they weren't scandalized).

Special thanks to Kate Frances and André Civil, Yolaine Civil, David E. Smith, Jr., Madhu H. Kaza, Rosamond S. King, Miré Regulus, Ellen Marie Hinchcliffe, Michael Abdou, Greg Bullard, Zetta Elliott, Juma B. Essie, Mankwe Ndosi, Eric Leigh, Moe Lionel, Josina Manu Maltzman, Amy Hamlin, Lewis Wallace, Eléna Rivera, Laura Sutherland, Purvi Shah, Rachel Moritz, David Naugle, Jerome Ty Neal, G.E. Patterson, Sun Yung Shin, and Molly Van Avery. Without whom. You are all beyond lovely.

Please visit:

http://copingmechanisms.net/portfolio/swallow-the-fish-by-gabrielle-civil/

to download full color PDFs of select photo spreads and documentation from this book.

GABRIELLE CIVIL is a black woman feminist poet, conceptual and performance artist originally from Detroit, Michigan. Since 1997, she has premiered more than 40 solo and collaborative performance art works, nationally (Minneapolis, New York, Chicago, Salt Lake City) and internationally (Puerto Rico, The Gambia, Mexico, Ghana, Canada, Zimbabwe). She holds a Ph.D. in Comparative Literature from New York University. She served as an Associate Professor of English, Women's Studies & Critical Studies of Race & Ethnicity at St. Catherine University in St. Paul, MN and also as an Associate Professor of Performance at Antioch College in Yellow Springs, OH.

The aim of her work is to open up space.

OFFICIAL

CCM ☻

GET OUT OF JAIL
✷ VOUCHER ✷

- -

Tear this out.

Skip that social event.

It's okay.

You don't have to go if you don't want to. Pick up
the book you just bought. Open to the first page.

You'll thank us by the third paragraph.

If friends ask why you were a no-show, show them
this voucher.

You'll be fine.

- -

We're coping.

☻

CPSIA information can be obtained
at www.ICGtesting.com
Printed in the USA
LVHW042048191120
672182LV00007B/1194